DIGITAL PHOTOGRAPHY

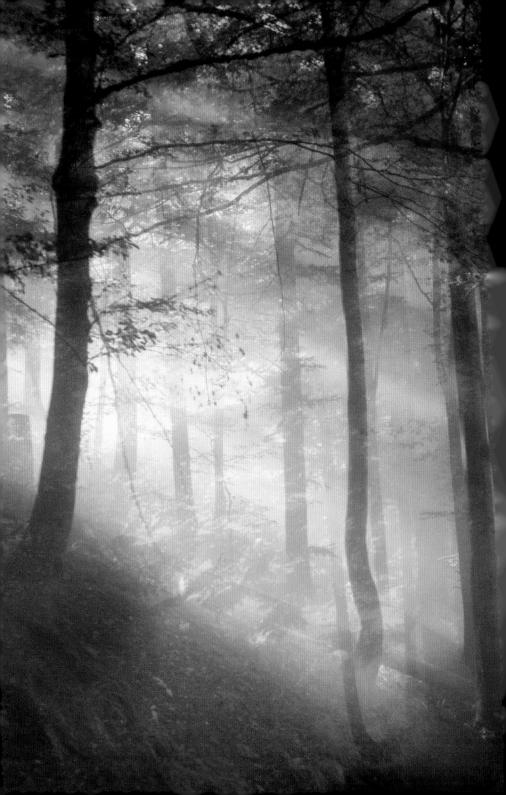

DIGITAL PHOTOGRAPHY

TOMANG

For Wendy

Senior Editor Nicky Munro Designer Joanne Clark Jacket Designer Mark Cavanagh Producer, Pre-production Rebekah Parsons-King Production Controller Mandy Inness

Managing Editor Stephanie Farrow Senior Managing Art Editor Lee Griffiths

First published in Great Britain in 2012 by Dorling Kindersley Limited 80 Strand, London WC2R 0RL

> Penguin Group (UK) 2 4 6 8 10 9 7 5 3 001-294569-January/2018

This edition published in 2018
Copyright © 2003, 2007, 2010, 2012, 2018
Dorling Kindersley Limited
Text copyright © 2003, 2007,
2010, 2012, 2018 Tom Ang
All images © Tom Ang, except where
otherwise stated.

All rights reserved. No part of this publication may be reproduced, stored in a retrieval system, or transmitted in any form or by any means, electronic, mechanical, photocopying, recording or otherwise, without prior permission of the copyright owner.

A CIP catalogue record for this book is available from the British Library.

ISBN 978-0-2412-5708-1

Printed and bound in China

A WORLD OF IDEAS: SEE ALL THERE IS TO KNOW

www.dk.com

CONTENTS

06 Introduction

CORE SKILLS

- 10 Your first pictures
- 12 Picture composition
- 18 Focusing and depth of field
- 22 Movement blur
- 24 Influencing perspective
- 26 Changing viewpoints
- 28 Quick fix Leaning buildings
- 29 Quick fix Facial distortion
- 30 Colour composition
- 34 Quick fix White balance
- **36** Exposure control
- 38 Low-key images
- 40 Accessory flash
- 42 Quick fix Electronic flash
- 44 Electronic flash

2 PHOTOGRAPHY PROJECTS

- **52** Abstract imagery
- 55 Architecture
- 58 Documentary photography
- **62** Street photography

- 64 Holidays and travel
- 70 Weddings
- 72 Children
- 76 Landscapes
- 82 Cityscapes
- **86** Low-light photography
- 88 Animals
- 92 Panoramas
- 94 Live events
- 98 Portraits
- 102 Camera phone photography

3 IMAGE DEVELOPMENT

- 106 Workflow essentials
- 108 Downloading
- 110 Image management
- 112 Capture defects
- 114 Colour management
- 116 Cropping and rotation
- 118 Quick fix Poor subject detail
- 119 Quick fix Poor subject colour
- 120 Levels
- 122 Burning-in and dodging
- 124 Dust and noise
- 126 Sharpening
- 130 Blurring
- 134 Quick fix Image distractions
- 136 White balance
- 138 Colour adjustments
- 140 Saturation and vibrance
- 142 Manipulation defects

- 144 Curves
- 148 Colour to black and white
- 156 Vintage effects
- 158 Working with RAW
- 162 Duotones
- 164 Cross-processing
- 166 Tints from colour originals
- 168 High dynamic range
- 172 Selecting pixels
- 176 Masks
- 178 Quick fix Removing backgrounds
- 180 Layer blend modes
- **186** Cloning techniques
- 188 Simple composite
- 190 Image stitching

4 BUYING GUIDE

- 194 Camera phones
- 196 Compacts
- 198 Mirrorless compacts
- **200** SLRs
- 202 Choosing lenses
- 206 Photographic accessories
- 210 Digital accessories
- 212 Electronic lighting
- 214 Computers
- 216 Computer accessories
- 218 Printers and other devices
- 220 Index
- 224 Acknowledgments

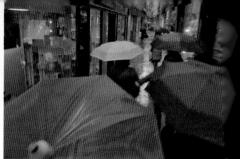

INTRODUCTION

This is the fifth edition of *Digital Photography: An Introduction* celebrating over 10 years in print. In that time, while few of the fundamentals of image-making have changed, digital technologies have transformed much of photography almost beyond recognition. The steady rise of photographers' skills as access to photography has spread to literally billions of people all over the world is itself a remarkable social and artistic phenomenon. One result is the bewildering explosion in the number of photographs being made: the total has passed a trillion images per year, and by the next edition we should not be surprised to learn that the 2-trillion mark has been reached.

While the steady improvement in photographic abilities is attributable in part to technology's ingeniously adept mediation, it is evident that skills and understanding of photography have genuinely grown and continue to blossom. Nonetheless, the hunger for photographic knowledge has also exploded, which drives the continuing demand for – and appeal of – this book.

We have responded to the latest developments with numerous updates to *Digital Photography: An Introduction*. We have taken account, for example, of the rise of the interchangeable lens compact and the diversification of image manipulation and management. In the process, our sections on film and scanning have finally had to be removed. In their place, we have introduced several new pages in which we examine images to understand the theory behind their impact.

With this fifth edition, we find photography approaching a turning point. Core practices such as photojournalism are under siege from changing economic, political, and ideological forces. The dominance of social media has driven sweeping changes in the nature of the photographic subject, pushing formerly trivial subjects such as the self, the mundane, and daily meals to centre stage.

Major technologies are now fully mature, so the computer errors, crashes, and corrupted files that made digital photography such a time-consuming process are no longer daily occurrences. The power of the internet and the ability to send a still image to a million places around the planet in seconds are now taken for granted. In short, the camera in your hand is the most elaborate and potent visual tool ever invented. You can enjoy enormous fun with it. You can have your life hugely enriched by its creative returns, and you can make a difference to the world. That is photography's strength – that is its gift to you. And it is yours to give back through your own humanity, artistry, and creativity.

May the light be with you!

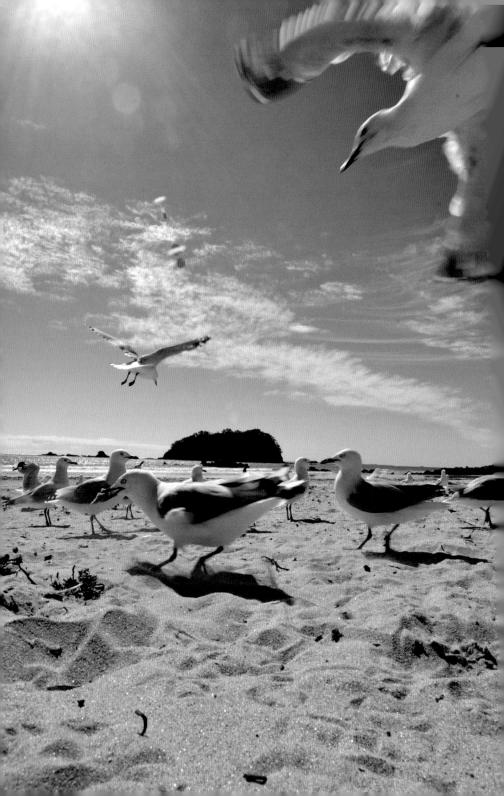

YOUR FIRST PICTURES

Photography first became truly popular when photographers no longer had to be personally responsible for processing their pictures. In the digital era, you can simply press the button and your camera or computer does all the rest. Indeed, with many cameras you can start snapping away the moment you take it out of the box. There is no need to hold back, and certainly no immediate call for the instruction book.

First date

After the initial fun, however, it is worth making a few conscious decisions. It is a good idea to set at least the date and time before you begin any serious photography. If you are going abroad on holiday, remember to change to local time – and if you are travelling with friends or family it helps if you synchronize your cameras' clocks, as this makes it easier to sort and sequence images later.

Quality or ease

The default, or "out-of-the-box", settings will be designed to help you use the camera easily and also to give a good impression of its abilities. You may find that, for this early stage of experimentation,

the image files are unnecessarily large. Change the image size to the smallest while you are learning to use the camera.

You can, and should, shoot freely with the camera. Try out all the different modes and scene settings, different sensitivities, and colour settings to see what results they produce. Try the camera indoors, on friends and family, take it out-of-doors, use it in bright light, and in darkened places. While at this stage of learning, it is OK to make a quick review of the images you capture. However, the best way to assess images properly is by using a computer monitor (see pp. 214–5).

Regaining control

You can leave all settings on automatic, thereby putting the camera in control. You may be able to teach yourself the basics of composition with this set up, but the finer points of exposure and colour control will be in the camera's hands, not yours. In short, you will not be making the most of your camera.

When you have an idea what each mode and setting does to your images, adopt a group of settings – for example aperture priority, high ISO, no flash, black-and-white, high sharpening – and

▶ Unlikely beauty

Photography has a unique talent for turning the unattractive into an intriguing image. The unlikeliest subjects, such as rusting doors, peeling paint and, as here in New Zealand, the worn bottom of a boat, can yield patterns of colours and textures that entertain the eye.

use it to make a whole series of images. This is a good way to learn all about your camera.

Chimping is for chumps

Chimping is short for "checking image preview" and seems very appropriate for photographers who exclaim "Oo! Oo! Ah! Aah!" while reviewing their images on the camera's LCD screen. If you allow yourself to be distracted by the preview image, you will miss many shots. It also breaks the rhythm of shooting, and interrupts the concentration you should be applying to the subject.

Try to reserve your reviewing to rest breaks and moments when you are sure nothing is going on. You do not have to go as far as some photographers, who tape up their camera screens to wean themselves off the habit, but turn off the preview and you will find you photograph more, and become more attuned to your subject.

▶ Out of the window

If you have a window, you have a source for images: there will be changes in the light, and there may be ever-changing activity in the street. Keep watch and pictures will present themselves.

▲ Even the kitchen sink

With its usual jumble of bright metallic pots and pans, colourful food, and areas of plain surface, a kitchen is a surprisingly rich source of images. Contrast colourful crockery with steel utensils, and place natural forms against machined surfaces. Take time to explore details with the camera set to close-up mode, with the flash turned off. Wait for sunny days to obtain the most light indoors.

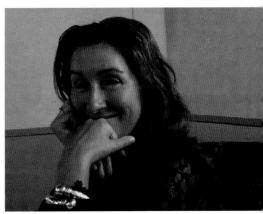

▲ Family snaps

Do not hold back from pointing the camera at members of the family. Catch them at relaxed times with any camera – here with a cameraphone at a restaurant – for portraits that capture their character.

PICTURE COMPOSITION

Photographers have the good fortune to be able to build on the experience of centuries of painting and graphic art with the unique visual tools of photography. Photographic composition arises through the joining of elements such as angle of view, perspective, depth of field, colour, and tone with the visual structures that generations of artists have found effective in their work.

Any photographic composition can be said to work if the arrangement of the subject elements communicates effectively to the image's intended viewers. Often, the best way to ensure a striking composition is to look for the key ingredients of a scene and then organize your camera position and exposure controls to draw those elements out from the clutter of visual information that, if left competing with each other, would weaken the photograph's impact. Composition is not only about how you frame the picture; it is also how you use aperture to control depth of field, focus to lead the viewer's attention, and expose to use light and shade to shape the image.

If you are new to photography, it may help to concentrate your attention on the scene's overall

structure rather than thinking too hard about very specific details; these are often of only superficial importance to the overall composition. Look for the lines that lead through the image. Are there any repeated elements, any arrangements that make a pattern? Try squinting or half-closing your eyes when evaluating a scene; this helps reduce the details and reveal the scene's core structure.

Explore each situation or opportunity by moving around the subject as much as possible, trying out different angles from as high and low as you can. When you feel the image looks right, make the exposure without further thought. If you are slave to the same rules as everyone else, your pictures will look like all the others. The fastest way to learn is to experiment freely.

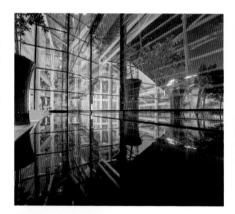

▶ Symmetry

Symmetrical compositions are effective for images that contain elaborate detail, such as this resort interior in Singapore. As a composition strategy, symmetry also works very well for subjects of the utmost simplicity, such as portraits against a plain background.

■ Radial

Radial compositions are those in which key elements spread out from the centre. This imparts a lively feeling, even if the subject is static. In this portrait, made in New Zealand, actual and implied lines radiate away from the central subject, pointing to the portrait sitter at the same time as leading away to all the other elements.

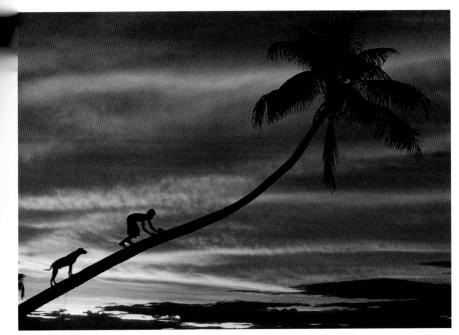

▲ Diagonal

Diagonal lines that lead the eye from one part of an image to another will impart more energy than horizontal lines. In this example, made in Taveuni, Fiji, it is not only the curve of the palm's trunk, but also the movement of the boy and

his dog along it that encourage the viewer to scan the entire picture, sweeping naturally from the strongly backlit bottom left-hand corner to the top, thus engaging with the textures of the sky.

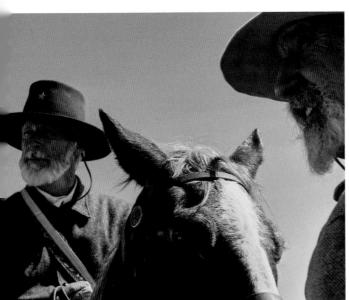

Overlapping

Subject elements that overlap indicate increasing depth, as do the relative sizes of objects of known dimensions. We can tell that the man on the right is closer, because he is larger than the horse, while the man on the left must be farther away; not only is he smaller than the other man, but he is also behind the horse. These elements work together to articulate the three dimensions in this photograph, taken during an American Civil War reenactment in the United States.

▶ The golden spiral and golden section

This image has been overlaid with a golden spiral based on the golden section, as well as with a grid dividing the picture area into phi ratios. This demonstrates that, even with a fleeting shot, photographers compose instinctively, to fit elements to harmonious proportions.

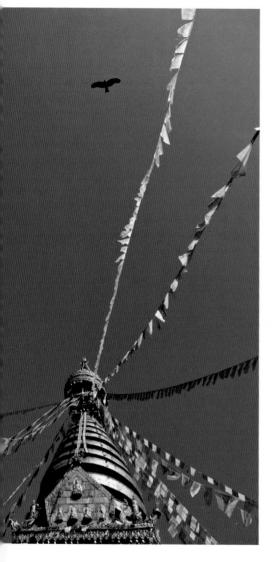

◀ Tall crop

The opposite of a letter-box composition (right) is a tall and narrow crop, which emphasizes an upward sweeping panorama – a view that can be taken in only by lifting the head and looking up. As with all crops based on a high aspect ratio, it usefully removes a lot of unwanted detail around the edges.

► Letter-box composition

A wide and narrow letter-box framing suits some subjects, such as these prayer flags in Bhutan, perfectly. Such a crop concentrates the attention on the sweep of colours and detail, cutting out unwanted – and visually irrelevant – material at the top and bottom of the image.

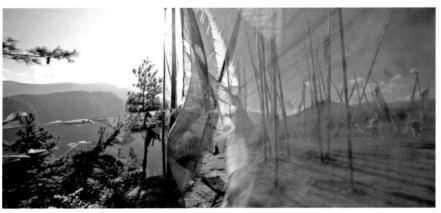

PICTURE COMPOSITION CONTINUED

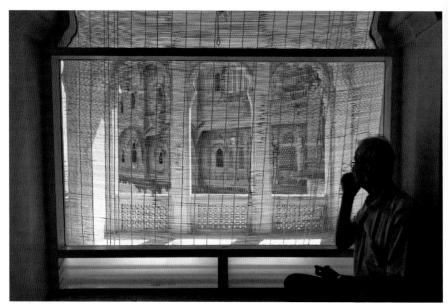

▲ Framing

The frame within a frame is a painterly device often exploited in photography. Not only does it concentrate the viewer's attention on the subject, it also often hints at the wider context of the subject's setting. Through overlap, the frame also describes the space receding into the distance as here, in Jodhpur, India.

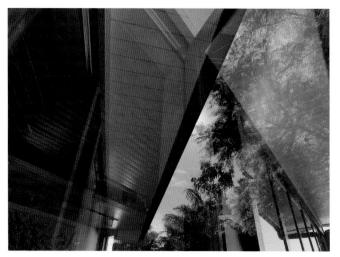

◆ Geometric patterns

Geometrical shapes, such as triangles and rectangles, lend themselves to photographic composition because of the way they interact with the rectangle of the picture frame. Here, in a 19th-century villa in Auckland, New Zealand, shapes from narrow strips to sharply acute triangles are all at work to make this an eye-catching composition. Colour contrasts between the warm reds of the wood and blue sky also contribute.

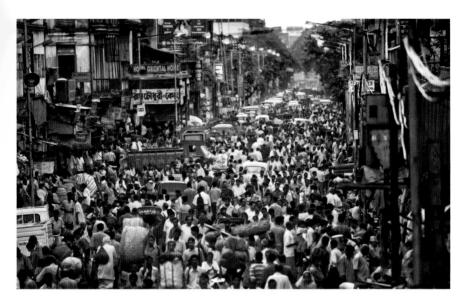

▲ Massed pattern

Even the massive crowds in this street in Kolkata, India, are organized. The receding parallel of the road, the glint in power lines, and the differences in scale of people can all be used to make sense of what initially appears to be chaos.

▼ Rhythmic elements

The ghostly silhouettes of trees in Palaia, near Pisa in Italy, organize the space into an irregular but discernible rhythm of lights and darks, with the more or less regular negative spaces between the trunks. Seen together, they create an ambivalent mood – mysterious, yet calm.

TRY THIS

Look out for patterns whenever you have a camera to hand. When you find an interesting example, take several shots, shifting your position slightly for each. Examine the pictures carefully and you may find that the shot you thought most promising does not give the best result. Often, this is because our response to a scene is an entire experience, while photographs have to work within the proportions of the format.

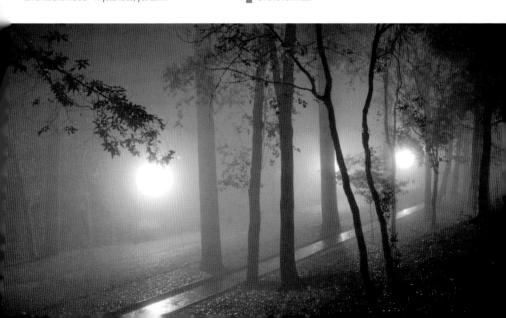

FOCUSING AND DEPTH OF FIELD

Depth of field is the space in front of and behind the plane of best focus, within which objects appear acceptably sharp (see opposite). Though accurate, this definition tells you nothing about the power that depth of field has in helping you communicate your visual ideas. You can, for example, vary depth of field to imply space, to suggest being inside the action, or to emphasize the separation between elements within the picture area.

Varying depth of field

Your chief control over depth of field is the lens aperture: as you set smaller apertures (using f/11 instead of f/4, for example), depth of field increases. This increase is greater the shorter the lens's focal length, so that the depth of field at f/11 on a 28 mm lens is greater than it would be at f/11 on a 300 mm lens at the same working distance. Depth of field also increases as the subject being focused on moves further away from the camera. Meanwhile, at close focusing distances, depth of field is very limited.

Using depth of field

An extensive depth of field (resulting from using a small lens aperture, a wide-angle lens, distant focusing, or a combination of these factors) is often used for the following types of subject:

- Landscapes, such as wide-angle, general views.
- Architecture, in which the foregrounds to buildings are important features.
- Interiors, including nearby furniture or other objects, and far windows and similar features.

As a by-product, smaller apertures tend to reduce lens flare and improve lens performance.

A shallow depth of field (resulting from a wide lens aperture, a long focal length lens, focusing close-up, or a combination of these) renders only a small portion of the image sharp, and is often used for:

- Portraiture, to help concentrate viewer attention.
- Reducing the distraction from elements that cannot be removed from the lens's field of view.
- Isolating a subject from the distracting visual clutter of its surroundings.

LENS FOCUSING

Spreading light reflected from or emitted by every point of a subject radiates outwards, and those rays captured by the camera lens are projected onto the focal plane to produce an upside-down image. The subject only appears sharp, however, if these rays of light intersect precisely on the sensor plane (achieved by adjusting the lens's focus control). If not, the rays are recorded not as points, but rather as blurred dots. If the image is reproduced at a small enough size, then even dots may appear as points, but as a subject's image diverges further from the sensor plane, so the dots recorded by the camera become larger and larger, until, at a certain point, the image appears out of focus - the points have become large enough to be seen as blurred dots.

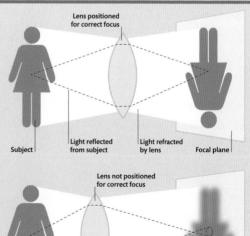

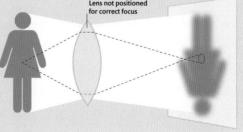

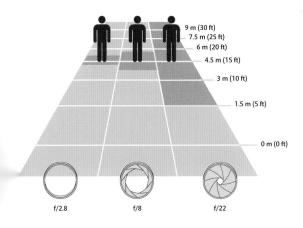

9 m (30 ft) 7.5 m (25 ft) 6 m (20 ft) 4.5 m (15 ft) 1.5 m (5 ft) 0 m (0 ft)

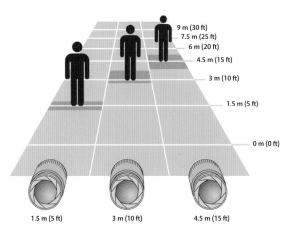

■ Effects of lens aperture

The main reason for changing lens aperture is to adjust camera exposure: a smaller aperture restricts the beam of light passing through the lens. However, the aperture also alters depth of field. As you set smaller apertures, the cone of light passing through the lens becomes slimmer and more needle-like. As a result, even when it is not perfectly focused, light from the subject is not as spread out as it would be if a larger aperture were used. Thus, more of the scene within the field of view appears sharp. In this illustration, lens focal length and focus distance remain the same, and depth of field at f/2.8 covers just the depth of a person, whereas at f/8 it increases to 2 m (6 ft) in extent. At f/22, depth of field extends from 1.5 m (5 ft) to infinity.

■ Effects of lens focal length

Variations in depth of field resulting from focal length alone are due to image magnification. With our figure at a constant distance from the camera, a long focal length (135 mm) will record him at a larger size than does a standard lens (50 mm), which, in turn, creates a larger image than the wide-angle (28 mm). To the eye, the figure is the same size, but on the sensor or film, the figure's size varies directly with focal length. Where details are rendered smaller in the image, it is more difficult to make out what is sharp and what is not. As a result, depth of field appears to increase. Conversely, longer focal length lenses magnify the image, so magnifying differences in focus. Thus, depth of field appears to be greatly reduced.

■ Effects of focus distance

Two effects contribute to the great reduction in depth of field as you focus more and more closely to the camera, even when there is no change in lens focal length or aperture. The main effect is due to the increased magnification of the image: as it looms larger in the viewfinder, so small differences in the depth of the subject call for the lens to be focused at varying distances from the sensor or film. Notice that you must turn a lens more when it is focused on close-up subjects than when it is focused on distant ones. Another slight but important reason for the change in depth of field is that effective focal length increases slightly when the lens is set further from the focal plane - in other words, when it is focused on subjects close-up.

FOCUSING AND DEPTH OF FIELD CONTINUED

Autofocusing (AF)

Cameras are able to focus automatically on your photographic subject by using one of two systems. The active system, which uses a beam of infrared (IR), is now largely obsolete but was formerly much used in compact AF cameras. In the passive system, however, sensors analyze the image to determine whether it is in focus and, if not, how best to bring it into focus.

One passive method detects the contrast of fine detail in the image: unfocused images present as low-contrast, because they lack detail. The lens is

then made to change focus so that contrast is at a peak, corresponding with a sharp image. This method requires good light levels to work well.

Another passive method samples a part of the image, then splits it into two beams. When these beams fall on certain reference points in the sensor (the beams are "in phase"), the lens is considered to be in focus. The crucial property of this method is that the phase differences vary, depending on whether the lens is focused in front of or behind the plane of best focus. This information enables the system to work very rapidly, even continuously.

For best results, note the following:

- For off-centre subjects, aim the focusing area at your subject, "hold" the focus with light pressure on the shutter or focus-lock button, then reframe.
- Extremely bright objects in the focusing region sparkling reflections on polished metal, say could confuse the sensor and reduce accuracy.
- Photographing beyond objects that are close to the lens – say, through a bush or between the gaps in a fence – can confuse the autofocus system.
- Restless subjects, such as children or flowers in a light breeze, may be best kept in focus by setting a distance manually and then adjusting your position backwards and forwards to maintain focus.

■ Mimicking depth

While a narrow field of view usually yields a shallow depth of field, you can simulate a more generous zone of sharp focus linked with a narrow field of view by cropping a wide-angle image. Here, a 28 mm view has been cropped to that of a 200 mm lens, and the scene appears sharp from foreground to background.

Selective focus

A telephoto shot (135 mm) taken with the lens aperture wide open (f/1.8) throws the model in the background well out of focus while the porcupine spines of her necklace are rendered pin-sharp. Although almost nothing is sharp in this image, its power comes from the suggestiveness of the blurred image: it is perfectly clear what the subject is about.

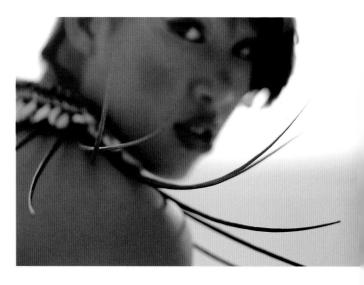

• With very rapidly moving subjects, it may be better to focus on a set distance and then wait for the subject to reach that point before shooting.

Hyperfocal distance

The hyperfocal distance is the focus setting that provides maximum depth of field for any given aperture. It is the distance to the nearest point that appears sharp when the lens is set at infinity, and it is the nearest distance at which an object can be focused on while infinity appears sharp. The larger the aperture, the further this point is away from you.

This is useful when the scene is changing so rapidly that you cannot keep focus on your subjects. With very rapid autofocus cameras, its utility is limited. It is better to focus on a subject than to hope depth of field will render it sharp enough.

▶ Off-centre subjects

With off-centre subjects, as here, you may need to ensure your camera does not focus on the middle of the frame. Modern systems may recognize the main subject and focus accordingly. For this image, I focused on the boys, locked the setting, and recomposed the shot. Even in bright conditions and focusing at a distance, depth of field is limited because of the very long (400 mm) focal length.

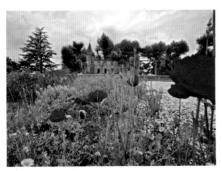

▲ Right aperture

Even an ultra wide-angle lens will offer insufficient depth of field when objects are close to the lens and very distant unless a small aperture is used. In this shot, the charm of the scene would have been lost had either the château or foreground flowers been unsharp. The smallest aperture on this lens was set to give maximum sharpness, but the long shutter time needed meant that a tripod was necessary.

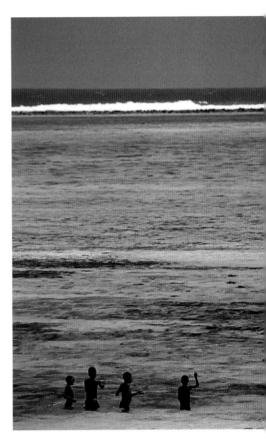

PERCEIVED DEPTH OF FIELD

Acceptable sharpness varies according to how much blur a viewer is prepared accept. This, in turn, depends on how much detail a viewer can discern in the image, which, in turn, depends on the final size of the image (as seen on a screen or as a paper print). As a small print, an image may display great depth of field; however, as the image is progressively enlarged, it then becomes more and more obvious where the unsharpness begins, thereby making the depth of field appear increasingly more limited.

MOVEMENT BLUR

The generally accepted advice is that you should hold the camera steady when capturing pictures. Any movement during exposure causes the image to move across the sensor. If that movement is visible, it is seen as a blur, which causes the image to look unsharp at best and, at worst, quite unrecognizable. Nonetheless, there is certainly a place for pictures that display a thoughtful or expressive use of subject blur.

Try it and see

The effects are of exposure during movement are unique, and no other recording medium represents the blur of movement in quite the same way as a

▼ Moving camera

The blur produced by taking a photograph from a speeding car streaks and blends the rich evening light in a very evocative and painterly fashion in this example. To the eye at the time of taking, the scene was much darker and less colourful than you can see here. It is always worth taking a chance in photography, as you never know what might come of it.

camera. However, since what you capture in the image will vary with the level of movement of the subject and with distance, its effects are hard to predict. Experiment freely with different settings and evaluate results on a computer monitor, rather than the camera's review panel.

With experimentation and experience, you will find that brighter areas quickly become too bright when overlapped. At the same time, dark areas tend to be reduced by overlapping with lighter areas. The net result is a tendency to overexpose. You can exploit this to create high-key images or set exposure overrides to force tones to be darker, which helps to maintain intense colours (see pp. 38–9). The tendency to overexpose also means that results are best in dull light with a limited number of light-sources.

Contrasting blur

The appearance of blur is usually enhanced when it is seen in contrast against sharply defined forms or shapes. By the same token, sharpness appears

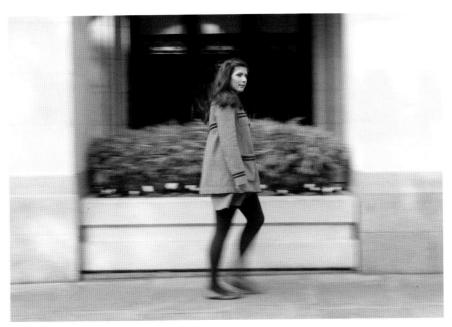

▲ Pan handling

Following the movement of a subject during exposure – panning – exploits the fact that different speeds of movement produce different levels of blur. Parts of the

greater where it contrasts with blur, so it is worth arranging for some part of the scene to remain sharp. This may call for the use of a tripod. Start with exposure times not longer than 1/8 sec with a normal lens. Very long exposures cause so much blur that it becomes difficult to identify the subject. They are also a lot more difficult to control.

Quality blur

It may seem unnecessary to bother with focus since you are working with blur, but you will find that it is worth focusing as carefully you would if you were aiming for a sharp image. By doing this you produce a solid "core" to the image, against which the viewer can more readily appreciate the blur.

For similar reasons, it is just as important to maintain image quality as ever. Movement blur produces smooth or milky tones, so any break-up of the image either from resolution that is too low for the output size (see pp. 112–3), or noise caused by high sensitivity (high ISO) settings can detract from the overall effect.

image that are relatively stationary in the image – such as the girl's face – appear sharper than elements that move more rapidly, such as her legs.

▲ Tossing the camera

This is a technique that can be huge fun and totally unpredictable: set shutter priority with an exposure time of 1 or more seconds. Hold on to the camera strap, press the shutter button, then toss the camera into the air with a spinning action (ensuring that the camera does not hit the ground). For the best results, try this at night with street lights or neon signs.

INFLUENCING PERSPECTIVE

You can exercise control over the perspective of a photograph by changing your camera position. This is because perspective is the view that you have of the subject from wherever it is you decide to shoot. Perspective, however, is not affected by any changes in lens focal length – it may appear to be so but, in fact, all focal length does is determine how much of the view you record.

Professional photographers know perspective has a powerful effect on an image, yet it is one of the easiest things to control. This is why when you watch professionals at work, you often see them constantly moving around the subject – sometimes bending down to the ground or climbing onto the nearest perch; approaching very close and moving further away again. Taking a lead from this, your work could be transformed if you simply become

more mobile, observing the world through the camera from a series of changing positions rather than a single, static viewpoint.

Bear in mind that with some subjects – still-lifes, for example, and interiors or portraits – the tiny change in perspective between observing the subject with your own eyes and seeing it through the camera lens, which is just a little lower than your eyes, can make a difference to the composition. This difference in perspective is far more pronounced if you are using a studio camera or waist-level finder on a medium-format camera.

Using zooms effectively

One way to approach changes in perspective is to appreciate the effect that lens focal length has on your photography. A short focal length gives a

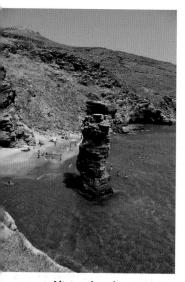

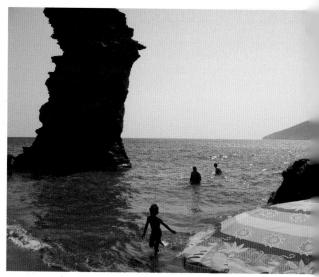

▲ Alternative views

This wide-angle view (*above left*), shows an unremarkable snapshot of a holiday beach, in Andros, Greece. It is a simple image of the place, but it lacks an engaging interpretation or inventive viewpoint of the scene. Once on the beach, the temptation is to take in a wide shot that summarizes the whole scene. Instead, a low viewpoint that

takes in the corner of a parasol gives a more intimate and involving feel: by using the parasol to balance the large rock, the picture is almost complete. Waiting for the right moment – a child running into the foreground – brings the whole perspective to life.

perspective that allows you to approach a subject closely yet record much of the background. If you step back a little, you can take in much more of the scene, but then the generous depth of field of a wide-angle tends to make links between separate subject elements, as there is little, if any, difference in sharpness between them.

A long lens allows a more distant perspective. You can look closely at a face without being nearby. Long lenses tend to pull together disparate objects – in an urban scene viewed from a distance, buildings that are several blocks apart might appear to crowd in on top of each other. However, the shallow depth of field of a long lens used at close subject distances tends to separate out objects that may actually be close together by showing some sharp and others blurred.

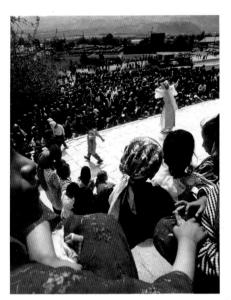

▲ Distant perspectives

Overlooking the action there is a sense of the crush of people at this festival in mountainous Tajikistan (above). Two children holding hands complete the scene. The long focal length version (above right) focuses attention on the dancer, but excludes all sense of setting beyond the crowd watching the traditional performance.

PERSPECTIVE FEFECTS

Wide-angle lenses

- Take in more background or foreground.
- Exaggerate the size of near subjects when used in close-up photography.
- Exaggerate any differences in distance or position between subjects.
- Give greater apparent depth of field and link the subject to its background.

Telephoto lenses

- Compress spatial separation.
- Magnify the main subject.
- Reduce depth of field to separate the subject from its background.

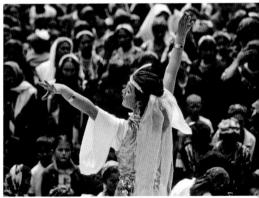

TRY THIS

For this exercise, leave your zoom lens at its shortest focal length setting. Look for pictures that work best with this focal length – ignore any others and don't be tempted to change the lens setting. This will help to sharpen your sense of what a wide-angle lens does. You may find yourself approaching subjects – including people – more closely than you would normally dare. The lens is making you get closer because you cannot use the zoom to make the move for you. Next, repeat the exercise with the lens at its longest focal length setting.

CHANGING VIEWPOINTS

Always be on the look-out for viewpoints that give a new slant to your work. Don't ignore the simple devices, such as shooting down at a building instead of up at it, or trying to see a street scene from a child's viewpoint rather than an adult's.

Your choice of viewpoint communicates subtle messages that say as much about you as they do your subject. Take a picture of someone from a distance, for example, and the image carries a sense that you, too, were distant from that person. If you photograph a scene of poverty from the viewpoint of a bystander, the picture will again have that distant look of having been taken by an aloof observer. Lively markets are popular photographic subjects, but what do they look like from a stallholder's position? If you enjoy sports, shoot from within the action, not from the sidelines

Practical points

Higher viewpoints enable you to reduce the amount of foreground and increase the area of background recorded by a lens. From a high vantage point, a street or river scene lies at a less acute angle than when seen from street or water level. This reduces the amount of depth of field required to show the scene in sharp focus.

However, from a low camera position subjects may be glimpsed through a sea of grass or legs. And if you look upward from a low position, you see less background and more sky, making it easier to separate your subject from its surroundings.

Less can say more

At markets and similar types of location, all the activity can be overwhelming - and the temptation is often to try to record the entire busy, colourful scene. However, if you look around you, there could be images at your feet showing much less but saying so much more. In Uzbekistan I noticed next to a fruit stall a lady who had nothing to sell but these few sad tulips.

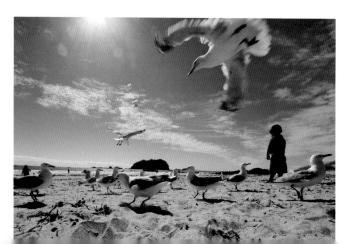

◆ Child's eye view

From almost ground level, the swooping gulls feel quite threatening and pull the viewer into the action. At the same time, looking upwards gives the viewer a sense of open skies - this would be lost with the gaze directed downwards.

HINTS AND TIPS

- In some parts of the world, it is a good idea to avoid drawing attention to your presence. Your search for an unusual camera viewpoint could attract the unwanted interest of officialdom. Even climbing onto a wall could land you in trouble in places where strangers are not a common sight or photographers are regarded with suspicion.
- As well as being discourteous, it might also be illegal to enter a private building without permission in order to take photographs. You may be surprised at how cooperative people generally are if you explain what you are doing and why, and then ask for their assistance.
- Try to be open and friendly with people you encounter – a pleasant smile or an acknowledging wave is often the easiest, and cheapest, way to elicit a helpful response from strangers.
- Prepare your equipment before making your move. Balancing on the top of a wall is not the best place to change lenses. With manual cameras, preset the approximately correct aperture and shutter time so that if you snatch a shot, exposure will be about right.

▲ Changing viewpoint

This conventional view of the Mesquita of Cordoba, Spain (above), works well as a record shot, but it is not the product of careful observation. Looking down from the same shooting position, I noticed the tower of the building reflected in a puddle of water. Placing the camera nearly in the water, a wholly more intriguing viewpoint was revealed (right). An advantage of using a digital camera with an LCD screen is that awkward shooting positions are not the impossibility they would be with a film-based camera.

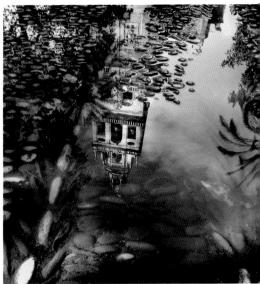

QUICK FIX LEANING BUILDINGS

Buildings and architectural features are always popular photographic subjects, but they can cause problems of distortion that are tricky to rectify.

Problem: Tall subjects – such as buildings, lamp-posts, trees, or even people standing close by and above you – appear to lean backwards or as if they are about to topple over. Extreme wide-angle views are particularly prone to this effect.

Analysis: This distortion occurs if you tilt the camera upwards to take the picture because you are trying to avoid taking in too much of the foreground and not enough of the height of the building. The top of the building is further away, so it appears smaller, causing the whole image to lean backwards.

Solution: Stand further back, and keep the camera level. You will still take in too much of the foreground, but you can crop the image later.

- Use a wider-angle lens or zoom setting, hold the camera precisely level, then crop off the foreground in image-manipulation software.
- Take the picture anyway and try to correct some or all of the distortion by manipulating the image later.
- Use a shift lens. Such equipment is expensive, but it provides the technically best solution.

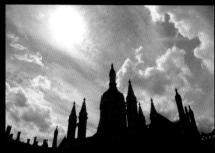

▲ Tilting the camera

An-looking view of the spires of Cambridge, England, makes the buildings lean backwards. The visual effect can be exploited for drama.

▲ Using the foreground

By choosing the right camera position, you can keep the camera level and include foreground elements that add to the shot.

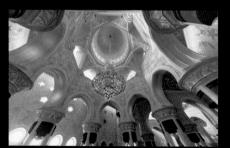

▲ Looking up

The awe-inspiring Grand Mosque in Abu Dhabi, United Arab Emirates, invites ultra-wide-angle views of the columns and ceilings. But in a small image, the strong convergences appear too exaggerated and extreme.

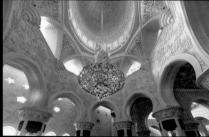

▲ Partial correction

By using the viewpoint or perspective features in imagemanipulation software, it is possible to reduce the converging lines and give a more natural look. Such a result is not possible using only a lens.

QUICK FIX FACIAL DISTORTION

Distorted facial features, such as an overly large nose, are often the reason that a portrait is unattractive. It is the consequence of moving in close to make the subject's face as large as possible within the frame.

Problem: Portraits of people taken close-up with normal lenses will exaggerate certain facial features, such as noses, cheeks, or foreheads.

Analysis: The cause is a perspective distortion. When an image is viewed from too far away for its magnification, the impression of perspective is not correctly formed. This is why at the time you took the photograph, your subject's nose appeared fine, but in the print or on screen it looks disproportionately large.

▲ Face-on

To emphasize the friendly character of this man, several "rules" were broken: a wide-angle lens was used close-up; the shot was taken looking upwards; and the face was placed off in one corner, thus exaggerating the distortion already present. **Solution:** Use a lens setting longer than a 35 mm equivalent of 50 mm - that is, about 70 mm or more. This helps ensure that for an average-sized screen from a normal viewing distance the perspective looks correct.

- Work at the longer end of your zoom lens.
- If you have to work close-up, try taking a profile instead of a full face (see below).
- Avoid using wide-angle lenses close to a face, unless you want a distorted view.
- Don't fill the frame with a face at the time of shooting. Instead, rely on cropping at a later stage if you need the frame filled.
- Don't assume you will be able to correct facial distortions later on with image-manipulation software. It is hard to produce convincing results.
- Don't worry too much about distortions: the expression and lighting give a greater visual impact.

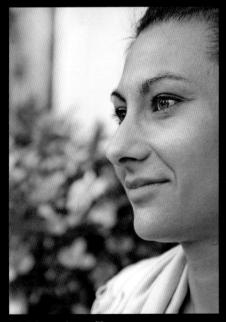

▲ Wide-angle profile

If forced to take a portrait close-up with a wide-angle lens – 35 mm in this instance – it is best to look for a profile, since this avoids many of the problems associated with distortion in face-on shots. Make sure you focus carefully on the eye.

COLOUR COMPOSITION

Colour can be used to express emotion in an image. Pale, soft colours are restful and tranquil, while rich, vibrant colours burst with energy and demand attention. Colour is integral to visual experience, but in photography it is almost a separate subject in itself. The basis of successful colour photography is to use colour in its own right, instead of merely capturing the many hues of a scene.

Colour as subject

One approach is to photograph colours themselves rather than the objects they imbue – that is, to try to treat the subject as if it were the incidental feature in the scene. You do not need to learn to see in colour, but you do need to learn to see colours for themselves – entirely separate from the thing that displays the colour.

This change of mental focus could radically transform the entire way you photograph. You evaluate a scene not in terms of whether it is a marvellous vista but in colour analytic terms. You will observe that colours vary not only with hue – the name given to a colour – but also with intensity, or saturation. Soon, you will appreciate another quality: the value, or brightness, of a colour. With more experience, you will appreciate that certain colours can be captured in their full richness, whereas others will appear weaker. Understanding each dimension adds to your ability to compose with colour.

Colour wheel

The colours of the rainbow can be arranged in a circle (the "colour wheel"): the basic primary colours are red, blue, and yellow. In between these are placed violet, green, and orange, and between these are all the intermediate colours. A hue that is directly to the left or right of a colour on the wheel is said to be an analogous, or adjacent, colour – such as light and dark green with yellow, or blue, purple, and cyan. A combination of these colours in your images will appear harmonious and will therefore be correspondingly easy to compose, as the colours work together and can help bind together disparate elements within the scene. Broadly speaking, landscape photographers tend

Fashion parade

The saturated colours of the different T-shirts could lead to a chaotic composition. However, several other elements help to organize the image: the regular lines of the windows, chairs, and railing all cut the image into neat frames around the blocks of colour. At the same time the blue of the sky and water form an even background against which the T-shirt colours can glow.

Colours do not have to be highly saturated or intense to be effective. In many cases subtle contrast works best, such as the tiny area of red petal against the overall green balance of this image. The sharpness of the flower against the vague shadows also helps define the colour regions.

▲ Betting on white

Any colour seen against white appears to be relatively stronger. The pale blue reflection of sky would be swamped by any other colours in the image, but with the large areas of neutral shades, even the very soft blues in the shadows become more apparent.

PERCEPTION OF COLOUR

If a pale subject is seen against a background of a complementary colour, its saturation seems to increase. Similarly, a neutral grey changes its appearance according to its background colour, appearing slightly bluish green against red, and magenta against green. If you compare the grey patches in the two-coloured panels below you can see this at work. If you were to cut small holes in a piece of white card, so that only the four patches are visible, you would see that the circles are, in fact, an identical shade of grey.

COLOUR COMPOSITION CONTINUED

to prefer working with analogous colours, so the viewer concentrates on forms and texture, whereas garden photographers tend to seek out contrasting colours, for livelier results.

A version of the analogous scheme is the monochromatic, in which all colours are variants of the same hue. Such images – think of seascapes with their infinite varieties of blue – offer tonal subtlety instead of colour contrasts. Close-ups of flowers are often rewarding because they offer narrow, subtle colour shifts.

Colours are said to clash where they lie opposite or far from each other on the colour wheel. While compositions with strong contrasts are appealing when initially experienced, they are more tricky to organize into a successful image. Look for simplicity in structure and a clear arrangement of subject matter – too many elements jostling for attention can lead to a disjointed, chaotic image.

Pastel colours

Referring to pastel colours as the weak versions of a hue is accurate, but also does them a disservice: it suggests that they are of limited use. Pastels are certainly more pale and less saturated or vibrant than full-on colours. They are nonetheless vital tools for the photographer.

Pale colours suggest tranquillity and calm, and are gentle where strong colours are more vigorous. They evoke responses of peace and wellbeing – which is why they are so popular for home interiors – and, for a photographer, they are also important as counter-balances to strong colours. You can achieve striking results by simply concentrating on pastel colours in their own right. You will find them where there is a good deal of light – which tends to dilute colours – and where pastel shades have been used decoratively in architecture, interior design, or garden planting schemes.

The easiest way to create pastel-dominated images is simply to over-expose them: this can be very effective for creating unusual effects in nature and landscape photography. Images such as these are often associated with high-key lighting, since the presence of dark shadows tends to make even the palest of colours look richer. Alternatively, many digital cameras can be set to record all the colours in a scene as pastels.

▶ Strong structure

The watered-down colours in this cityscape provide a canvas for the morass of steel structures that crawl up the buildings. It may be tempting to increase contrast and saturation, but that would over-dramatize the true nature of the view. In flat lighting, expose with care, as poor accuracy impacts on every tone in the image, and use the lens at its best aperture to ensure sharply defined details.

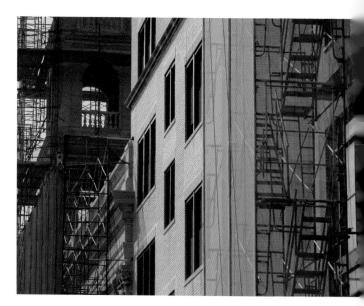

◆ Grounded colour

The neutral block of grey in the centre of the image provides a grounding for the opposing visual lures of the patches of deep blue and red. In addition, the structure imposed by strong lines and curves ensures this image, made in the Atomium in Brussels, presents a rich articulation of space and form.

▲ Soft but strong

Flowers of a Scottish Highland spring make a striking image despite being made up of largely pastel colours, all seen under a dull light. Compose to overlap contrasting colours and try zooming to a long focal length setting to compress space and juxtapose different patches of colour.

TRY THIS

One effective way to work with colours is to ensure the main colours in your pictures are complementary pairs – such as red–green, yellow-violet, orange-blue. Try to capture subject matter with complementary colours; it is not easy as you might expect. But you will find that, with practice, complementary colour pairs will catch your eye even if you are not consciously looking for them. As you refine your technique, see if you can use colour complementaries to separate out elements in your image – use the language of colour to express and communicate your response to a scene.

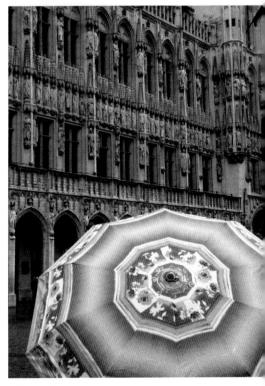

▲ Saturation contrast

The attention-grabbing colours of an umbrella appear to be even stronger than they are because of contrast with the grey tones of the buildings. This, together with the radial structure of the umbrella straining against the linear form of the building, creates a contrast that is almost too vigorous.

QUICK FIX WHITE BALANCE

White balance ensures the colour of illuminating light is as close as possible to that of normal daylight. This is the foundation for accurate colour reproduction. If there is no adjustment for a tint. such as red, in the illumination, all colours in the scene will carry a reddish tint.

Problem: Images made indoors tend to appear unnaturally warm-toned. In other situations, pictures taken under fluorescent lamps appear greenish overall. A related problem occurs in outdoor shots: you see a blue cast in the shadows on a sunny day, or images appear unnaturally cold on cloudy days. Problems are compounded if you work in mixed lighting, such as daylight from a window and light from a table lamp. If you correct for the orange cast of the lamp, the window light looks too blue; if you correct for the window light, the lamp light looks too orange.

Analysis: All imaging systems assume that the light falling on a scene contains the full spectrum of colours. This produces the "white" light of daylight. If, however, the light is deficient in a specific band of colours or is dominated by certain colours, then everything illuminated by it will tend to take on the strongest colour component. Our eyes and brain make automatic adjustments by balancing various colour signals to reduce dominant colours. As a result, for example, we do not experience indoor light as being unduly orange. Likewise, we seldom notice the blue colour cast that is often present in the shadows on sunny days.

Digital camera manufacturers have achieved a similar effect in their products' automatic white balance: the red, green, and blue signals are monitored, and the camera compensates for any dominant levels of a particular hue. But there are limits to the adjustment, and when these are exceeded, we see more or less strong tints in our images. The resulting "inaccurate" colour reproduction may be important for establishing the mood of a scene; the red tones of a sunset or the cool tones of a snowfield, for example, are appropriate and integral to each cituation

Orange street lamps The lighting in this square in Malacca. Malaysia, was recorded as a lurid red in the image. Even the white windows look too red.

White balanced A firm correction turns the white windows to a nearly neutral grey but at the cost of losing the atmosphere and mood of the scene. The tree now looks too blue.

Half-correction An incomplete correction gives an effective balance of realistic rendering with a retention of the **Solution:** Image-manipulation software can make extensive corrections to white balance – use the White Balance tool, the dropper tools in Levels, or Curves controls. The dropper tool samples or measures a small area of the image to calculate the change. Choose carefully. If different parts of the image show different white balances, you may need to mask one area to limit corrections to that area (*see right*).

When capturing images in JPEG format, you may set Auto White Balance (AWB) for convenience. For better results, set a white balance appropriate to the scene – for example, "cloudy" for overcast days. For maximum flexibility, record in RAW format and decide on the white balance during post-processing.

White balance generally corrects the blue-yellow balance. Some images may need correction of the green-magenta balance, called "tint" control. These may be needed to correct skin tones and are available in some software.

HOW TO AVOID THE PROBLEM

- Avoid photographing in mixed-lighting conditions unless you specifically want the image to display unpredictable colours.
- Avoid making colour-critical shots under fluorescent lamps: the colour cast can prove very difficult to correct.
- For colour-critical work, use a grey card to set custom colour balance following your camera's instructions. Photograph the card or colour chart to provide a standard for calibration.

As captured
With white balance set to "cloudy", this model's skin tones are beautifully warm, but the lamps behind her are too yellow-red.

Global incorrection
A correction aimed at the lamps using the
Highlight dropper - it sampled from the bright lamp
area - leads to too much blue in the model.

3 Masked correction

This result was achieved by selecting the area behind the model before sampling with the Highlight dropper, taking care to leave some yellow in the lamp.

EXPOSURE CONTROL

Exposure control is the process of making sure that you capture your image with the exactly the right amount of light needed to produce the effect you wish to obtain. You measure light levels with an exposure meter – usually one that is built into the camera or a separate hand-held meter – and with the aid of meter readings, you adjust the shutter, aperture, and ISO settings.

It is important to control exposure accurately and carefully, since it not only ensures you obtain the best from whatever system you are using, but it also saves you the time and effort of manipulating the image unnecessarily at a later stage.

Measuring systems

To determine exposure, the camera measures the light entering the camera that is reflected from a scene. The simplest system measures light from the entire field of view, treating all of it equally.

Many cameras use a centre-weighted system, in which light from the entire field of view is registered, but greater account is taken of that coming from the central portion of the image. This can be taken further, so that the light from most of the image is ignored, except that from a central part. This can vary from a central 25 per cent of the whole area to less than 5 per cent. For critical work, this selective area, or spot-metering, system is the most accurate.

A far more elaborate exposure system divides the entire image area into a patchwork of zones, each of which is separately evaluated. This system, commonly referred to as evaluative or matrix metering, is extremely successful at delivering consistently accurate exposures over a wide range of unusual or demanding lighting conditions. This is now widely used in modern cameras – from compacts and SLRs, to mirror-less cameras.

As good as they are, the exposure systems found in modern cameras are not perfect. There will be times when you have to give the automation a helping hand – usually when the lighting is most interesting or challenging. This is why it is so crucially important to understand what exactly constitutes "optimum exposure".

Optimized dynamics

Every photographic medium has a range over which it can make accurate records – beyond that, the representation is less precise. This range, or latitude, is represented by a scale of greys either side of the mid-tone – from dark tones with detail (for example, dark hair with some individual strands distinguishable), to light tones showing texture (for example, paper showing creases and wrinkles). If you locate your exposure so that the most important tone of your image falls in the

▶ What is "correct"?

To the eye, this scene was brighter and less colourful than seen here. A technically correct exposure would have produced a lighter image - thus failing to record the sunset colours. Although it looks like this might challenge a basic exposure-measuring system, by placing the sun centre frame you guarantee underexposure, resulting, as in this example, in a visually better image than a "correct" exposure would produce.

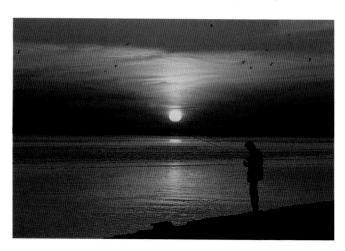

▲ Narrow luminance range

Scenes that contain a narrow range of luminance and large areas of fairly even, regular tone do not represent a great problem for exposure-measuring systems, but you still need to proceed with care for optimum results. The original of this image was correctly exposed yet appeared too light because, pictorially, the scene acquires more impact from being darker, almost low-key. The adjustments that were made to darken the image also had the effect of increasing colour saturation, which is another pictorial improvement.

middle of this range, the recording medium has the best chance of capturing a full range of tones.

In general, the aim of exposure control is to choose camera settings that ensure the middle tone of an image falls within the middle part of the sensor's recording range, to make the most of the available dynamic range while meeting the need to capture movement and adequate depth of field.

▲ Wide luminance range

The range of luminance in this scene is large – from the brilliant glare of the sky to deep foreground shadows. Exposure control must, therefore, be precise to make the most of the sensor's ability to record the scene. In these situations, the best exposure system is a spot meter, with the sensor positioned over a key tone – here, the brightly lit area of grass on the right of the frame. Evaluative metering may also produce the same result, but if you are using a film camera, you will not know until you develop the film.

Spot metering

The most reliable method for achieving precision in exposure control is to use spot metering (see box below). Aim the measuring spot at the key tone to obtain a reading to ensure it is correctly exposed. The key tone could be a person's face or the sunlit portion of a valley wall. From this, the rest of the image's tones will fall into place.

SENSITIVITY PATTERNS

Cameras use a variety of light-measuring systems, and the representations shown here illustrate two of the most common arrangements. With a centre-weighted averaging system, most of the field of view is assessed by the meter, but preference is given to light coming from the middle of the frame. In the majority of situations, this arrangement gives predictable and reliable results. The metering on modern cameras can be arranged so that all of its sensitivity is concentrated in a small spot in the very middle of the field of view. Used in any autoexposure mode with the reading held or memorized once made, this method gives reliable results quickly and easily.

▲ Metering systems

Centre-weighted metering (above left) takes in all of the view but gives more weight, or emphasis, to the light level around the centre of the image, tailing off to little response at the edge. A spot-metering system (above right) reads solely from a clearly defined central area – usually just 2–3 per cent of the total image area. So a bright light at the edge of the image will have no effect on the reading.

LOW-KEY IMAGES

A highly effective yet very simple way to imbue an image with expression is by deliberately giving less exposure than normal, resulting in a darker-thannormal image. This manoeuvre simplifies the content of an image – as there is little room for detailed renditions – and intensifies colours.

Swing low

Technically, dark or "low-key" images are easier to create than those that are full of light: they call for less lighting, less exposure, and less precision. Ideally, you light a subject with a single weak light. For example, with a portrait, a single source such as a window lights the face from an acute or glancing angle so that textures and features cast sharp shadows. Expose for the bright areas: this renders them as mid-tones or lower, which forces all darker tones into deep shadows and blacks.

The best way to determine exposure for low-key pictures is to concentrate your exposure reading on the areas that must retain subject detail; this ensures that texture and form are recorded. If you point your spot or selective-area meter at such a region of your subject, that tone will be rendered as a mid-tone grey. As shadows become featureless black, take care to balance their shape and form carefully against the lighter areas. Also note how light colours become more intense when darker than normal.

Underexposure with digital cameras can introduce noise in the shadows, so it may be best to create a low-key effect from a normally exposed image via image-manipulation software. When it comes to printing out low-key images, beware: inkjet prints with large areas of black can easily become overloaded with ink.

▲ By design

You can force mid-tones and highlights to be darker than usual through manipulation. Here, an image from Tuscany produced through the Hipstamatic app has been further darkened to emphasize the storm-laden atmosphere.

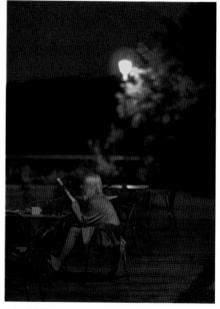

▲ Twilight

The natural time for capturing low-key images is the evening and night. Here a hotel guest reads by lamplight while the day darkens around her. Almost every tone is darker than mid-tone.

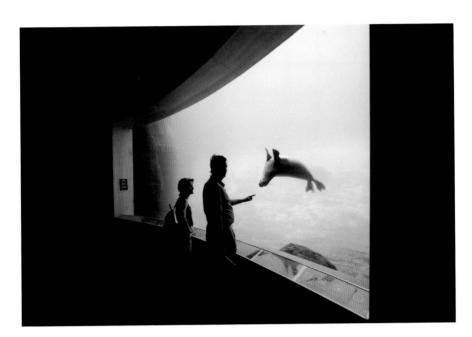

◆ Dramatic portrait

For a low-key portrait, all that is required is sidelighting from a low angle, as here, with enough underexposure to send the majority of tones into the shadow. The absence of really bright areas creates a moody feel. This type of portrait is much favoured for older subjects, as it conceals imperfections and wrinkles.

▲ Two-toned

Silhouettes – in which the subject is seen only in dark outline against a relatively bright background – are a special kind of low-key imaging. By forcing mid-tones to be very dark, we lose all shadow detail and retain only shape.

TRY THIS

Seek out scenes with a broad subject-luminance range, such as a building with one side lit by sun leaving the other in deep shadow. Make a series of decreasing exposures, starting with the correct one. As the mid-tones progressively deepen to black, the bright areas simply shrink until the image consists of sharply drawn highlights. Notice that the image can work well at many stages.

ACCESSORY FLASH

The modern flash is nearly universal because it is both highly miniaturized and "intelligent". Units may be small enough to fit in a camera phone, for example, yet deliver extremely accurate computer-controlled doses of light that balance the ambient light in the scene. Thanks to this versatility, flash units are found on virtually all camera phones, compact cameras, and many SLR and mirrorless cameras.

Making flash work for you

Whatever you might gain in terms of convenience by having a ready source of extra light built into the camera, you lose in terms of lighting subtlety. To make the best use of flash, you need to exploit the control facilities on your camera.

First, use the "slow-synch" or "synchro-sun" mode if your camera is equipped with it. In low-light conditions, this allows the ambient exposure to be relatively long, so that areas that are beyond the range of the flash can be recorded as well as possible, while the flash illuminates the foreground (see below). This not only softens the effect of the

flash, but it can also mix white balance – the cool tint of the flash and the warmer colour of the ambient light – which can be eye-catching.

Second, try using a reflector on the shadow side of the subject. If angled correctly, it will pick up some light from the flash and bounce it into the shadows. Any light-coloured material can be used as a reflector – a piece of white paper or card or a white wall, for example. Flexible reflectors that are lightweight and opened out for use but can be collapsed to compact size are inexpensive and very effective. Some models offer two different surfaces – a gold side for warm-coloured light and a matte or silvery white side for harder light.

Third, an advanced option is to use slave flash. These are separate flash units equipped with sensors that trigger the flash when the master flash (built into or cabled directly to the camera) is fired. If you have a flash unit, it is not expensive to add a slave unit. However, you will need to experiment with your camera to check if the synchronization of the multiple flash units is correct.

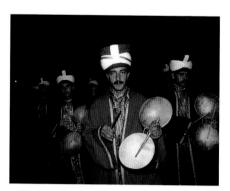

▲ Flash limitations

Dusk in Istanbul, Turkey, and traditional musicians gather. The standard flash exposure used for this image lights only the foreground subjects and the rapid light fall-off, characteristic of small light sources, fails to reach even a short distance behind the first musician. Adding to the problems, camera exposure is not long enough for the low ambient, or available, light levels prevailing at the time. As a consequence, the background has been rendered black. This type of result is seldom attractive, nor does it display any sound photographic technique.

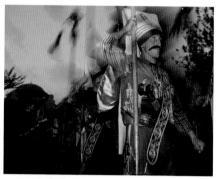

▲ Effective technique

When illumination is low, make the most of what light is available rather than relying on electronic flash. Here, exposure was set for the sky: this required a shutter of ½ sec, giving rise to the blurred parts of the image. At the same time, the flash was brief enough to "freeze" the soldier in the foreground, so that he appears sharp. Utilizing all ambient light ensures that the distant part of the scene is not wholly underexposed – some colour can even be seen in the background building. Compare this with the image in which flash provided all the illumination (left).

Using any set-up with more than one flash means trying out different levels of flash output to discover the best results. Start by setting the slave to its lowest power output, bearing in mind that the task of this unit is to relieve subject shadows, not act as the main light. Some camera models are designed for multiple-flash photography.

Flash synchronization

Because the pulse of light from electronic flash is extremely brief, even when compared with the shortest shutter time, it is crucial that the shutter is fully open when the flash fires. Only then will the entire sensor area be exposed to the flash light reflected back from the subject. There is usually a limit to the shortest shutter time that synchronizes with the flash, often known as "x-synch". For most cameras with focal-plane shutters, this is between 1/100 and 1/100 sec. In some models, x-synch corresponds to the shortest available shutter time, which may be 1/100 sec, but only when using flash units dedicated to that particular camera model.

▲ Without flash

Bright, contrasty sunshine streaming in through large windows behind the subjects – a troupe of young singers dressed in traditional costume from Kyrgyzstan – produced a strongly backlit effect. Without the use of flash, the shadows would appear very dark, but in this case a wall behind the camera position reflected back some light from the windows into the shadows to relieve the contrast a little and so retain some subject details. Use of a fill-in flash would have spoiled the composition, which relies on the pattern of the shoes.

FLASH EXPOSURE

All flash exposures consist of two separate illuminations occurring simultaneously. While the shutter is open, or the light sensor is receptive, light from the overall scene - the ambient light - creates one exposure. This ambient exposure takes on the colour of the prevailing light, it exposes the background if sufficient, and it lasts longer than that of the flash itself.

The second exposure is in addition to the ambient one. The burst of light from a flash is extremely brief, possibly less than $\frac{1}{2000}$ sec (though studio flash may be as long as $\frac{1}{2000}$ sec), and its colour is determined by the characteristics of the flash tube (which can be filtered for special effects).

The fact that there are two exposures means that it is necessary to control their balance for the best results. But it also allows you to make creative use of the process by, for example, allowing the flash to freeze movement, while the longer ambient exposure produces blurred results.

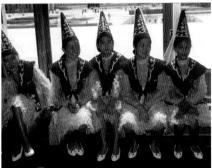

▲ With flash

In this alternative interpretation of the previous scene (left), flash has been used. This produced enough light to fill most of the shadows. Now we can clearly see the girls' costumes, but note the shadows that still remain on the carpet. The camera was set to expose the background correctly: here, an exposure time of ½50 sec was used. The f/number dictated by the exposure meter was then set on the lens, and the flash was set to underexpose by 1½ stops. This ensured that the foreground was exposed by both the flash and the available window light.

QUICK FIX ELECTRONIC FLASH

Modern electronic flash units are versatile and convenient light sources, ideal for use when light levels are low (and the subject is relatively close) or when image contrast is high and you want to add a little fill-in illumination to the shadow areas. However, due to the intensity of their output, as well as their limited range and covering power, they can make it difficult to obtain naturalistic lighting effects and correct exposure.

Problem: Common types of problem that are encountered when using electronic flash include overexposed results – particularly of the foreground parts of the image – and underexposed results – particularly of the image background. In addition, general underexposure of long-distance subject matter is very common, as is uneven lighting, in which the corners or foreground are less bright than the centre of the image.

Analysis: Flash units are controlled with their own light-sensitive sensor or with sensors in the camera. These measure the light output from the flash or the amount of light reflecting back from the subject and reaching the sensor. As a result, they are just as prone to error as any camera exposure meter. Furthermore, the light produced by a flash unit falls off very rapidly with distance (see above right and p. 40).

Overexposed flash-illuminated pictures are usually caused by positioning the flash too close to the subject, or when the subject is the only element in an otherwise largely empty space.

Flash underexposure is caused by the unit having insufficient power to cover adequately the flash-to-subject distance. For example, no small flash unit can light an object that is more than about 10 m (33 ft) away, and even quite powerful flash units cannot adequately light an object that is more than about 30 m (100 ft) distant.

Uneven lighting is caused when the flash is unable to cover the angle of view of the lens – a problem most often experienced with wide-angles. And another problem occurs when an attached lens or lens accessory blocks the light from a cameramounted flash.

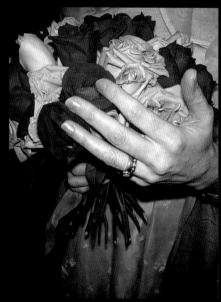

▲ Light fall-off

Light from a flash unit mounted on the camera falls off, or loses its effectiveness, very rapidly as distance increases. This is evident in this close-up image of a bride holding a posy of flowers. The subject's hands and the roses nearest the flash are brightly illuminated but even just a little bit further back, the image is visibly darker. This is evident if you look at the back edge of the wedding dress, for example. The effects of this light fall-off can be greatly minimized by using a light source that covers a larger area – hence the very different lighting effect you get when using bounced flash (opposite).

Solution: For close-up work, reduce the power of the flash if possible. When photographing distant subjects in the dark – landscapes, for example, or the stage at a concert – flash is usually a waste of time and is best turned off. A better option is to use a long exposure and support the camera on a tripod or rest it on something stable, such as a wall or fence. With accessory flash units – not built-in types – you can place a diffuser over the flash window to help spread the light and so prevent darkened corners when using a wide-angle lens.

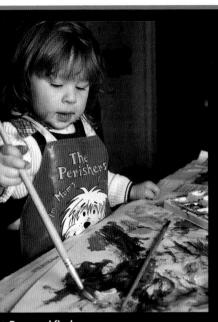

▲ Bounced flash

Direct flash used at this close distance would produce a harshly lit subject and a shadowy background. In this shot, the flash was aimed at the wall opposite the child. In effect, the light source then becomes the wall, which reflects back a wide spread of light. Not only does this soften the quality of the light, it also reduces the rapid light fall-off characteristic of a small-sized source of light. But bounced flash is possible only if you use an auxiliary flash unit. Note, however, that the background is rather darker than ideal – to overcome this, there must be sufficient ambient light to mix with the flash illumination to provide correct exposure overall (above right).

HOW TO AVOID THE PROBLEM

The best way to obtain reliable results with flash is to experiment in different picture-taking situations. With a digital camera you can make exposures at different settings in a variety of situations to learn the effects of flash. Some flash units feature a modelling light, which flashes briefly to show you the effect of the light – this is a useful preview, but it can consume a good deal of power and is likely to disturb your subject.

▲ Mixed lighting

The result of balancing flash with an exposure sufficient to register the ambient light indoors delivers results like this. The lighting is soft but the colour balance is warmed by the ambient light. Also, the background is bright enough for it to appear quite natural. If a greater exposure had been given to the background, there would have been an increased risk of subject movement spoiling the image.

▲ Uneven light

On-camera flash typically delivers these unsatisfactory results. The lighting is uneven, the shapes the flash has illuminated look flat, and there are hard, harsh reflections on all shiny surfaces. In addition, the flash has created unpleasant shadows (note the shadow of the lip-brush on the background woodwork). Always be aware of any flat surfaces positioned behind your subject when using flash from the camera position.

ELECTRONIC FLASH

Today's battery-powered electronic flash units offer an impressive combination of high power, portability, flexibility, and convenience. Moreover, these units are easy to use, with many automatic features. In addition, lighting effects are repeatable and colour temperature is constant (see p. 138). In fact, portable electronic flash units are the single most powerful accessory you can attach to your camera. They widen the range of situations you can photograph in while expanding the lighting effects available for in many situations. It is also easy to match flash units to budget, as low-power units are very affordable. For greater expense, you are rewarded with higher power, more rapid recharging, and more automatic features such as wireless (infra-red or radio) synchronization.

Digital advantages

Digital photographers are at a great advantage compared with their film-based counterparts in being able to assess the result of a flash exposure immediately after it is made – either by observing the image on the camera's review screen or on a computer monitor. Assessing images on the relatively small screen of a typical digital camera is more reliable than before, thanks to improved and

larger screens. Nonetheless, if possible, it is always preferable to download the image onto a computer for assessment via a full-sized and calibrated monitor (see pp. 214-5).

Types of equipment

For a range of photographic tasks, from still-life to portraiture, a single flash unit will suffice. The single most useful light-shaper – which changes the quality of the emitted light – is a large diffusing panel, also called a soft-box. A substitute for a soft-box is a reflector, but that incurs a big loss of light through the inefficiency of reflection.

A second synchronized lighting unit is useful for adding highlights – a halo of light from behind, for example, or controlling background lighting, or increasing overall light levels. The two units need to be synchronized with the camera. This can be done wirelessly with infra-red or radio, which is available on the better-specified models. You can also attach a sensor to one of the units: when it picks up a sudden rise in light levels, it triggers the unit it is attached to. Using these methods you can synchronize several units.

For the greatest flexibility, you also need a camera with a lens offering a wide range of adjustable

BROAD LIGHTING

Young children can be demanding subjects if you have too fixed an end result in mind. Often, they are curious about all the equipment in a studio, they are very mobile, their concentration span is short, and they are difficult to direct. One approach is to position them against a plain background and set a broad lighting scheme - perhaps two soft-boxes, one either side of the set. The wide spread of soft light allows your subjects to move about without you worrying where shadows will fall.

FILL-IN FLASH

Fill-in flash is used to light shadowy areas, particularly when the background is much brighter than the subject (right). The flash is set so that it lights the subject with between 0.5 stop to 1.5 stop less than a full exposure. For example, the aperture setting is f/5.6 but the flash level is set as if the aperture is f/4: this puts out 1 stop less than is needed as the actual set aperture is smaller by 1 stop. At its best, fill-in flash is invisible: the lighting simply looks gorgeous (far right).

apertures. As adjusting the aperture is your principal means of controlling flash exposure reaching the camera sensors, cameras with just three or four aperture settings can limit your creativity.

Studio lighting

In mastering the basics of portable flash lighting you will also learn the fundamentals of studio flash lighting. The difference is that not only are studio units far more powerful and controllable, but also the range of light-shapers available is very wide, making it possible to create lighting effects that are all but impossible to reproduce outside the studio.

In the studio, you can have everything under control – from the colour of the walls to whether you cover the windows. You may therefore light your subject with only the studio units, or you can balance existing, ambient light from the sky with flash light: the range of possibilities is infinitely rich.

Building a lighting scheme

The sequence on the following pages shows what differences you can achieve by working with the simplest lighting set-up: a single flash. Analyze the images for the quality of the light and shadows in order to learn how to obtain the same effects with your own equipment.

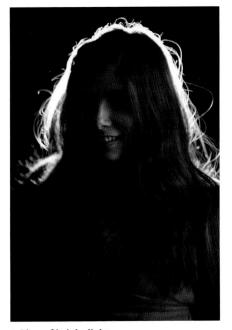

▲ Ring of bright light

One of the most delightful lighting effects in portraiture is the rim light or halo: place the flash pointing towards the camera but hidden behind the subject's head. This throws some of the hair into bright highlight while leaving the rest of the image in shadow and relatively flat light.

ELECTRONIC FLASH CONTINUED

INVERSE SQUARE LAW

If you double the distance between a light source and the surface that light falls on, brightness at the surface is not just halved. For a small, or "point", light source, without a reflector or lens for focusing output, doubling the distance reduces intensity by four times (by a factor of two squared). This is the inverse square law. Although commonly applied to studio and accessory flash lighting, the inverse square law gives inaccurate results since nearly all luminaires (sources of light) use reflectors or lenses, so light distribution is not even and equal in all directions.

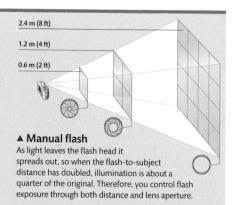

Direct on-camera with subject close to wall

The normal position for flash – mounted on the camera and pointed directly at the subject – is only for convenience. And it was necessary when flash units were weakly powered, as it makes the most efficient use of light. However, it is one of the worst possible ways to light a subject: shadows on the face are flattened, which smooths out form and texture, and any slightly reflective surface returns as a shiny bright patch. Furthermore, a strong shadow is thrown behind the subject, which is visible if there is a wall too close.

Direct on-camera with subject away from wall

The strong shadow from direct lighting can be reduced by moving the subject away from any wall or surface behind that would catch the shadow. By adjusting the distance from the wall, you may be able to balance the brightness of light on your subject's face with the background. However, the lighting is still harsh and unflattering.

Direct on-camera with diffuser

You can soften the light from the flash by applying a diffuser: this can be as simple as a piece of white paper or tissue held in front of the flash-tube that emits the light. Or you can attach an accessory plastic dome onto the flash unit. The diffusing reduces the amount of light by spreading it over a wide area. This delivers soft shadows with just a hint of highlight concentration, giving a natural look.

HARSH SHADOWS

Using a single camera-mounted flash is by far the most convenient lighting arrangement. However, effects are often harsh and unattractive. Here, a flash on the left of the camera has provided adequate illumination but it has also cast hard shadows behind the subject and from the pen she is holding. At the same time, the modelling effect on the face is flat, while the background appears too dark due to the rapid fall-off of light. To avoid these problems, you will either have to bounce the flash off an intervening surface or, better, use more than one lighting unit.

On-camera with bounce from above

Bouncing turns any nearby surface into a flash accessory: with your flash mounted on the camera, turn its head towards the ceiling. The flash travels from the flash unit to the ceiling which, in reflecting the light, becomes the main source of light. As the light has spread over a wide area on the ceiling before being reflected, the light is softened. However, because the light comes from above, it causes deep shadows over the eyes. A little light may leak from the flash to light the subject directly: this is useful for filling in shadows.

On-camera with bounce from side

There are two advantages to bouncing light from the flash against a nearby wall. As the light reaches the subject from the side, there is better modelling, with no heavy shadows around the eyes. Also, you can usually get closer to walls than to ceilings, which means you lose less light and can control its quality by varying your distance from the wall. Work close to the wall for a harder light; shoot from further away for a softer effect. Naturally, white walls (or ceilings) are the best to work with as they do not disturb colour balance.

Detached with subject lit at 45°

Lighting becomes very interesting when the flash is freed from the camera. Some units use a cable to connect to the camera, others use infra-red or radio to synchronize. At any rate, unless you have assistance, you can hold the flash only as far as you can reach. Fortunately, it is easy to hold the flash so that it lights a portrait subject from about 45 degrees. This oblique lighting brings out the form of the face or body; here giving shape to the nose, cheeks, and chin.

ELECTRONIC FLASH CONTINUED

HINTS AND TIPS

If you are new to working with studio flash and accessories, you might find it useful to bear the following points in mind:

- As a general rule, always use as few units as possible to achieve the desired lighting effects. Start with one light only and use reflectors to control the quality of the illumination reaching your subject. Only if this is insufficient should you consider adding extra lighting units to the scheme.
- Remember that it is easier to remove light than to add light. Using accessories, such as barn doors or snoots, you can easily control the fall of light and any shadows that are created as a result.

- However, an additional light immediately casts a set of new shadows.
- A reflector placed facing the main light, angled so that it bounces light into subject shadows, is usually a more effective solution than using another light source to reduce shadows.
- A large light source, such as a brolly (umbrella reflector) or soft-box, produces softer light and more diffused shadows than a small light source.
- A small light source, such as a spotlight with a small bowl, produces harder light and sharper shadows than a large, diffuse light source.
- You can use coloured gels to add tints to the background of your subject.

Off-camera at 90° with flash close to model

The closer a light-source is placed to the subject, the harsher the light appears to be. And if it is placed to the side, deep and long shadows result. The combination of hard light with deep shadows delivers dramatic effects thanks to the marked contrasts of tone and visible detail. At normal portrait distances, you will probably need to mount your flash on a small stand or ask an assistant to hold the flash to one side of the subject. For maximum contrast, ensure the subject is not close to a wall on the side opposite the flash.

Off-camera at 90° with side reflector

If you light your subject from one side but place them so that they are near a wall facing the flash, some light bounces from the wall into the shadows. This lifts or fills the shadow side with soft light. This reduces the drama but creates a most attractive lighting. Alternatively, you can hold a card or sheet of paper on the shadow side to reflect light. By working with the colour of the reflector and its surface texture – whether glossy or rough – you can alter the quality of the reflected light.

Off-camera from below pointing upwards

Seldom flattering but always recognizable, lighting a portrait subject from below has the most specific uses of any lighting set-up. This is because it is the least likely to be found in the natural world. The light looks as if it comes from a fire or a hand-torch held low down. By casting unusual shadows on the face and leaving everything else in the dark, this scheme conveys mystery and tension.

▶ Mixed light sources

An aim of studio lighting can be to mimic the quality of daylight. In this scene, it was important that the table light appeared to be the main light source. The levels of daylight were inadequate to illuminate the dark-coloured interior of the room, so a flash was directed at the ceiling behind the table. The reflected light was just enough to bring out important details in the setting without creating tell-tale hot spots in the glass-fronted pictures.

Ambient with full fill-in from flash

All flash exposures consist of two separate exposures: one using light from the flash, one using ambient or available light. When the levels of the two are equal, or the flash is brighter, the effect usually appears over-lit and unnatural. A full fill-in with flash is useful in situations where you do not wish to lose any details to shadows; where you need maximum clarity. If the ambient light is coloured, as here, it will warm up the white balance of the image.

Reduced exposure overall with fill and ambient

Under-exposure softens the lighting by allowing shadows to differentiate from mid-tones. At the same time, colours become deeper and the contribution from the tinted ambient lighting from indoor lamps makes a significant shift in white balance.

On-camera flash with diffuser plus daylight

The white balance of many flash-units tends to be on the cool side of neutral, some giving a noticeably bluish colour cast. You can correct this using a filter, in post-processing, or by working with ambient light. If you use indoor lighting, the resulting white balance will be distinctly warm. If you work with daylight, the balance is cooler. In this image, the brown walls of the room contributed their colour to the final balance. This shows how each source of light and every reflecting surface in the scene contributes to the final result.

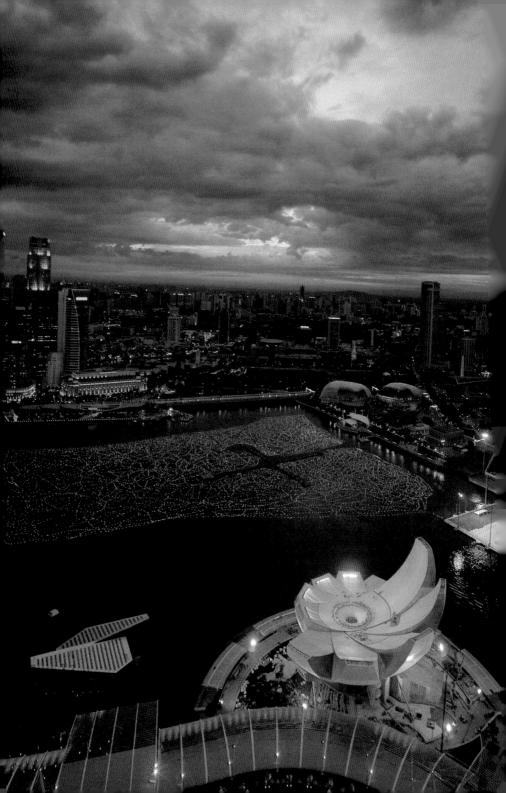

2 PHOTOGRAPHY PROJECTS

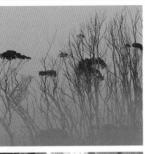

ABSTRACT IMAGERY

Photography has the power to isolate a fragment of a scene and turn it into art, or to freeze shapes that momentarily take on a meaning far removed from their original intention. Or chance juxtapositions can be given significance as a result of your perception and the way you decide to frame and photograph the scene.

Close-ups and lighting

The easiest approach to abstracts is the close-up, as it emphasizes the graphic and removes the context. To achieve this, it is usually best to shoot square-on to the subject, as this frees the content from such distractions as receding space or shape changes due to projection distortion.

Longer focal length settings help to concentrate the visual field, but take care not to remove too much. It is advisable to take a variety of shots with differing compositions and from slightly different distances, as images used on screen or in print often have different demands made on them. For example, fine detail and texture are engrossing but if the image is to be used small on a web page, then a broad sweep may work better. And since you will usually be shooting straight onto flat or two-dimensional subjects, you do not need great depth of field (see pp. 18–21). This is useful, as it is often crucial to keep images sharp throughout.

► Complicated abstract

Abstract images do not need to be simple in either execution or vision. Try working with reflections and differential focus (focusing through an object to something further away). Here, in Udaipur, India, a complex of mirrors, coloured glass, and highlights from window shutters battle for attention - and bemuse the viewer. Control of depth of field is critical: if too much of the image is very sharp. the dreamy abstract effect may be lost.

▼ Found abstract

Here, the decaying roof surface at a busy railway station must have been glanced at by thousands of commuters every day but seldom seen. Perhaps it is a simple expression of the process of ageing, the origins of which can only be guessed at.

ABSTRACT IMAGERY CONTINUED

▲ Modern forms

Contemporary architectural details are rich sources of abstract imagery. Their strong graphic design invites you to take – and delight in – small elements and examine their interaction with other, equally graphic elements. Here, the frosted glass of an apartment block gives a partially obscured view of the courtyard beyond. To increase the abstract look of the image, I simply turned it on its side.

▲ Light play

Observe shadows closely and you will find a challenging and constantly changing source of images. Clear, clean light helps give well-defined shadows that contrast sharply with man-made textures and surfaces. Take care not to overexpose, because that will cause you to lose highlight textures. This type of image often benefits from increased contrast and saturation, as seen here.

COPYRIGHT CONCERNS

You may think that because a poster or other subject is on public view, you can photograph it with impunity. If you are taking the photograph for research or study, for example to illustrate a school essay on advertising, then this may be true. In other cases, however, you may be infringing someone's copyright. If you use a recognizable and sizeable portion of an image on public view as a significant part of another image that you go on to exhibit, publish, or sell, then in many countries you would be in breach

of copyright. If you really want to use the image, then at least be aware of the potential legal situation. Note that sculptures, buildings, logos such as McDonald's arches, cars such as the Rolls-Royce, the French TGV train, certain toys, for example Disney characters – even landmarks such as the Lone Cypress tree at Pebble Beach, USA – all enjoy a measure of copyright protection. In reality you may never be taken to court for photographing them – but be aware that, theoretically, you could be.

ARCHITECTURE

The built environment can provide endless photographic opportunities – the problem is not in finding subject matter, but in reducing it to a manageable scale. At the same time, digital techniques make it easier than ever to create stunning images. For example, we can work with a wider range of lighting options than ever before, thanks to tone-mapping software, which blends different exposures into a tonally compressed image (see pp. 168–9).

Technical considerations

You can approach photography of buildings in broadly two ways – artistically, in which you treat the architecture as a subject for free interpretation; or you can attempt to be faithful to the architect's design intentions. For technical renderings, you need to ensure that straight lines appear straight and, where possible, that parallel lines are also recorded as parallel. This means using lenses with accurate drawing; that is, those that produce images with minimal distortion. A secondary requirement is that the illumination of the image is as even as possible, so that the corners of the image are not darkened. In practice this is achieved with medium-

KNOW YOUR RIGHTS

Areas open to the public such as shopping malls, or even landmarks such as London's Trafalgar Square, may be privately owned, so if you intend to publish pictures of a particular building, you may need to obtain permission first. Avoid using professional-looking equipment, and make your shots swiftly to avoid drawing attention.

Fears that photographs may be used for planning terrorist acts have caused some police and security forces to prevent pictures being taken in certain urban locations. In many countries you cannot be made to delete your images or to hand over your memory card without being charged with an offence, but it is always best to cooperate with the authorities when you are abroad.

▼ Dramatic highs

The architect may not thank you for this vertiginous view (of Singapore's first high-rise apartment block), but it effectively conveys the structure and its height. Wide-angle views looking directly upwards or downwards are usually quite disorienting, but added to the strongly converging lines, the result is visually powerful.

ARCHITECTURE CONTINUED

speed prime or single-focal length lenses such as 35 mm, 28 mm, or 24 mm – all of around f/2.8 maximum aperture. Note that almost all zoom lenses cause unacceptable levels of distortion and uneven illumination, although some defects can be corrected in image manipulation software.

Foreground reduction

You can also use software to improve the shape of buildings – correcting converging parallel lines and turning distorted rectangles into a squared-off (orthogonal) shape. But there are limits to how convincing image adjustments can be, compared to correct capture. Aim the camera level and square to any subject that you do not wish to distort. If you cannot capture the whole height of the building, photograph from further away, if possible, or use a lens with wider angle. Both options result in capturing a great deal of foreground, but this is easily cropped off. For professional architectural work, the shift lens (see p. 205) is indispensable: the lens slides upwards to crop out foreground.

View variety

Extreme wide-angle views, that is, focal lengths less than 24 mm or equivalent, are tempting, but objects near the edge of the frame appear distorted in small images when viewed close up. If you need really wide

views, you can stitch several shots together to create a panorama (see pp. 190-1): this is best done with the aid of a panoramic head and tripod (see p. 206).

Although it is natural to reach for a wide-angle lens to photograph buildings or interiors, a wide view is not always best. A carefully chosen, narrower field of view can reveal more of a building and its surroundings, so remember to look for telling details, such as a high-up window or decorative elements. In fact, the best way to improve your architectural photography is not by buying a new lens, but by being painstaking about choosing perspective and framing.

Dynamic colour

Photography of buildings needs perhaps greater flexibility with white balance than any other field of photography. This is because lights originating inside the building are usually of a different colour temperature to the light coming from outside. A contrast of colours can be attractive, but too great a difference can distract from the building itself. For the greatest amount of flexibility in adjustment, capture in RAW format (see pp. 158–61). You do not always have to correct colour balance fully: improvements can often be made simply by reducing the saturation of reds, or increasing their lightness – or a bit of both (see pp. 140–1).

■ Vernacular

Pictures of buildings usually focus on the grand and the monumental, but there are many more possibilities. Buildings locally made without design pretensions - ranging from animal shelters, barns, sheds, and farm houses to fishing huts - are all rich imagery sources. Use local signage and street furniture to enrich picture content.

◆ Distant charms

When in search of the perfect Italian piazza and the grandest duomo, you can start shooting long before you arrive. Here, in Urbino, great towers dominate street views, guiding your exploration of the town and inspiring each step of the way. You can include the ephemera of street signs, hanging washing, and bunting or flags to provide context - or avoid them, to reinforce the atmosphere of timelessness.

▲ Opportunities

Even as you enter a hotel, you may spot a picture possibility. Take a second out to make the shot, for the light may change or you may lose the inspiration of the moment. If your lens does not take in a sufficiently wide-angle view, tilt the camera to use the diagonal of the frame.

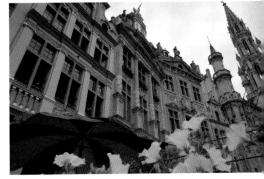

▲ Leaning back

Pointing a camera upwards to capture a building seldom flatters it, but for specific pictorial effect, a steeply upward view can work well. Use contrasting foreground elements to help articulate the space in an engaging way.

TRY THIS

Photographing from one spot, using a zoom lens to vary framing, helps train the eye to find compositions. Choose a location to shoot from, then create the greatest variety of images you can by using only the zoom to change the framing. Return to the same spot at different times of the day and in different weather conditions to obtain an even greater variety of images.

DOCUMENTARY PHOTOGRAPHY

The full spectrum of documentary photography covers prosaic recording, or the "soft" story, such as construction progress or family life, through to the "hard" stories, such as a civil war or drugs trafficking. Whatever the subject, what matters is the approach: classic documentary is about recording with empathy the everyday existence of people, wherever they may live – if necessary revealing unpalatable truths, and recording for posterity events that some would prefer to be forgotten.

Preparation

In this, perhaps the most vocational of all genres of photography, subjects tend to choose you, the photographer. Injustices in an occupied territory may suddenly come to your attention, and you feel you must do something about it. Orphans in a city may break your heart, and you are moved to tell the world about them. While it is important to be motivated, it is also important to be a dispassionate observer. Study the subject area: read relevant legislation, speak to people affected, talk to local experts and charity workers – become an expert yourself. This prepares you for the photography by informing your vision and directing your search for the telling image. It will also prepare you for the essential step of writing informative, accurate captions.

When it is clear to your subject that you are serious in your intentions, know what is going on, and can be trusted, you will find it easier to obtain cooperation. This is vital a step, if only to ensure your safety: do not be too eager, nor believe that you have to be pushy and determined. And never forget that your safety is more important than any images you could obtain.

Softly, softly

Technically, documentary photography is 90 per cent being there, 10 per cent pressing the button. Small, discreet cameras such as point-and-shoot or compact interchangeable lens (CIL) models attract less attention and are less intimidating than large SLR models with long zoom lenses. Cameras without mirrors are also quieter than SLRs – some are totally silent in operation. Point-and-shoot

cameras are also much less expensive, so you can use two or three at the same time and you do not have to worry too much about damaging them in rough conditions.

When choosing a camera, look for good low-light operation – rapid autofocusing and images with low noise (see pp. 124–5) – so you do not have to use flash indoors or at night. Cameras with larger sensors – APS–C or larger – give the best performance at high ISO settings, and CIL cameras can be fitted with very fast (large maximum aperture) lenses, for example 24 mm f/1.8. The ability of modern cameras to capture high-definition (HD) video can also be invaluable in documentary work – more and more documentary photographers are combining moving images and sound with still images.

Formal requisites

Reliable documentary work relies on the unaltered digital image in order to be a truthful, unvarnished record. It is acceptable to make tonal, exposure, and colour balance corrections, and to convert to black-and-white. There should be no change of content such as the removal of distracting elements.

◆ Container movements

Even if circumstances such as safety concerns prevent you from being close to the action, there is always a way to pull the viewer into the shot. Here, by holding the camera with an ultrawide-angle lens close to the operator's head, I made him appear large compared to the workers behind. Converging parallel lines draw attention into the "back" of the image.

▲ Intermezzo

Dancers of the Singapore Dance Theatre relax between rehearsals in an image that may not be first choice for publicity or promotion, but is an affectionately truthful portrayal of a moment in the lives of hard-working dancers.

CITIZEN REPORTING

With more than 3 billion cameras and camera phones in use around the world, there is sure to be a photographer near any newsworthy incident. Increasingly, ordinary people are recording news instead of being passive witnesses. It is essential that all of them accept the responsibility for accurate reporting, with truthful, non-manipulated images and no staging or re-enactment of news events. Camera phones are ideal for posting images to media news desks and to social-network sites. Before submitting images, including to photo-sharing sites, ensure you do not lose your rights to the image.

DOCUMENTARY PHOTOGRAPHY CONTINUED

▲ Proud portraits

Some people can be too cooperative, sitting to attention with a broad smile when they see a camera pointing at them – as this melon-seller in Tajikistan did. Make the exposure anyway, thank them and expose again when they return to a relaxed, more natural pose.

▼ Wordless image

The ideal documentary photograph says it all in the image; there is no need for a caption to tell you what is going on. All you might need to identify it is location: in this case, Tashkent in Uzbekistan, where heavy rain in a desert-dominated country is unusual.

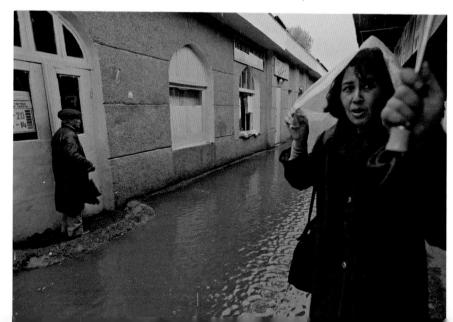

▲ Combining elements

In documentary photographs everything counts: there is information in every corner of the image, and every portrait of a person is also a portrait of the place and the situation. Make it all count: a boy tailing me wears local clothes, the door casts shadows on carpets – all have stories to tell.

MODEL RELEASE FORM

If you take pictures of people and intend to use them in commercial ventures, a legally binding agreement between subject and photographer allows you to use the pictures without any further financial obligation or reference to the person depicted. For the personal use of a photograph, it is generally not necessary to obtain the model's release: however, if an image is intended for commercial use, it is advisable - sometimes mandatory - to obtain signed consent. A simple form of words is: "I permit the photos taken of me (subject's name) by (photographer's name) to be printed and published in any manner anywhere and at any time without limit." The release form should also note the date and location the pictures were taken and carry the signature and contact details for both the subject (or parent/guardian) and the photographer. Both parties should sign two copies - one is kept by the photographer, the other by the subject. The payment of money or giving of a gift - for example, a print of the image - may be required to make the contract binding.

▼ Eloquent scenes

It is easy to capture pictures of buildings and living spaces, but it is always worth waiting for a little of ordinary life to pass by. You never know what will turn up and what it will tell you. Here neglect of a traditional district is brought into focus by a woman crossing the road.

STREET PHOTOGRAPHY

The invention of 35 mm miniature film and small cameras completely freed photographers from the studio to photograph the world at large. Since then the urban street, with its unending, bustling activity and unpredictability, has proved to be an inexhaustibly rich source of images. With your camera, you can explore any city's streets: the photographic rewards can be great, and you will also get to know your surroundings better.

Fortune telling

The core of street photography is the spontaneous juxtaposition of the different elements of a street scene – people, objects, and features of the urban landscape – in such a way that the composition gains a meaning or significance that is greater than the mere accident of its subjects being in the same place.

This means that composition and timing are crucial, but more importantly, street photography is driven by a keen, highly tuned awareness of movements and objects in the street. With practice this leads to what is almost an ability to read the future. This is essential because meaningful compositions or juxtapositions usually appear with only a faction of a second of lead-in time, and

dissolve in even less time. Therefore street photographers must anticipate every shot: a little experience will show that if you merely try to respond to a situation that you are witnessing, you will already be too late.

Street wise

The great French photographer Robert Doisneau explained that the secret of his success at street photography was to "Walk, walk, and walk some more". Explore your city on foot, watching and experiencing the variety of scenes and subjects on offer. Take advantage of the fact that many cameras are extremely compact and lightweight, and can be easily carried all day – keep your camera in your hand, powered up and ready to use.

Use manual focus set, for example, to 4 m (13 ft), and ensure you capture action within that distance: this greatly speeds up your camera's responsiveness. Remember that an imperfect shot perfectly timed is preferable to a perfect shot badly timed. Be mindful of your own safety while you are shooting on the street, especially at night; conversely, if you sense that your presence is making someone uncomfortable, desist immediately.

▲ No room for boredom

While waiting for your bus or train, or even for a thunderstorm to clear, you can help pass the time by being observant and taking an interest in how people behave. Here, a camera phone was the perfect tool for capturing reactions to a downpour in London.

PRIVACY AND SECURITY

In some countries, the legal view is that people have a right to private lives even in public. Therefore taking photographs of people in public spaces without their permission may be an offence. In other countries, photography of people may be offensive on cultural grounds. With increased awareness of photography worldwide, the safest and most polite course is always to obtain permission whenever you wish to photograph someone in such a way that they will become the main focus of the image. For an image to be used commercially, a model release will be mandatory (see p. 61). Street photography featuring large numbers of people is not usually problematic, but even so, you should be sensitive to people's feelings, which take precedence over your right to photograph.

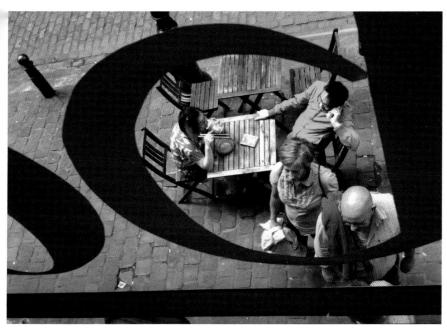

▲ Opportunistic juxtaposition

From a vantage point in a Brussels café, the signage on the window provided a stylish framing for the activity on the street below. By adjusting the camera's position, the curves

fitted around the table below. All that remained was to pay attention to what was going on. A compact camera is ideal for such shots because it is easy to hold for long periods.

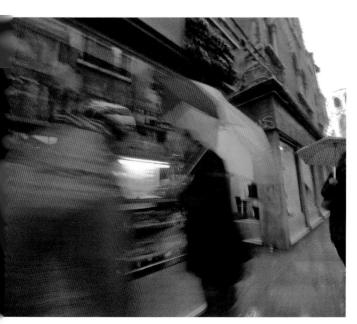

■ Blur of life

There are no rules in photography: you do not have to frame or time your shots precisely, you do not have to capture expressions, and your images do not have to be sharp. Enjoy yourself by working with random occurrences such as unexpected combinations of colour and light - you can even capture them while on the move. In this shot, the varying degrees of blur add textural variety.

HOLIDAYS AND TRAVEL

Modern cameras make it a fun pursuit to capture pictures of your holiday that will remind you of the trip for years to come. But you will find it far more satisfying to create images that can stand on their own, and that have an appeal and interest that goes beyond your circle of friends and family. At the same time, if photography is not a priority for other members of the group, you need to be careful not to spoil their fun or keep them waiting around while you take pictures.

This is us

An effective way to get everyone used to you pointing the camera at them is to start shooting from the very beginning – for example, from the moment you meet up at the airport. Avoid arranging everyone into a formal group shot, but capture your friends as they chat to each other, consult maps, or send last-minute texts. Keep shooting as you move from one location to another. Before long, you will be creating a natural, sequential record of your holiday, in which the more obvious shots of landmarks and monuments will have a fitting context.

Subjects and approaches

Looking to your broader surroundings, you can develop photography projects that tell the viewer

▲ Food and drink

Part of the fun of holidaying is experiencing different food in new locations. You can incorporate this into your photography: record not only the meals, but the place settings, the reflections of a sunset on the table and the refractions of candlelight in your wine glasses.

something about the location – for example, local street food, posters, transport, or graffiti – whatever interests you. As you travel, your portfolio will grow in depth and extent in a most rewarding way. More importantly, you will find that as you become attuned to your subject matter – perhaps pursuing a particular theme and actively seeking out interesting or unusual examples – your eye for all kinds of other detail will be sharpened, with great benefit to your photography.

► Sunbed views

Even from a lazily prone position, you will see picture opportunities. Be prepared to grab your camera phone to snap the shot, and then you can get back to the serious business of relaxing.

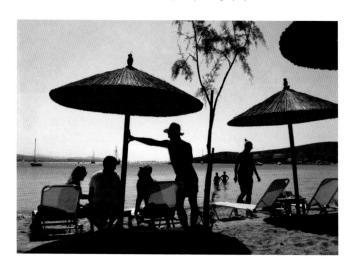

▲ Changing emphasis

Even when the weather is less than perfect, the observant photographer can always find picture opportunites. In this view of downtown Auckland, New Zealand, rain from a storm beats on the windows of an observation tower. It is usual to focus on the distant view, but by concentrating on the raindrops the scene shifts, and there is suddenly a picture to be made.

Looking beyond

However, your travel pictures do not have to be simply a record of a place, or of the day-to-day minutiae of your visit. If you can capture a human emotion, tell a story in which one picture entices the viewer to look forward to the next, and create images that inform as well as delight, you will make a breakthrough. This takes skill: you will need sharp reflexes to respond to changing circumstances – your subjects may move unpredictably, you will be in unfamiliar situations, and light conditions may change without warning. This calls for well-practised camera technique, and it helps if you have equipment that can react quickly.

Even more important is acute sensitivity to the friendliness or antipathy of your subject, and to the cultural and social subtleties of your surroundings. You will also find it much easier if you are engaged and involved with your subject on a personal level that goes beyond simply photographing them in passing.

▲ Key components

Instead of posing them in front of the sunset, try incorporating your travel companions into the scene, so that their presence enhances the image.

SHARING MEMORIES

Of the many tasks to follow up after you return home, perhaps the most easily forgotten is the promise to send prints to people you have made friends with and photographed on your trip. However, digital photography makes this easier than ever before. You can make individual prints from files, or even travel with one of the very small, portable printers available. You can also post images onto social networking or picture-sharing websites, then contact people you have met and direct them to the sites.

HOLIDAYS AND TRAVEL CONTINUED

Recording relationships

A photograph of someone you meet on a trip is much more than a likeness: it is a record of your encounter, the meeting of two worlds. Pictures of people are perhaps the single most rewarding aspect of travel photography, particularly since developing genuine relationships with people opens doors that would otherwise remain closed to you.

A useful practice is to restrict your focal length (see box opposite). In order to fill the frame with your subject, you will have to move physically closer. This is easier if you have first formed a relationship with them – even if it is a fleeting one. Indeed, if you have created a rapport – often all that is needed is eye contact and a friendly smile – it is actually more comfortable to photograph from close up than from a distance.

The eyes have it

The most eloquent part of a portrait image is a person's eyes; that is what we instinctively look at first. Face to face, a glance at a person's eyes tells us their mood and intention, and likewise with images: we immediately gather information about the

person from their eyes. The expression in your subject's eyes concisely conveys the nature of your relationship with them: if there is warmth and cordiality, we will be drawn to the image.

When you see someone you want to photograph, get your equipment ready. Set aperture depending on whether you want minimum depth of field with a blurred background, or if you want your image to be sharp throughout. If your subject is dark-skinned, set any exposure compensation to underexpose by around ½ stop. Anticipate the best angle, bearing in mind the direction of ambient lighting and the background, as well as what the subject is doing. Only when prepared should you reveal your intention to photograph. The rest involves simple life skills: approach honestly and openly, make eye contact, and say hello in the local language.

▼ Evocative imagery

The receding parallel lines of these railway tracks in Uzbekistan powerfully evoke a sense of space. In this image I balanced the need to show a long stretch of track with the size of the people on the line. If they were too far away, they would appear too small to have impact, and if they were too near, they might overpower the background.

▲ Fresh views

Every corner of Burano, one of the prettiest settlements in the bay of Venice, cries out to be photographed. If you are not satisfied making the same old images, there is still room for innovation. You need a little more patience – here, to wait for water to settle to mirror-like calm – and a bit of luck too. By seeking out the unexpected, the surprising shots will come to you: be ready for the unusual, and stay alert for you may get only one chance.

■ Incongruities

A glamorous pirate in sunglasses is not something you encounter everyday. But if you are in Arezzo, Italy, you may see a band of "pirates" rampaging through its most perfect piazza regularly as an event put on for tourists. Treat such unexpected opportunities as a gift, and photograph freely.

TRY THIS

Restricting the focal lengths available to you helps improve agility, composition, and your ability to get close to subjects. Start with a maximum of 90 mm or equivalent and compose your images by moving towards or away from your subject. Try to fill the height of a landscape format or width of a portrait format with a person's head and shoulders. Next, learn to use a 50 mm setting. Then a 35 mm setting: try to fill the frame with action and content. You can do this only by stepping inside the action. As you gain experience, try to use even shorter focal lengths; however, 24 mm or less is widely considered very tricky for general use.

HOLIDAYS AND TRAVEL CONTINUED

▲ An outsider's eve

There is no clear distinction between travel and documentary photography. A single shot of Himba and Herrero women collecting water makes an engaging travel shot. But they are walking in the heat of the day instead of the cool of evening: this tells us something is amiss. Indeed, there was a lion attack earlier, so it was safer to walk during broad daylight. Revealing aspects of a subject's life can lend a documentary element to your holiday photographs.

RESPECT YOUR HOSTS

You will find that when you dress and behave appropriately, you will receive a warmer, more cooperative reception when you want to photograph. Treat your hosts' country with the same respect you would expect of tourists in your homeland. Dress in a style that is appropriate to the cultural or social expectations of the country you are in: wear long sleeves and cover your legs if you expect to visit religious sites. By the same token, be respectful of the locals: don't insist on taking pictures of people if they wave you away or seem unhappy about it. And always keep in mind the sustainability principle that you should leave a country as you would wish to find it.

▶ Selective view

Ostensibly this is a study of contrasts – between the baby's hands and those of his grandmother; of colourful clothes against tanned skin – but this view also delicately draws the viewer's gaze from the subjects' faces, making an unusual portrait.

▼ On the road

The advantages of staying awake while travelling cannot be stressed enough. After six hours on a bus it is easy to nod off, but you would miss telling moments such as this: the driver had to be paid from outside because the bus was so full.

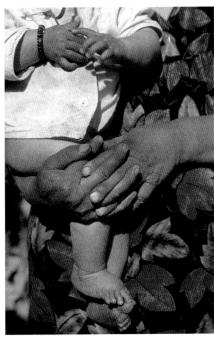

■ Way of life

It is natural to concentrate on the exotic beauties of a country, its customs and way of life. While it may not be very beautiful, the realities of day-to-day existence in a foreign land are not only more true and useful for an understanding of the country, they are vastly more interesting. You do not need to seek out poverty or destruction - you are not working on a documentary story. All it takes is to keep your eyes open and camera at the ready: this scene in Tajikistan came and went in a second.

WEDDINGS

The documentary approach to weddings is as much a reaction against stiffly posed formal shots as it is a product of improved cameras. This enables every wedding guest – from grandmother to toddler – to capture pictures of the event. If you are not the official photographer, you can shoot freely without concerns for comprehensive coverage of all guests and ensuring all the formal groupings are captured.

Professional challenge

The role of the professional wedding photographer is to provide a set of unique images that will record and evoke the experience one of the biggest days in a couple's lives. To do this they must search for angles and interpretations that, as well as being creative and inventive, raise their images well above the ordinary: a celebration of a special day should be matched with some very special pictures. A popular solution is to capture the couple in a fantasy setting. Use an off-camera flash to balance against twilight skies or shoot the couple against a plain screen (green is preferred but any plain or black background can work) ready to composite against a glorious sunset or woodland scene.

At the same time, you need to capture all the key moments too. Make sure you are familiar enough

with the ceremony to position yourself ready to take the shot of the exchange of rings, the signing of the register, or the first married kiss. Take care not to interrupt delicate moments such as the exchange of vows or the blessing from the presiding person.

One straightforward way to distinguish professional work from others is to work with a very large-aperture lens – for example, an 85 mm f/1.4 or 135 mm f/2 – which you can use exclusively at large aperture settings. The resulting shallow depth of field and softness is unlikely to be matched by people using compact point-and-shoot cameras. Besides, the soft focus also perfectly suits the romantic nature of the subject.

Another way to stand out from the crowd is to use available light instead of flash when working indoors or at night. Full illumination by flash is often necessary, but it easily destroys the atmosphere of dim or coloured lights.

Rounded views

The inventive wedding photographer does not neglect to record those aspects which others may not think of capturing, but which create a rounded record of the event. Often the most charming and amusing moments occur in the run-up to the main

▶ Bride showered

The intimate moments of preparation may be barred to all but female photographers or close relatives, but it is worth capturing the process of adorning not only the bride but the bridesmaids, as well as best man. The images display the process of transformation - from the ordinary to the celebratory. Use limited depth of field to emphasize key elements such as the jewellery and accessories.

event: seek out fleeting moments in the frenetic activity of preparation. A lot of effort goes into the details, so make sure you look at the rows of champagne glasses, the furniture decorations, and the details of the costumes and flowers.

Follow on

Once you have captured all the happy moments, you have completed only half the work. Unlike many photography assignments, the choice of images is one in which the photographer may be expected to lead, as clients are usually not experienced in picture editing. In addition, some images are obligatory, whatever small technical defect they may have.

Remember to be clear to the couple about the image rights at all times, and when handing over the images remind them that the pictures should not be reproduced or posted on social networking sites without further fees.

▶ Supporting cast

Everyone and everything is important on the big day: the bride's flowers will be seen in many pictures taken by the guests, so aim for a shot that is less obvious. Here, backlighting and graceful continuation of lines gives charm to the complementary beauty of bride and bouquet.

▲ Hilarity seriously shot

The funny moments of a wedding are essential for recreating happy memories of the event. However, you can shoot them with some sophistication. Wide-angle views lit with flash are commonplace. Try using a long focal length setting and exploit blur and overlap. In this shot, the blurred figures frame the beautiful profile of the bride, while the champagne glass helps anchor attention around the smiling faces.

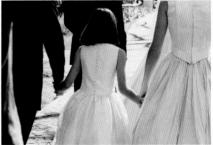

▲ Transitional states

While the key moments, such as the exchange of rings and the kiss, are must-have shots, the quiet moments also make up the event as a whole. These transitions often reveal touching moments and true relationships between family members and guests. Here, a bridesmaid walks happily between older family members, her head of dark hair framed by backlighting against the dark jacket of another guest in front of her.

CHILDREN

Children tend to be photographed in different ways according to whether they are known to us or not. The reason for this is that we tend to approach familiar subjects in a different way to unknown ones. For example, most people prefer to photograph their own children when they are looking their best in attractive, clean clothes, and smiling for the camera. However, the opposite approach may present itself when, for example, you are visiting another part of the world and you photograph a child as part of the local colour of a street scene. This will naturally give your image a very different feel.

A change of attitude

So the photographic challenge is clear: how to bring the two approaches together, being more honest when photographing our own children, while being respectful and considerate when our photographs feature other people's children, especially those from other cultures.

Informed photography is the key, as the more we know, the more perceptive our photography becomes. For example, try to learn about the games that children play, or take an interest in their

PUBLIC STANDARDS

Taking photographs of children may create unexpected risks for the photographer because of the – entirely understandable – desire to protect children's safety. Photography of children who are not your own should be approached with caution, particularly in public spaces such as parks and beaches, and near schools. Always seek the permission of parents or legal guardians (carers may not have sufficient authority) before starting to photograph. If you are at all in doubt, err on the side of caution.

pastimes. If you are photographing your own children, try to avoid obviously staged images, and instead concentrate on capturing some of the spontaneous moments that occur in everyday family life. Children tend to pose either too readily or not at all. The trick is to wait for them to get bored of you. Keep shooting, whatever they do: aim at them if they are acting up, or aim away if they are being shy. Sooner rather than later, young children will tire and let you get on with shooting. All you need is to have more patience than they do.

■ Having a chat

Children often learn to pose for the camera from an early age. If you are looking for a more natural portrait. try engaging your subjects in conversation. When they become interested in what you are talking about, they will stop playing up to the camera. They also stop running about and become easier to keep in focus, giving you a chance to set maximum aperture to throw the background out of focus, and use a shorter exposure time.

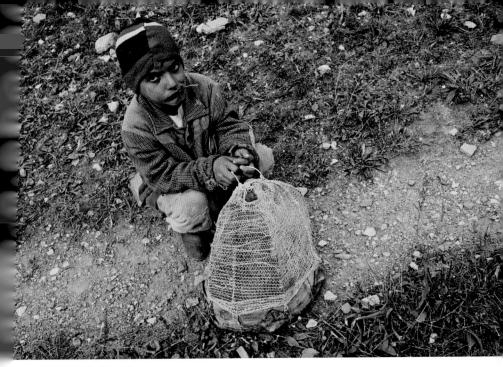

▲ The eyes of mistrust

A lad in the high mountains of Tajikistan looks decidedly cautious, as well he might. More important to him than how he looks on camera is whether he will have to fight to keep the birds he has captured in his makeshift cage. Once he overcame his mistrust, a very different image resulted, but it is this edgy image that is more interesting.

▲ Child's world

Images of children are not only about them, but also about the space they inhabit. By zooming out, you can show the child in relation to the world at large.

▲ Otherwise occupied

A distraction can be beneficial for the photographer: it not only takes the child's eye off the camera, it can show your subject lost in his or her world. Recording the best of these moments may call for many exposures, but do not be tempted to keep only "the best": these judgements vary over time, so hold on to everything you shoot. With cheap mass storage readily available, your only regret will be deleting an image.

CHILDREN CONTINUED

HINTS AND TIPS

Children can be a challenge in technical terms, as they are small, low down, and move quickly. They require stamina and fitness on the part of the photographer, as well as quick reflexes. You can help yourself by trying out these techniques:

- With very small children, work at a fixed distance: focus your lens manually to, say, 0.5 m (18 in) and keep your subjects in focus by leaning backward or forward as they move. Small children move very quickly but usually only over short distances. This method requires little effort and can be superior to relying on autofocus.
- When you first photograph a group of children, fire off a few shots in the first minute they need to get used to the sound of the camera or light from the electronic flash, while you need to exploit their short attention span. Once they have heard the camera working, they will soon lose

- interest and ignore you. If, however, you wait for them to settle before taking your first picture, they will be distracted by the noise.
- For professional photography of children, the best cameras to use are CXL (compact interchangeable lens) or SLR cameras, preferably equipped with a prime lens. These give you more flexibility than compact point-and-shoot cameras. You also need the shortest possible shutter lag (the time interval between pressing the shutter and actually recording the picture) if you are not to miss out on the really spontaneous images.
- In low light, increase the ISO setting in preference to setting the lens's maximum aperture when using non-professional lenses. If you have high-quality optics, use the widest aperture freely, but you will need to focus more carefully. Avoid using flash lighting except as a fill-in (see pp. 40-9).

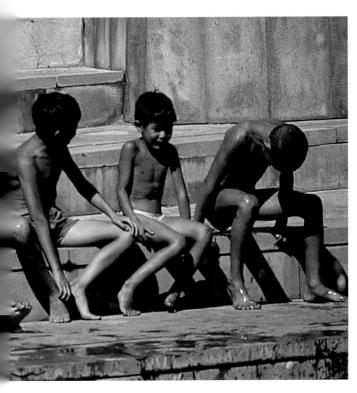

◆ A candid approach

A large fountain in hot weather is irresistible to children anywhere in the world. The problem here was trying to photograph the boys without them realizing – otherwise they would start playing to the camera. I mingled with the crowds, enjoying the sun, and waited for a suitable grouping and rare moment of repose.

► Sibling rivalry

A set of nothing but smiling, happy pictures of children quickly makes for predictable and dull viewing. Children also get cross, cry with frustration, exhaust themselves, and fight or play with siblings. With compact and responsive cameras and camera phones, you can be on hand to record all those telling moments.

LANDSCAPES

The natural landscape – topographies of land and water decorated with plant forms and lit by sun and sky – is one of the most accommodating yet challenging areas of photography. A landscape may be photographed from any angle, at any time, and in any weather. But you have to do all the work. Stylistically, you also have decisions to make about how much of your own individual mark you wish to make in your images.

Patience and perseverance

A vital but little-appreciated truth about landscapes is that anywhere can look wonderful at some point in time. A ploughed field, the edge of a forest, or a grand sweeping vista is, photographically, a set of ingredients just waiting for the key elements of light, sky, and your personal vision to come together to concoct a stunning result. You just need to be sure to be there for the occasion. A glorious landscape photograph is seldom the product of a happy accident. While practice can prepare you to be in the right place at the right time, the truly great

▼ Self inclusion

It is fun to include yourself in a view, but there are many ways to do it. Here, the long, late-afternoon shadows suggested a natural way to put ourselves into the shot.

▲ Clarity and tranquillity

Use man-made structures to contrast with topography: these sharply-defined silhouettes provide a foil to the soft clouds and distant hills of New Zealand's Northlands.

images are usually the result of a photographer returning to the same spot again and again, sometimes over a period of years. From time to time they may obtain a successful shot, but they know there will always be a better one – tomorrow, next month, perhaps next year. Over time, these photographers also explore and refine their viewpoint and composition, until, one quiet and perfect moment, everything comes together.

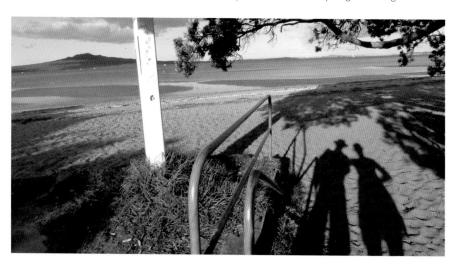

▲ Upstaging

As one's eye is drawn to the monumental landforms – here in Valley of the Gods, USA – it is natural to focus on the distant features. You could use extensive depth of field to keep the foreground in focus too, but a more inventive variation is to focus on the small elements at the front, using a large aperture to blur the giants further away.

Bare necessities

There are therefore three essentials of landscape photography - place, time, and means - but the most crucial of all is place. Once you see a view that is promising, it is best to slow down completely even put your camera away. Then just walk and look, walk a little more and look a little harder. What you are seeking is a manipulation of the relative scale of elements in the scene, with which to create a powerful sense of space within the picture frame. For example, flowers in the foreground appear as tall as mountains in the distance, and pebbles in a river bed are the size of trees further upstream. Your viewers share your experience of the world and the distorting effects of perspective, so they understand the real relative sizes of objects. What they see in your image leads them to reconstruct the spirit of the landscape in their minds, but guided by you. You will find that miniscule changes in position or height can make the difference between a revealing image and one that is unsurprising and ordinary.

▲ Three in one

Tone compression is effective not only for scenes with extremely wide dynamic ranges, but also flatly lit scenes where you wish to extract shadow detail. Combining three different exposures of this subject, in the Welsh Marshes, provided great flexibility over tonal control.

LANDSCAPES CONTINUED

Once you find your position, you may need to wait for the light to add the finishing flourish. This might mean pausing while a cloud makes its way across the sky, or returning again and again until you catch the perfect moment. Light may be raking and dramatic in effect, or flat, bringing out subtleties of tone. On three different days you might obtain three very different images – and all from the same position.

Style and means

A tradition has developed that demands large, high-resolution cameras for "proper" landscape photography. This is an issue of style rather than technique. If you wish to make poster-sized prints and you prize extreme detail, by all means use the highest quality equipment you can afford. However, even a camera phone is perfectly acceptable, if you actively use the imperfections of the capture – such as light fall-off – as features of your images. Furthermore, any lens may be used, from ultra wide-angle through to the longest telephoto.

Working in black and white is another way to individualize your landscapes: the exact way you remove the variety of hues to translate a full-colour facsimile of the view turns any black-and-white image into an artistic interpretation. You might also manipulate the image towards a vintage look, to make it appear to be the product of irregularities of processing. Other ways to build a personal style include consistent use of extremely shallow depth of field, by setting apertures not smaller than f/2, for example. Some photographers use long telephoto lenses, while others exploit motion blur through long exposure. Or you could try over-exposure in flat lighting to obtain pale, bright results.

▼ Unconventional views

In a world saturated with beautiful travelogue-style landscape images, there is a place for the more dispassionate view, one that does not flinch from showing scarring from agriculture or the impact of industry. This image, from the Marche of Italy, was made with a long telephoto zoom to pull far-separated elements onto the same plane.

■ Vintage views

While it always pays to capture the best image you can at the time, the demands of the environment may mean that you have to grab what you can when you can. This image of a snow-line walk in Tajikistan was improved in post-processing by adding a layer of tone and vignetting to suggest it was captured by early processes.

▲ Friendly shadows

Often treated as an enemy, shadows are in fact a landscape photographer's friend: they sculpt shapes, define textures, and delineate distance. Fully lit, this scene lacked depth, but when a cloud darkened the foreground, it was visually separated from the valley sides that were still in sun. A duotone effect (see pp. 162–3) recompresses the tones.

HINTS AND TIPS

All landscape views respond well to being shot as black-and-white or converted from colour. However, default conversions often deliver a lack-lustre result.

- Convert colour using channel mixing or similar controls that allow different tones to be assigned to bands of colour, for example, to make greens lighter, or to darken the blues (see pp. 148–53).
- After conversion, exposure and contrast may need improvement: use tonal controls such as Levels (see pp. 120-1) or Curves (see pp. 144-7) to effect this.
- Try applying unsharp masking (see pp. 126-9): this applies a micro-contrast adjustment to edges, which adds sparkle to an image.

▲ Cold toning

Conversion from colour darkened the blue shadow areas in this snowy scene in Kazakhstan, allowing sunlit areas to define the topography. Changing to Duotone mode, a blue tone was added to enhance the effect – with special care taken to keep the highlights white (see pp. 162–3).

LANDSCAPES CONTINUED

▲ Dawn mist

Landscape photography may seem leisurely, but often you have to act quickly. As I drove out of Auckland airport just after dawn, this mist-shrouded scene presented itself. I knew that it would disappear quickly, so I jumped out of the car and raced back down the road to record it. Just seconds later, the rising sun masked the delicate hues in the sky and the mist evaporated.

► Receding lines

It is unusual to find strong parallels running from side to side in a landscape. Here, in the Cinqueterre, Italy, the eroded strata of the rocks in the foreground inspired a composition that strongly converges to the point of land at the extreme right-hand edge of the picture. A gull helpfully defines the principal Golden Section of the image.

POLARIZING FILTERS

One of the most popular accessories for the landscape photographer is the polarizing filter. This is a neutrally dark filter in a rotating mount. When fixed on the front of a lens, pointing away from the sun, then rotated, it has the effect of making blue skies appear much darker at certain settings compared to others. This is because blue light from a clear sky vibrates in a small range of angles: as you turn the filter it passes some light at most positions but when it reaches the "crossed" position it maximally blocks the light from the sky, making it dark.

Note that maximum darkening may not be a good idea as the sky can appear almost black. The filter can also be used to reduce reflections on glass, leaves, or water. This makes it useful for controlling scenes with a large luminance range, as it reduces the specular shine on smooth surfaces. This filter is best used on an SLR, where you can monitor changes through the viewfinder. The circular type of polarizer should be used with SLRs, but linear polarizing filters may be useable with some cameras, such as compact interchangeable lens cameras (CILs); check your instructions to confirm.

▲ Lowly viewsWith experience, you will find it helpful to work within the framework of a project, rather than searching for any kind of promising landscape. This image was taken with a fish-eye lens as part of a project that views the world as seen by local wildlife - from close to the ground, or partly obscured by foliage, or both.

CITYSCAPES

As most of the world's population lives in cities, it is natural that the city is one of the richest sources of pictures. In any city in the world, whether drab or stunning, medieval or modern, you will find endless potential for photography. Indeed, entire careers in photography have been built on the photogenic qualities of cities as diverse as Prague, New York, Delhi, and Paris. Cityscapes concentrate on the architecture of the built environment and its layout, shapes, and structure. While it does not actively exclude people, cityscape photography largely ignores them, unlike street photography.

Finding inspiration

In choosing an approach, it is instructive to follow in the footsteps of great photographers who have portrayed their beloved cities, such as Alfred Stieglitz of New York, Josek Sudek of Prague, and Eugene Atget of Paris. Their achievement was to show the myriad aspects of their cities without any kind of artifice, and all in black-and-white. In fact, working in black-and-white can simplify your compositions, allowing the viewer to appreciate form, texture, and depth without the distraction of colour.

However, you have important advantages over photographers of the past: you are highly mobile and can work in just about any lighting condition. Exploit the capabilities of your camera and work to capture images not only in bright sunshine, but on rainy days, in the fog, or at night.

Exploration

You can go further than the masters of the past: use colour in an abstract way, capture the surprisingly deep and rich colours of the city at night, or zoom into the distance to find magnified views that are not visible to the naked eye.

The city is a rich source of reflections and unintended juxtapositions – of shapes, colours, and signs. Just as a landscape can be seen in overview as well as in detail, you will find cities yield different layers of meaning and possibility with each change of scale. You could also choose one prominent landmark and investigate the way it can be seen from different places all over the city.

▲ London Eye

Capturing the colours of city lights at night is less of a challenge than it used to be. This shot was taken from London's giant ferris wheel at the top of its trajectory, using a high ISO and underexposing by 1.5 stops.

BUILDING RIGHTS

In the majority of cities you can photograph buildings freely. But exercise caution if any that are in view are flying a national flag or appear to be military in character. In some countries photography of bridges, airports, police stations, armed forces barracks, and government buildings is illegal. Beware that commercial use of images featuring certain iconic buildings such as the Rockefeller Center, the Flatiron Building (New York), the Eiffel Tower, the Louvre, and the Pei Pyramid (Paris) may be subject to legal processes by various rights holders. Restrictions may also apply to commercial use of images that show works of art, such as installations or sculptures.

▲ Contrasts and conflicts

Using a long-focal-length lens brings relatively distant objects together, emphasizing their differences – old apartments in Paris and the tower block appear to be right next to each other, but are in fact hundreds of metres apart. Frame from as far away as possible, using a zoom to adjust image size and composition.

▲ City skies

The skyline of a city is defined as much by the sky above – the so-called "negative space" – as by the outlines of the buildings themselves. And if we are given a gloriously fluffy-clouded sunset, so much the better. This view of Singapore needs to give emphasis to the sky as the "hero" of the shot with the skyline taking a secondary role, so it can be allowed to go into deep tones.

▼ Working with the enemy

Cars rarely contribute to city scenes in a positive way, yet they are perennially present, and are therefore a common problem for photographers. Try to use them to your advantage, for example by making a feature of the red lights of a traffic queue at night, or by looking for interesting reflections in their windscreens, and so on.

CITYSCAPES CONTINUED

▲ Working around a subject

A simple exercise is to take an obvious landmark and then shoot as varied a set of views of it as possible. These images of the Sky Tower in Auckland, New Zealand, were all taken as I went about my business in that city. This shot, taken from a car, was very nearly missed – it is of such an ordinary scene, yet there is a rhythm in the multiple framing, a sense of a hidden story. In addition, its crisp colours make it a surprisingly rich picture. The passenger seat of a car makes a wonderful moving platform from which to work.

▶ Supplementary flash

Noticing these flowers first, I went over to photograph them only to find the tower unexpectedly in view. The flash on the camera illuminated the foreground flowers but not those a little further away. The shadow visible on the bottom edge of the image was caused by the lens obstructing the light from the flash.

▲ Silhouette lighting

The silhouettes of a variety of trees serve to frame the sleek, industrial lines of the distant tower. As the trees are represented by shape alone, they look very sharp – although depth of field in such views appears extensive, it is, in reality, an illusion of perception.

■ Converging lines

Generally you would want to avoid pointing the camera steeply upwards at buildings, as the strong convergence of normally parallel lines causes distortion. However, this can be exploited to create the sense of disorientation or of being loomed over. Its effectiveness is increased in this view by avoiding any alignment between the picture frame and the sides of any buildings.

■ Distant view

The Sky Tower is visible even an hour's ride away by hydrofoil. A strong telephoto perspective – produced by the 35efl of a 560 mm lens – leaps over the distance and appears to compress the space between the intervening islands. The haze has desaturated colours to give a nearly neutral grey.

LOW-LIGHT PHOTOGRAPHY

Taking photographs in low light used to involve extra lighting, the use of ultra-large aperture lenses, or inevitable loss of image quality – or all of these things. No longer. The sensitivity of sensors has improved to the point that images can be captured by the light of the moon. The result is an extension of the world of available light photography. Simply set a high ISO setting, for example, ISO 1600 or greater, and a large aperture: you are then ready to concentrate on artistic issues, rather than struggle with technical limitations. If your camera produces noisy images at high ISO settings, you can deal with the problem in post-processing (see pp. 124–5).

Perception shift

The most thrilling aspect of low-light photography is that the camera sensor is not subject to the same limitations as the human eye when perceiving colour in low light. In brief, sensors see almost as much colour in low light as they do in bright light (there is a slight reduction due to increase in noise). This means that scenes that appear lacking in colour, or where lights appear white, will record with much more colour than you can see. This is particularly true of the evening sky: what appears grey to our eyes can be recorded as brilliant dark blues, while colourless city lights can be recorded as yellows, reds, or even greens. With a little experience, you will learn how to exploit these differences between our own visual experience of low light and the images that can be captured on camera.

Staying in the dark

One aspect of low light photography that poses problems for many photographers is how to allow dark subjects to stay dark. In general, you are aiming for low-key images (see pp. 38–9), that is, images in which the key tones are darker than mid-tones. The key tone should convey the sense of low light, while important details are distinguished and, at the same time, coloured lights are not over-exposed. This means that you over-ride auto-exposure to -1 to -2 stops, in other words, you set the exposure as under-exposed to the usual meter reading from -1 stop to -2 stops, or even more.

Remember to set any automatic flash to remain off. If the flash is effective at all, it is effective in destroying the character of the lighting. And at distances greater than about 3 m (10 ft), built-in flash has no effect whatsoever on the scene.

■ Twilight zone

The half-light between the day and the onset of full night-time darkness is a truly magical time as you can easily balance foreground and sky light. At the same time, colours seem much more intense than at any other time, with the sensors capturing all the perceived brilliance. Under-expose by at least 1 stop to obtain rich colours.

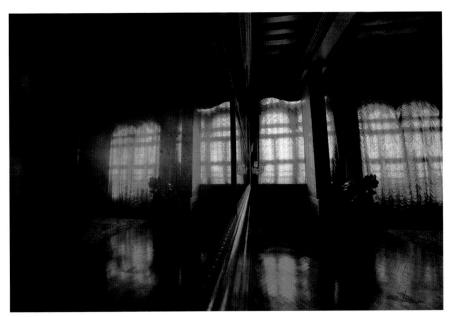

▲ Noisy interior

Even when there is dazzling sunshine outside, the interiors of buildings can be very dark – as was the case here in the hall of The Casino, Venice. Tripods were not permitted, so I pressed the camera against the mirror to keep it steady during the exposure, which I set at 1 stop less than metered. As noise is greatest in dark shadow areas and this image is almost all dark shadow, noise levels were judged to need

post-processing. For normal purposes, noise reduction filters in standard software such as Adobe Lightroom, Apple Aperture, and Adobe Photoshop produce acceptable results. For high and obtrusive levels of noise, use specialist software such as Topaz Denoise or Noise Ninja.

▲ Night blindness

To the eye, this scene appeared to be hopelessly dark, relieved only by the bright points of the city lights, and the pale blue glow of the pool's underwater illumination. Exposed at -1.3 stop to the metered reading, the image revealed blues and purples in the distant hills and the city. The image also made the light in the trees, which came from distant street lamps, more easily visible.

▲ Black as night

When there is very little light in the sky, any attempt to capture it will result in over-exposure of lights on the ground. In this image of Pisa and the River Arno, the main concern is to expose the street lamps correctly: the better-lit buildings are over-exposed and the sky is featureless. But what we really want is the lovely reflection in the river.

ANIMALS

When photographing a much-loved pet, it is easy to let your feelings influence the creation of the image. A more detached approach – in which you aim for visual interest in addition to the aesthetic qualities of the animal – is sure to result in more successful images, with appeal that extends beyond immediate family. Look for interesting compositions by focusing not only on the face; wait for moments of elegant gesture or expressive action.

Unusual approaches

You can broaden the scope of your images by including the relationships between people and their pets, or the contrasts between human and animal behaviour. The challenge lies in finding original or illuminating approaches to the subject. One controversial technique is to use unusual props, or even clothes - take a look at the work of the artist William Wegman, who achieved worldwide acclaim for his portraits of Weimaraner dogs. Or you could experiment with abstract images. The isolated details of just about any animal can be rendered with beautiful results, for example using dramatic lighting to highlight sculptural detail on the body of a horse. Consider shooting in black and white (with or without tinting) or sepia instead of full colour. Basic manipulations such as cross-processing (see pp. 164-5) can lift animal portraits out of the ordinary.

▶ All shapes

All kinds of animals are kept as pets. Pursuing the idea that owners look like the animals they adore, you could track down people who keep different kinds of animals, and photograph animal and owner together. This image of a golden eagle with his falconer in Kyrgyzstan provides a rich testament to relationships between man and animal.

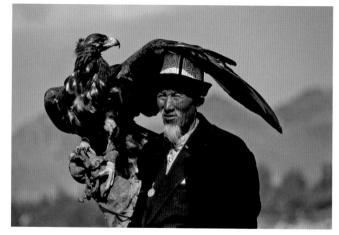

Quick reflexes

A cold, windswept beach makes an unusual setting for pet photography, but it also presents many opportunities. For a split second a picture may present itself - you need to stay alert to record it. Here, the dogs not only appear to blend with the tones of the beach, they also seem to be responding to the contours of the landscape. The original colour image was converted to black and white, then tints were added to hint at the natural colours.

▼ Laying low

This puppy makes a wonderful subject, but you can raise the bar by looking for an angle that is unusual, yet natural and intimate. As with people, work with your subject to gain their trust so you can catch them looking happy and relaxed.

PROFESSIONAL SERVICE

Proud pet owners seeking professional portraits of their animals can provide a good source of work for a photographer. Although potentially unpredictable, pets can also be most rewarding subjects, and the immediacy of digital photography means that you should easily be able to make a varied range of images for your clients to choose from. You can display the images straight away on a monitor, or even simply on the camera's preview screen – this spontaneity can be a great asset, especially if the owners have seen you capturing their pets' charming antics. It also saves time and enables you to fulfill the order with the bare minimum of delays.

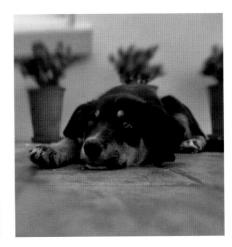

ANIMALS CONTINUED

Know your subject

Animals can be notoriously tricky subjects. They do not respect your wishes – in fact, it often seems that they know precisely what you do not want them to do, and then do it. In these circumstances, knowledge of the animal's behaviour can be as important as photographic skill.

Having an appropriate lens for the kind of image you want to make will also save you a great deal of time and trouble. Normal to medium-long focal lengths are the most useful for portraits, and wide-angle lenses are good for shooting in aquaria, and for scene-setting shots. The smaller the animal, the longer the focal length needed to fill the frame. Very long focal length lenses are best for following highly mobile animals, as you only need to pan the lens a little to follow them as they move about. Animals with very long heads such as horses are also much easier to photograph from a distance: set a medium-small aperture to ensure depth of field covers the whole length of the head.

Animals in captivity

Modern zoos in major cities are taking on the role as centres for the study and preservation of wildlife; they are often models of animal care. You can see well-fed animals in something that resembles their natural habitat, and for many people, zoos offer the only chance to get up close to wild or exotic animals. Of course, this offers many opportunities for photographing animals you would not normally come into contact with.

Zoos are ideal places to practise elements of wildlife photography before venturing into the field. You will learn that if you set up at the right place at the right time, your wait for the right shot can be greatly shortened – and from this you learn the importance of knowing your animal and its habits. Try to pick a time for your visit when the zoo will not be too busy, for example midweek mornings. It may be possible to gain privileged access to some of the animals by approaching the relevant keepers or the zoo director, and offering free photographs for use in the zoo's publicity material or on its website.

▶ The right moment

When taking pictures of animals in zoos, you can take your time to wait for a perfect expression or composition – family groups are especially interesting to watch. Keep shooting and pick the best shots later: try not to review your images while on location because you are bound to miss something.

It is thrilling to be close to a normally elusive animal, such as this giant otter. Even if you know it is tame, it is wise to keep your distance: use the long end of a zoom with a high ISO setting to enable you to set a combination of relatively small aperture and short exposure time.

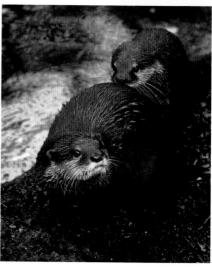

◀ In their element

In modern zoos it is possible to photograph animals in their element, such as a polar bear underwater, which only a very few specialists ever see in the wild. Make full use of the unusual level of access provided by the artificial environment.

PANORAMAS

A panorama is an image that encompasses more of a scene than you could see at the time without having to turn your head from one side to the other. In fact, to obtain a true panoramic view, the camera's lens itself must scan the view from one side to the other.

Visual clues

The give-away visual clue to a panorama is that there is necessarily some distortion – if the panorama is taken with the camera pointing slightly upwards or downwards, then the horizon, or any other horizontal line, appears curved. If the camera is held parallel to the ground, any objects near the camera – usually those at the middle of the image – will appear significantly larger than any objects that are further away from the camera.

▼ Landscape view

The landscape is the natural subject area for the panorama, and it also presents the fewest technical problems. In addition, it can transform a dull day's photography into a breathtaking expanse of quiet tones and subtle shifts of colour. Here, a still day in Scotland creates a mirror-like expanse of water to reflect the fringing mountain, thus adding interest to an otherwise blank part of the scene. This image consists of six overlapping shots, and it was created using Photoshop Elements.

Digital options

In recent times, the concept of panoramas has been broadened (confusingly) to include wide-angle shots that have had their top and bottom portions trimmed or cropped into a letterbox shape. As a result, the images have a very long aspect ratio – that is, the width is much greater than the height of the image. These pseudo-panoramas are popular because they do not suffer the curvature of horizon or exaggerated distortion of image scale of true panoramas. They can be created simply by cropping any wide-angle image.

True panoramas are almost as easy to create. For best quality, set the camera on a panoramic head on a tripod, ensure the camera is pointed horizontally, and adjust for the lens in use. (Handheld capture can also give acceptable results.) Next, capture a number of overlapping images of the scene from side to side or from top to bottom. Once you are back at your computer, stitch or join all these individual views together using readily available software (see 190–1). Many cameras offer a panorama mode, which stitches images in camera: you turn on the mode, then swing the camera steadily across the scene as it takes either a single exposure or several, depending on the technology used.

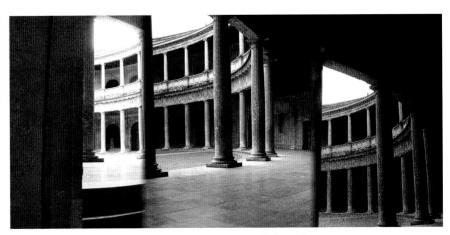

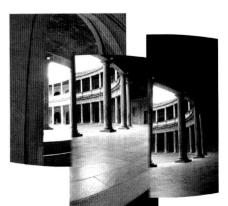

▲ Unlikely subjects

You can experiment with component images (*left*) that deliberately do not match, in order to create a view of a scene with a contradicting or puzzling perspective. The software may produce results you could not predict (*above*), since it is designed to make the best matches of subject detail on either side of the join. You can crop the result to form a normal panoramic shape or leave it with an irregular shape. While the final picture is by no means an accurate record of the building, in Granada, Spain, it may give the viewer more of the sense of the architecture – of the never-ending curves and columns.

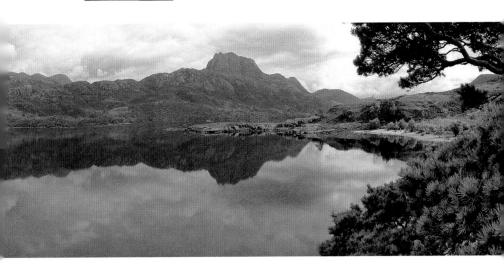

LIVE EVENTS

Photographing live events such as parades, street parties, or concerts presents many challenges: fast-moving subjects, unpredictable lighting, and action that may be over in seconds. This is also true of weddings, family gatherings, or school sports days. Fortunately, with today's marvellous cameras, you do not need to worry too much about camera settings: "sports" mode should cover most of your needs. However, if you want more control, set a medium ISO of around 400 in good lighting. Using SLR and mirrorless cameras, you can set ISO 8000 or more indoors, with shutter priority and an exposure time of ½50 sec or shorter.

Right place, right time

The most important question here has little to do with equipment: where exactly should you stand to be sure to get the shots you want? The answer relies on one part instinct, one part planning, and a big dose of luck.

Instinct is what might prompt you to walk that bit further than you intended, or to look around a corner. It is what tells you to wait a little longer to capture an unexpected moment. The vital element to improving your photography at events is taking the time to go this extra distance.

Combine your instinct with careful planning, and luck will favour you. Once you have explored the location thoroughly, choose the best vantage points, and have your camera ready at all times. Then, when the bride turns around unexpectedly to flash a gorgeous smile, for example, you have your picture, not only because you were lucky but also because you were prepared.

Golden rules

Begin covering the event before it starts: images of preparations, such as set-building or make-up artists at work, produce a well-balanced view. During the height of the event, keep the camera switched on and close to your face, or hold it at arm's length above your head to shoot over the crowd. You need to be quick, so do not record at the highest resolution or in RAW format if this slows down your camera's operations.

STAYING SAFE

There are no medals for bravery in photography. Do not put yourself or others at risk in pursuit of your photograph. Ask for advice from the staff in attendance, obey all safety notices, and wear appropriate and high-visibility clothing. Have your identification pass easily visible to avoid being asked to prove identity at inconvenient times. When photographing high-speed vehicles, do not shoot from corners unless there is adequate protection. Keep your wits about you at all times, and pay attention to your surroundings, as well as to the viewfinder.

■ All aspects, great and small

Use the full capabilities of your equipment to cover the different aspects of live events – the main event, the supporting activities, and the action on the periphery. Use wide-angle settings and get into the thick of things whenever possible. Use normal or wide-angle settings when shooting people to ensure a good level of involvement. Look out for colourful details, such as souvenirs and merchandising (above).

The reputations of live events lie not only in the central attractions but also in their environments. A full account of an event records its context – whether it is a theatre festival in a Greek amphitheatre, a car rally in the desert; or, as here, at Glastonbury, in England, where the music festival famously turns into a sea of mud when it rains, as it usually does.

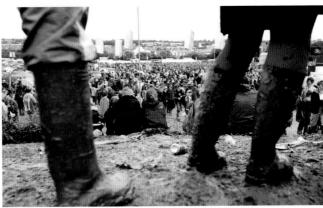

LIVE EVENTS CONTINUED

Sports coverage

While many professional sports events are now inaccessible to amateurs, there is still a vast number of other sporting events open to photography. Outdoor events such as marathons and triathlons often welcome photographers, as do sailing events and gymkhanas. It is worth hiring a long lens such as 300 mm or even 400 mm, used with a monopod or tripod to enable you to "reach" right into the action. Amateur sportsmen like to have good images of their exertions, so you might find a ready market for your work.

When using a zoom lens, choose a loose, wide setting for the event, and avoid changing it while framing shots, since this slows you down. Don't check the image preview during action: wait for a break before reviewing your shots. Remember: the event is not over until you are off-site. Even when the action is over, you can shoot the clean-up, the exhausted players, and more.

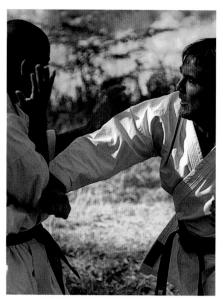

▲ Sharpness and blur

It takes the reflexes of a martial artist to photograph sports well, and the better you know a sport, the greater your chance of catching the moment of truth. But remember that

HINTS AND TIPS

The essence of the sports photograph lies in choosing the right moment to press the shutter. A split second can represent the moment one tennis ace turns the tables on another, or one misjudged tack separates the winner of a sailing regatta from the also-rans. The strategy for sports photography is, therefore, constant vigilance to ensure you are at the right place at the right time.

- Allow for shutter lag: The time interval between pressing the shutter and actually capturing the image is usually at least 1/10 sec, but can be as long as 1/2 sec, depending on your camera.
- Use balanced flash: For best results when using flash to capture movement, balance the flash exposure with daylight. Take care not to endanger competitors by setting off your flash in their eyes from close by.
- Position yourself carefully: Try to view the event from a point at which you not only have a good view of the action, but also from where your target is not moving impossibly swiftly.
- Know your sport: Use this knowledge in your photography. As a race track becomes worn down, for example, do the riders take a slightly different route around it? As the sun moves across the sky, do the players pass the ball from a different direction to avoid the glare? In dry conditions, do rally drivers take a corner faster than in the wet?

sports are about movement, so sometimes it is appropriate to use long exposures to capture action as a blur – this is certainly true of fast-moving full-contact sparring.

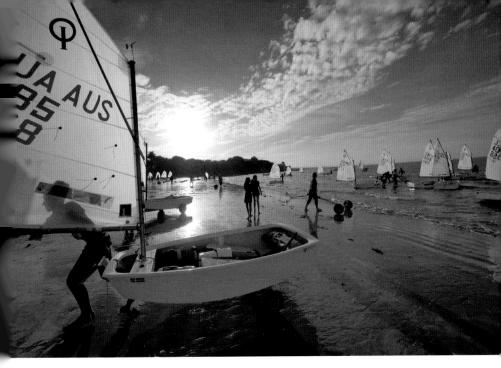

Where you want to photograph a lot of activity concentrated into a short period of time, the best chance of covering it all is to work with two cameras. Use your compact point-and-shoot in addition to your SLR, or supplement your compact with a camera phone. The cameras can be set at different focal lengths – one to capture wide-angle views (top), the other to zoom in on the action (above). And if one slows down, you can give it a rest and use the other.

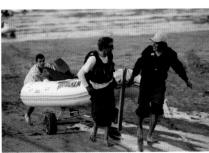

THE ART OF PASSES

Many public events around the world are tightly controlled, both for security and to limit recordings and photography of the event. From school sports days to concerts with top artists, you may need to obtain a pass before taking pictures. Apply to the organizers for permission, explain your interest, and give them a reason why they should welcome you. With commercial events, you may have to sign a contract limiting the use you make of photographs. But before you sign away your rights, remember: you never know what might happen to make your photography extremely valuable to you.

PORTRAITS

The possibility of easily making life-like representations of family and friends was what most excited everyone about the invention of photography, and portraiture remains the most cited reason for making photographs today. With changes in society, a portrait now means any image that shows an aspect of a person's personality. This means the face may not even be visible or clear. In short, stylistically, there are no limits.

Anything goes

It is a very exciting time to take up portraiture: while you cannot rest on formulaic solutions, you are also no longer limited by them. In fact, anything goes. Faces can be hidden in the dark with only a sliver of hair visible, or distorted by blur from movement or lack of focus. You can photograph from behind, above, or below; you can have your subject pose naturally or with exaggerated artifice; and props, clothes, and makeup offer endless possibilities.

Relationship matters

Central to portraiture is your relationship with the sitter. How well you know them, and how much they trust you, may dictate the kinds of poses and expressions your sitter can give you. Even with paid

models, a session will go more smoothly once they understand what you are trying to achieve and are able to work with you on it.

A great variety of portraits is possible when photographing a willing sitter. Once you have covered the basic, straight-on shots, it is time to explore other approaches. Have fun, be inventive and, above all, work at a creative partnership with your partner. The following tips will help you get the best results from your portrait session:

- Agree with your sitter the kind of image you wish to create, or that they wish to see.
- Review the first few shots with the sitter to show them what you are trying to achieve.
- After the first shots, do not show the model any images until the end of the session unless you wish to try some other pose or effect. Constant reviewing interrupts the flow of photography.

Technical pointers

We humans retain extremely clear ideas about the normal range of facial features: departures from the norm are obvious. As a result, it is best to avoid approaching within touching distance of your subject when using short focal length lenses or a zoom set to the short end of the range, unless you

◀ At work

To photograph someone at work, it is best to let them do what they normally do: if they move quickly, watch out for moments of quiet, or learn when it is safe to ask them to hold a position. Use all local props such as tools, desks, and computers. In this shot, the light from a laptop perfectly balances the dim evening light in rural Guyana.

BOKEH

In portraiture more than in any other genre of photography, the quality of the blur in the out-of-focus parts of the image - the bokeh - is vital to the picture's success. Whether you expose with maximum depth of field or not, it is usual for the majority of the image to be rendered blurred. If the lens creates blurs that do not blend smoothly with each other, but instead create distinct disc-shaped blobs of colour, the result is very distracting. Good bokeh produces a fuzzy or feathered blur, even at high-contrast junctions. At full aperture, virtually the entire image is composed of blur, so if you intend to use a portrait lens at full aperture it is vital that its bokeh is good, and that is usually a product of top-class design and construction - in other words, an expensive lens.

Less than half the face is visible here, the eyes can't be seen, and the hair is obscured. Yet the strong character and beauty of the subject is apparent. That is thanks to the inclusion of the accessories: the smart hat, fashionista shades, and expensive clothes. An image may break the rules yet still deliver an effective portrait.

▲ Transitional mystery

Portraits are most interesting when they do not tell the whole story, and when they raise more questions than they answer. In this image, the contrasts between the refined clothing and the prosaic background, the strong shadow, and the cool colour tones all intrigue, yet the whole is visually appealing.

▲ Editorial accuracy

Newspaper and magazine markets are the hungriest for good portraits. There is a constant demand for images that depict personalities in an attractive but accurate way in an atmosphere or context that is appropriate to the feature article or interview. Here the out-of-focus highlights frame the profile effectively and sympathetically.

PORTRAITS CONTINUED

intend to distort your subject comically. On the other hand, being able to get so close to someone suggests trust and intimacy, so that can be a useful signifier to exploit.

It is hard to go wrong if you focus on the eye nearest the camera, particularly if you are using a large aperture (f/2 or greater). This forces attention on the all-important eye, while painting the rest of the scene with broad, blurred brush strokes. If your camera uses multiple focusing points, it is easiest if you set it to use the focusing point over or nearest to the eye. It always helps to ensure there are no highlights or specular reflections in the background, unless it is an important part of the scene – a desk lamp or the setting sun, for instance.

Environmental impact

By making portraits outside the studio, you can take full advantage of your sitter's environment – their living or working space – as part of the observation about the person. Remember that the size of the person in the image relative to the space shown is intuitively proportionate to the importance of the context to the person's life. For example, if you make someone appear small in their work space

you are commenting on their relative power in that context: you could have shown them dominant in the same space. The environment and person reciprocally contribute significance to a portrait. The following points are also worth bearing in mind:

- Locating the sitter in the centre of the image signifies that they truly are intended to be the centre of attention, even if they are small in relation to the background.
- Locating the sitter to one side suggests that atmosphere, mood, or the environment is just as important as the person, particularly if they are small relative to the background.
- If you are working in colour, pay particular attention to colours of objects in the background: they can contribute information and visual interest, or they can tear the image apart. Intense, hot colours are distracting, as are bright highlights and shiny objects with strong, geometrical shapes. Movement blur in the background is also distracting.
- Compositional techniques such as converging lines and framing devices, such as doorways or tree branches, help direct attention to your sitter.
- Shallow depth of field with a varied background works well to bring the sitter forward visually.

◆ Team work

Group photographs may concentrate on the team, in which everyone is equally important: the photograph is really about the team as a whole and is best composed as such. Or groups may be made up of individuals: it is part of accuracy in visual language that the composition reflects the dynamics of the group of people. Here, each person is shown relaxing in different ways, paying varying levels of attention to the photographer, all held by the receding lines and repeated chairs.

▲ Grace under fire

Even when exhausted from hard training in stifling hot conditions, this dancer holds herself with peerless elegance, surrounded by the paraphernalia of her studio. Greens, browns, and pinks in the scene were too distracting, but

rendered in black-and-white, we can concentrate on the dancer who is framed by the geometric shapes around her. Unfortunately, the light behind her head is too bright to be welcome, but this can be easily removed digitally.

▲ Handyman

While the face is the most emotional and evocative part of the body, telling much of the story, it does not tell the whole story. Hands, feet, hair and arms can all contribute. In the case of working hands, they may be able to tell the story by themselves. You usually have to work in low light, so prepare your settings – high ISO and large aperture for short exposure time – then approach closely and observe.

▲ Keep it simple

For many purposes, such as small business websites, pamphlets, and picture albums, the straight-forward posed shot remains the best option. A smile and an example of the product in the context of the business is the kind of image that is equal to a thousand words. Shoot such images in flat lighting, with centred composition with a normal or moderately wide-angle lens.

CAMERA PHONE PHOTOGRAPHY

Project compilation

As image quality is more than acceptable in many camera phones, there is no reason not to use them for photography projects. They are especially useful for ongoing projects, where you need to keep a camera with you at all times, such as capturing a variety of weather conditions, collecting interesting cloud formations, or cataloguing landforms. If you need to make wide-angle views, you can take overlapping shots that you then stitch together as if making a panorama (see pp. 190-1).

The cameras built into modern mobile or cell-phones comfortably surpass the quality and capability of early digital cameras. By combining utmost convenience – you always have a camera with you because you always carry your phone with you – with fair- to good-quality imaging, camera phones have become the most widely used type of camera. It is worth noting that the companies making the most cameras (by a very large margin) are, in fact, in the business of making phones.

Bare necessities

One of the main attractions of camera phone photography is that you are forced back to the very basics: with minimal controls, you have no choice but to concentrate simply on picture-making. Some camera phones allow digital zooming, some offer touch-screen choice of focus point and exposure, and many allow images to be shot in various modes such as vintage (usually sepia), or with filter effects applied, either after normal capture or as part of image processing (see pp. 156–7). But simplicity is the overriding virtue.

Bare technique

For all its simplicity, you can help your camera phone to produce superior results. The Achilles heel of the camera is the tiny lens: as it is so small, even the smallest smudge or smear will reduce the quality of the image. Use a micro-fibre cloth to keep the lens scrupulously clean.

- Hold the phone steadily during exposure: squeeze or tap gently for the shot.
- Give the sensor plenty of light to work with: low light produces noisy images.
- Give the camera time to focus: camera phones cannot focus as quickly as larger cameras.
- Use features that give more accurate focus or exposure control; for example, on touch-screen camera phones such as the iPhone, touching on the image shifts the focus and exposure determination to that part of the scene.
- The flash on camera phones is very weak and is effective only to about 2 m (6 ft). Turn it off for more distant objects.

▲ Visual notebook

Camera phones are the ultimate visual notebook: you can use them to snap images of captions in exhibitions, make visual notes of items of furniture or objects for interior design, or to help document a house-hunt. The ability to

attach GPS and other data to images increases their value for documentation. And, despite everyone being familiar with phones being used as cameras, a camera phone attracts much less attention than even a compact camera.

▲ App effects

There are a number of applications available that allow you to apply effects to your camera phone images. Some, such as Instagram, apply the effect to a normally captured image. Others, such as Hipstamatic, apply the effects as part of the capture process. This commits you to the effect and is a challenging and refreshing way to work.

DIGITAL HUB

The modern mobile phone is also a camera that can make calls and connect to the world. Images captured on a camera phone are easy to send around the world to social-network sites such as Facebook to be viewed by friends, uploaded to picture-sharing sites such as Instagram or Flickr, or attached to an email or text message.

- Ensure the orientation of your images is correct for its intended use before sending them out.
- Resize the images to no larger than 640 pixels on the longer side for quick transmission (if that option is available).
- If you are not in your home country, sending images can be expensive. Check with your service provider to ensure that you do not exceed your data limit.

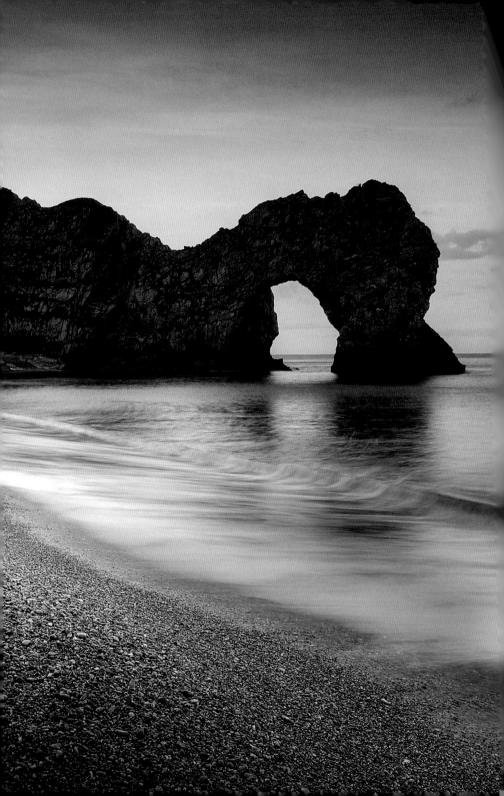

WORKFLOW ESSENTIALS

Digital workflow is similar to processing black-and-white film in that there are efficient ways and less efficient ways of working. And just like film processing, an error can reduce the quality of your images, or even ruin them. The big difference is in the numbers of images you can work with: now you could have thousands of images after only a wedding. It is important to avoid having to spend hours in front of the computer wading through them. A little time planning a workflow will save days over the course of a year.

Horses for courses

It makes sense to match the flow of images to suit the project. If you shoot for yourself, a scheme that fine-tunes one image at a time is fine: this is how it was done in the early days of digital photography. One simple scheme is to set up your camera so that you can use the images immediately – on photo-sharing and social networking sites, or for printing out – without any post-processing. This workflow is almost effortless and all that is needed for many users. It is only when you want higher quality and more control that the extra effort is justified.

Soft options

One of the key decisions you need to make is whether to use the same software application – such as Google Picasa, Adobe Photoshop or Lightroom, ACDSee, or Apple Aperture – to manage and correct your images throughout. Lightroom, ACDSee, and Aperture treat all images non-destructively, operating only on proxy files. Alternatively you can use a different software package for each task – for example, Photo Mechanic for managing files, then Adobe Photoshop Elements for manipulation. Match the type of software and its cost with your needs.

Basic steps

The principle of workflow is to minimize time at the computer by never duplicating work unnecessarily and ensuring that at any time in the future, it will be easy to find an image. At the time you upload your

images is when all the details of the shoot are fresh in your mind and you know where, when, how, and why you made the images. This is when crucial tagging data and notes should be appended to the image. Following the sequence below will give you an efficient and time-saving workflow:

- Ingest: on your computer, create a new folder named by subject, date, or location, and upload your images into this. Add metadata such as subject, date, location, and copyright to each image. If necessary, you can rename the images with sequential numbering. Finally, you should back-up the images to a secondary disk.
- Inspect: check the technical quality of a sample of your images. Ensure that they are sharp, well-exposed, and have accurate white balance. If your camera does not turn images that you have shot in portrait format to the upright orientation, you

▲ Plain sailing

In the early stages of editing images, you may have wildly differing images to choose from. Leave the final selection until you have become very familiar with the shoot. Making tonal and colour adjustments is easiest with proxy-working software such as Lightroom, Aperture, and ACDSee.

should do that now. If any of the images appear corrupted, upload them again.

- **Evaluate:** locate the first choices, second choices, and reject images, and apply ratings to rank them.
- Apply metadata: write information-rich captions. Make sure that you add identifying tags and other descriptive keywords.
- Set up: create a new folder for work in progress. Save images with new filenames if you are making changes to the original files. Use a storage device different from that holding the original image. Straighten, crop, or re-size images as required.
- Enhance: normalize the blacks and highlights with exposure and curve correction.
- **Soft proof:** check how the image will look when outputted by reviewing proof colours. Adjust the image settings as required.
- Clean up: remove any flaws such as dust spots.

- Final effects: apply any drastic changes, such as conversion to black and white or sepia. Leave noise reduction to this step; apply sharpening, if required.
- **Prepare:** if you used layers, use Save As to keep the layered image in case you wish to modify the corrections you applied. Prior to export, flatten the image, re-size it, and save it in the required format.
- **Use:** export directly to the target destination; for example, from Lightroom straight into your Facebook page. If you cannot export directly, create a transit folder for exports.
- Archive and tidy up: Make back-up copies of new files on hard-disks. If you have created any folders for temporary files or files for download, remove them from your main machine. Doublecheck that you have two copies of images from your memory cards, then reformat the cards in your camera so they are empty and ready to use.

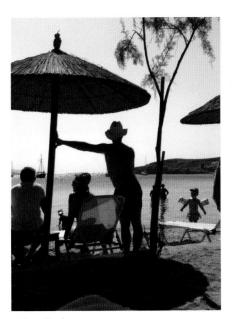

▲ Drastic changes

Substantial image changes, such as layering a sunset with a mid-afternoon scene, should be made on a copy of the original file. Work at full resolution even if you need only a small final image: perhaps one day someone will want to use the image large, having seen it on your website.

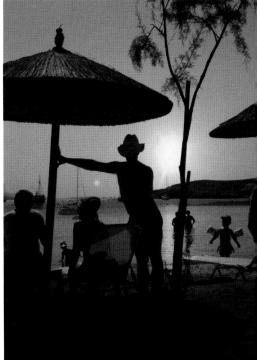

DOWNLOADING

Like it or not, the centre of your photographic work is the computer. It is crucial to download images captured on your camera to hard-disks under the control of the computer, as you can then back-up and work on the images. Then, when images are ready to be used, you will upload them from your computer to picture sites or into emails.

Computer by-pass

However, there are ways to avoid using the computer. You can download images from a memory card directly to a portable storage device that combines a hard-disk drive with a card reader. Also, you can send images from camera phones directly to social networking sites. Cameras equipped with WI-FI can connect to the internet and upload images to distributed networks - this is popularly known as Cloud computing. Having logged-on to your cloud account using, for example, Google Docs, Dropbox, or Box.net you can upload your images to the storage space in your account. Sooner or later. however, the images will need to pass through your computer. One reason for this is security: your digital images are safe as long as you keep copies in different places at the same time.

Quick download

The fastest way to download images is to remove your camera's memory card and use a card reader connected to your computer via USB 3.0, Firewire 800, or Thunderbolt – whichever is your fastest connector. You can connect your camera directly but if you have multiple cards, it saves wear and tear on the camera to use a dedicated card reader.

The key to keeping your images safe is to download the pictures – as soon as possible – to your computer's hard-drive or a mounted drive, leaving the images on the memory card. When you can, copy the images to another hard-disk, or DVD or Blu-Ray disc; then they will be in three different places and pretty safe from loss. If you are working wirelessly and subscribe to services such as Apple iCloud or Adobe Carousel, then upload to these services. Only when you are sure your images are backed-up should you re-format the memory card.

▲ Bit error

Errors in the memory card or occurring during download cause a break in the sequence of data, so part of the image looks fine but the rest is corrupted. Download it again to isolate the error: if it recurs, the memory card is at fault.

▲ Incomplete scan

If data recording or downloading was interrupted for some reason, this results in a blank area. The preview may be visible but the full file may not open at all. The memory card may be faulty or the download might need repeating.

Auto correction

Images may be corrected automatically by the camera when they are saved or downloaded. If there was a serious error at the time of capture, the image may appear but be seriously degraded, but the file itself is not faulty.

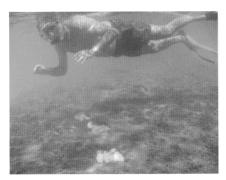

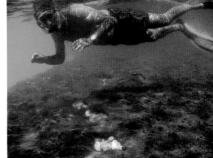

▲ Choosing colour mode

An image's colour mode is crucial to the success and quality of manipulation. RGB is useful for most image enhancements, but it is not the only mode. LAB is less intuitive to understand, but it is most flexible and versatile when preserving colour data to maintain image quality is a high priority. Here, the initial RGB capture underwater (above) was low in contrast and carried an overall green cast. If left in RGB, Auto Levels correction gives it a bright, colourful, but not accurate result (above right). In LAB mode, Auto Levels correction produces true-to-life colours with accurate tonality (right).

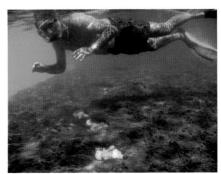

CHECKING THE IMAGE

- Check the colour mode and bit depth. Files from scanners may be saved as LAB files. Most image-manipulation software works in 24-bit RGB colour, and if the image is not in the correct mode, many adjustments are unavailable or give odd results.
- Check that the image is clean that there are no dust spots or, if a scan, scratches or other marks. Increasing the contrast of the image and making it darker usually helps to reveal faint dust spots.
- Ensure that the image has not had too much noise or grain removed.
- Assess the image sharpness. If the image has been overly sharpened, further manipulation may cause visible edge artefacts.
- Is the exposure of your pictures accurate? If not, corrections may cause posterization or stepped tonal changes.

- Is the white balance accurate? If the file is not in RAW format, corrections may cause inaccurate colours and tones.
- Are the colours clear and accurate? If not, corrections may cause posterization, stepped tonal changes, or less accurate hues.
- Check that there is no excess border to the image. It may upset calculations for Auto Levels or other corrections.
- Check the file size. It should be adequate for your purposes but not much larger. If it is too small, you could work on it for hours only to find it is not suitable for the output size desired. If it is too large, you will waste time as all manipulations take longer than necessary.
- Check the colour profile for the image: for general purposes, use sRGB; for demanding uses, set Adobe RGB (1998).

IMAGE MANAGEMENT

Whether you are a casual, amateur, or professional photographer, your photographs represent a considerable investment. It is not just the cost of the camera and the computer equipment, but also the time spent learning how to use the equipment and software, not forgetting the time spent on chasing photos. And, no false modesty here, there is also the valuable input of your artistry and skill.

There are two sides to managing your photographic assets. One is ensuring that you do not lose any, and that they last forever. The other is to make them easily available – at least to yourself and, at best, to anyone who wishes to use them.

Safety in numbers

In the current state of technology, no digital medium can match film-based images for archival safety – the ability to survive unchanged and easily used for more than a hundred years. Those who would like their legacy to stretch into the next century or two may be best advised to return to shooting on film. For the more modest, the best strategy is to keep digital image files in multiple storage systems and in multiple places. For small numbers of images, use DVD or Blu-Ray disks to archive your images, even though these are slow to write and access. Hard-disk systems are much better for working with, but are less reliable (see p. 216).

Hard-disk systems called RAID (redundant array of independent disks), which allow for the failure of one or more disks without any loss of data, are now affordable to anyone who takes photography seriously. They may cost as much as an SLR, but they are arguably more important than an extra camera if you value your photos. The RAID's contents can be backed up on inexpensive desktop drives that are kept in different locations – for example, at a relative's house.

Soft gold

The total number of pictures on the internet is climbing well beyond a trillion, thanks to your contribution, among several hundred million other photographers. Locating a particular image, for example, to illustrate a magazine feature or use on

a leaflet, must be text-based. Metadata or tags (also called soft data) are descriptive words, names, and other data added to or embedded in an image.

We find an image of Cape Town, for instance, not by examining millions of images on the lookout for features belonging to South Africa's great city, but by first looking for images carrying the name tag "Cape Town". What is more, you might have no idea what Cape Town looks like, yet you can collect dozens of excellent shots merely by searching for the tag. In fact, any image failing to carry the tag is very unlikely to be found, even if it is the best possible shot of the city.

The addition of metadata is an essential skill. Minimally, metadata should identify the subject or event, the date, the location, the copyright holder, and the photographer. The information should be enough for anyone to know for sure what the picture is about and to be able to contact you, so it should carry a caption and your details. In addition, keywords that refer to key elements of the image and a unique identifier, such as a serial number, can help anyone to locate your image.

Caption marvel

The rule for an effective caption is simple: answer the what, when, where, and who questions. Many agencies have a limit to the number of characters you can use, so it takes some skill and planning to get down all the information in the space available. While keywords are essential in helping a potential user to locate your photograph, the caption may clinch the deal as it can confirm the exact details and timing needed.

Start today

It may seem unnecessary to organize a collection of a few hundred images, but it is an easy task, and you will learn through the process. If you start when you really need to – with a collection of thousands of images – the task could be discouragingly onerous. So your most important decision is to decide to start right now, before you lose any precious images in a hard-disk crash and long before it is really necessary.

CALLING NAMES

- There are two main ways of naming your images. You can use the names given by the camera, usually a generic DSC1234 or _IMG1234. (The underscore prefix means that the embedded profile is Adobe RGB.) Alternatively, you can name files more specifically, such as _ANG1234. Professional users will benefit most from using specific image names.
- File names are most easily changed at download time or renamed in a batch.
- If you create specific names, keep a running catalogue to ensure that each is unique – for example, by job number or date.
- Camera-generated names usually repeat after 9,999 images.

◄ File lists

Image files can be shown in lists that display a thumbnail of the image together with all its associated metadata. Selecting one of the images allows the metadata to be edited. In software such as Apple Aperture (shown here) or Adobe Lightroom. image-enhancement controls are available alongside tools for organizing material for slide shows, web pages. or books.

■ Management software

One of the best ways to organize your images is to use management software. Applications worth considering include Adobe Lightroom, Apple Aperture, Extensis Portfolio, ACDSee, and Camera Bits Photo Mechanic (shown here). Not only do all these programs help you to keep picture files organized, they can also create "contact prints" and slide shows, as well as publishing picture collections to the web.

CAPTURE DEFECTS

There is a story about a group of great photographers who decided to make a list of what could go wrong in photography. They gave up when they reached 200 items. The defects highlighted here are only the common errors that are easy to miss – some even for the experienced photographer – leaving out the obvious such as poor focus or camera shake.

Original sins

There are two kinds of image defect: those arising from inadequacies of equipment such as poor image quality, flare, noise, and problems with colour.

The other defects result from inadequacies in technique, such as poor focus or exposure, camera shake, and unwanted distractions – such as an object sticking out of a subject's head, or telephone wires across the sky.

To varying degrees, all defects can be corrected or hidden: this is one of the glories of digital photography. However, you will find that you save yourself a great deal of time and frustration at the computer by taking utmost care when capturing the image. Your ultimate aim is never to have to manipulate an image to make it usable.

▲ Distractions

Some distractions may be avoided altogether through careful choice of position and framing, but wires and cables that stretch between buildings, spoiling the view of the sky, are notoriously difficult to avoid. Treat them as an image defect, whose removal is part of post-processing.

▲ Highlight clipping

When overexposure causes highlights to lose all colour and detail they are said to be clipped. It is impossible to recover these areas, so they are best avoided altogether. Recording in RAW format and bracketing exposures for tone compression (see pp. 168-9) may help.

▲ Noise

When visible, irregular spots of colour or large "clumps" of light or dark pixels disrupt image detail and colour. Noise is commonly blamed on sensor performance, but can also be made apparent by post-processing; it is the price you pay for rescuing under-exposed images.

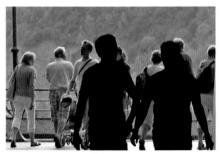

▲ Shadow clipping

The opposite of highlight clipping (above) is loss of detail and colour in shadows due to underexposure. It is usually easier to extract some detail and colour from clipped shadows than from clipped highlights. Recording in RAW (see pp. 158-61) increases the chance of a successful fill.

Avoid if possible

Certain defects are impossible to correct fully. If a lens hood for a wide-angle lens is misaligned it will cause shadowing or vignetting in the corners: the only way to remove them is to crop the image. The same applies to tilted horizons. Flare caused by pointing the camera at the sun can be extremely troublesome to remove or disguise. And, of course, poor focus leads to loss of details that cannot be recaptured. However, some unsharpness or blur resulting from movement can be reduced using modern algorithms.

▲ Tilted horizon

This problem is commonly caused by cameras that are heavier on one side than the other, also by using small live image screens. A tiny tilt looks like an error, but very obvious tilts look deliberate and can be acceptable. Correcting the tilt is easy but always involves cropping.

▲ Leaning verticals

Tilting the camera up to take in the full height of a building usually causes the building to look as if it is leaning back awkwardly. This often looks like poor technique. But tilting up strongly is often accepted as a deliberate visual effect. Small amounts of lean can be corrected.

WORSHIPPING QUALITY

Image quality is usually over-rated. While the combination of a stunning image with technical perfection is a very fine thing, it is a common mistake to focus on quality alone. Remember that many of the greatest pictures in the history of photography were made on equipment and film far inferior to even today's amateur cameras. But no-one complains about their grain or poor colour. Concentrate on making a wonderful image; quality comes a long way behind.

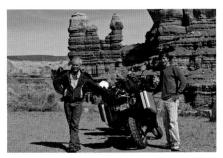

▲ Excessive depth of field

A common problem arising from the widespread use of small sensors, too great a depth of field gives too much prominence to the background, distracting the viewer from the main subject. Use post-processing to blur the background selectively (see pp. 130–3).

▲ Unbalanced colour

Until more cameras use intelligent white balancing, a common defect is the inaccurate capture of neutrals in the presence of a strong illuminating colour, such as here, where the red candles cause the white walls to look blue. This may need careful, hue-specific correction (see pp. 136-9).

COLOUR MANAGEMENT

The aim of colour management is to control the imaging chain so that between the subject, its captured image, the image displayed on a monitor, and any of its printed forms, there is the least possible variation in appearance. The key strategy is to define the behaviour of each component in terms of a common standard, known as the profile connection space.

Digital colour management

The central problem is that the colour gamut or range of reproducible colours of different devices vary considerably. It is easy to make a set of adjustments that ensure our images appear on our monitor as they print out: this was what the old Adobe Gamma control was used for. But we might change our printer or update our camera: each time we make a change – even of paper type – we need to make new adjustments.

The solution is to use a common colour space – essentially that which can be seen by the eye – to describe how the colour reproduction of a correctly set up device differs from the standard. This generates the device's profile. Note that the device must be correctly set up: this is the task of calibration. Cameras and printers are essentially self-calibrating, but monitors need to be set up manually because a

number of variables (gamma, white point) need to be set by the operator.

Monitor calibration

There are software-based methods for calibrating monitors and hardware-based methods. The former is free but less accurate than the latter, which you have to purchase, but prices are now a fraction of what they used to be. CRT (cathode ray tube) monitors should be warmed up for 30 minutes before calibration, and should be recalibrated at least once a month. LCD monitors need less warm-up time, but should also be recalibrated regularly.

After calibration, a profile for the monitor is created. This should be used as the monitor profile. In addition, you need to ensure that your work takes colour management into account. This profile can be set as the output space or applied to the viewed image directly. Applying an output profile usually makes the image look duller, but it should be a close match to the print.

Viewing conditions

It is useful to consider the features of ideal viewing conditions, if only to make you realise how far your own conditions fail to reach them. Walls should be

CALIBRATION

Using the most accurate monitor calibrators or using on-screen targets will be of little help if the basic settings for gamma and white point are not carefully chosen to suit the end use of your images. If you supply to third parties such as stock agencies, magazines, or printers, consult them to find out their preferred monitor settings.

▲ On-screen calibration

On-screen calibration offers prompts such as the above, showing steps for setting luminance response curves and the balance between the three colours. Settings are altered to match targets.

▲ Linear gamma

With the screen set to Linear Gamma, the overall result is very bright, blacks are grey, and colours look washed out. Images adjusted on this screen would look too dark, saturated, and contrasty on normally adjusted screens.

▲ 1.8 gamma

The 1.8 gamma was formerly the default setting in Apple Macs and the print industry. It is now regarded as too bright compared to the 2.2 gamma standard on Windows machines. A gamma of 2.0 may be set as a compromise.

painted white or a mid-tone neutral grey. Curtains should not be coloured, that is, they should block out the light without filtering it – neutral coloured blinds are best. Light levels in the room should be constant, and preferably only bright enough to allow you to find your way around the room – around 4 lux is ideal – and those parts of the image that are black should look black on screen.

The monitor should be hooded against local light sources such as desk-lamps.

Ideally, prints should be viewed in standard daylight viewing booths and transparencies should be viewed on standard light-boxes, placed as close to the screen as possible. Booths should comply with ISO 3664:2000, that is, they should use the CIE reference illuminant D50.

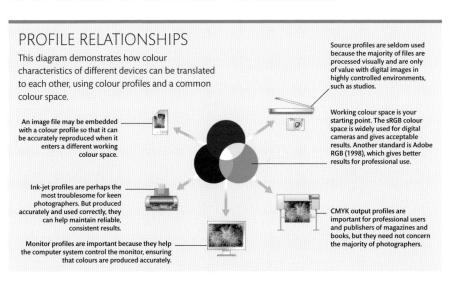

▲ 2.2 gamma The standard on Windows machines, indicating a high level of correction to the monitor's output. Colours are rich, and blacks appear solid while retaining shadow detail but the image quality is a poor match for print quality.

▲ D50 target white
Formerly widely accepted
as the standard target white
point for a monitor – that
is, the monitor attempted
to display white according
to the definition for D50.
The result appears to
modern eyes to be
creamy or yellowish.

▲ D65 target white
As incandescent lights are
used less and more prints
are made on bright white
paper, the D65 target white
has become more widely
adopted. It gives a cooler,
bluer result than D50 and is
a good choice for general
digital photography.

▲ 9300 target white Suitable for domestic TV and video, where the final viewing is on TV sets, this white point is generally too blue for digital photography. Using 9300 will result in images that look too red or yellow, and with flattened contrast.

CROPPING AND ROTATION

The creative importance of cropping, to remove extraneous subject detail, is crucial in digital photography – it can even be used as a compositional tool in its own right. A single image can have many different interpretations according to how it is cropped, although you should not let this affect your decisions when composing and framing your images.

Not only does digital cropping reduce picture content, it also reduces file size. Bear in mind that you should not crop to a specific resolution until the final stages of image processing, as re-sizing by interpolation will then be required. This reduces picture quality, usually by causing a slight softening of detail. Image cropping without a change of resolution does not require interpolation.

Image rotation

The horizon in an image is normally expected to run parallel with the top and bottom edges of the image. Similarly, you may want to make sure that vertical lines in your image are correctly aligned, particularly when photographing buildings (see pp. 55–7) or other subjects with strong geometry. Slight mistakes in aiming the camera not an uncommon error when you are working quickly or your concentration slips – can be corrected by rotating the image before printing.

With film-based photography, this correction was carried out in the darkroom during the printing stage. In digital photography, however, rotation is a straightforward transformation, and in some software applications you can carry out the correction as part of the image-cropping process.

Note that any rotation that is not 90°, or a multiple of 90°, will need interpolation. Repeated rotation may cause image detail to blur, so it is best to decide exactly how much rotation is required, and then perform it all in a single step.

Correcting scans

Cropping and rotation are also useful tools if you are scanning old film images from your archive. For example, you may want to remove the border caused by inaccurate scanning. This area of white or black not only takes up valuable machine memory, it can also greatly distort tonal calculations, such as Levels (*see pp. 120–1*). If a border to the image is needed, you can always add it at a later stage using a range of different applications.

Rotation can also be used to correct any inaccuracies in placement on the scanner. However, always check that scanned negatives are correctly oriented – that left-to-right in the original is still left-to-right in the digital image.

◆ Creative cropping

Cropping can help rescue an image that was not correctly framed or composed. By removing elements that are not required or are extraneous to what you intended, you can create a more visually coherent final image. Beware that crops to one side of a wide-angle image may appear to distort perspective, since the centre of the image will not correspond to the centre of perspective. Cropping decreases the size of the image file and calls on the image's data reserves to maintain image quality.

SAVING AS YOU GO

When working on image manipulations, make sure you adopt good working practices: always work on a copy of the original file, and get into the habit of saving your working file as you proceed: press Command + S (Mac) or Control + S (PC) at regular intervals. It is easy to forget in the heat of the creative moment that the image on the monitor is only virtual – it exists just as

long as the computer is on and functioning properly. If your file is large and what you are doing is complicated, then the risks of the computer crashing are increased (and the resulting loss of the work more grievous). A good rule to remember is that if your file is so large that making frequent saves is an inconvenient interruption, then you definitely should be doing it, inconvenient or not.

■ Sloping horizon

A snatched shot taken with a wide-angle lens left the horizon with a slight but noticeable tilt, disturbing the serenity of the image. But by rotating a crop it is possible to correct the horizon (below), although, as you can see from the masked-off area (left), you do have to sacrifice the marginal areas of the image. Some software allows you to give a precise figure for the rotation; others require you to do it by eye.

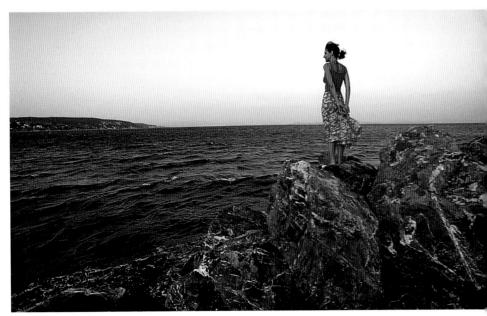

QUICK FIX POOR SUBJECT DETAIL

Producing the sharpest possible image in most situations provides the most flexibility later. You can easily blur a sharp image, but it is very difficult to rebuild detail that is lost to blur.

Problem: Images lack overall "bite", and sharpness and subject detail is soft or low in contrast overall.

Analysis: Unsharp detail rendered with low contrast can be caused by any of the following: use of a poor-quality lens; inaccurate focusing; dust or scratches on the lens; or an intervening surface, such as a window. Movement of the camera or subject during exposure may also cause loss of detail.

Solution: The core technique for improving detail is digital sharpening, or increasing clarity, using a

▲ Lacking bite

This snap of a bandsman lacks clean definition of detail, in particular in the face. The shiny metal gives the impression of sharpness, but that is just an illusion as a result of the reflections and high-contrast lines.

variety of techniques such as unsharp masking (USM). Some cameras also apply USM as they record so that images appear sharper when viewed on screen. However, too much in-camera sharpening effectively reduces the final image quality, so it is best to apply manually controlled sharpening, viewing the effects on a large computer screen. Monitor sharpening effects with your image at 100 per cent or larger while you apply them. For print use, sharpen until the improvement is just visible. For screen use, sharpen until the effect is apparent but no more than that (see also pp. 126-9).

A boost of image mid-tone contrast and colour saturation also improves the appearance of image sharpness. Sharpening filters cannot retrieve details lost by movement during exposure, but new algorithms can help reduce motion blur.

▲ Clarity of detail

By applying strong unsharp masking to the image, its impact is greatly improved. In particular, the musician's eye reveals an intense concentration, probably focused on the band leader.

HOW TO AVOID THE PROBLEM

- Keep the front and back surfaces of your lens and any lens filters clean. Replace filters as soon as they are scratched.
- Focus as precisely and carefully as possible.
- Release the shutter smoothly, in a single action.
 For longer hand-held exposures, make the exposure as you breathe out, just before you start to breathe in
- For long exposures, use a tripod or rest the camera on some sort of stable support – such as a table, window ledge, wall, or a pile of books – to prevent camera movement.
- Experiment with your lens some produce unsharp results when they are used very close up or at the extreme telephoto end of their zoom range.

QUICK FIX POOR SUBJECT COLOUR

If subject colour is disappointing, despite your best efforts, the key to effective improvement is to be selective.

Problem: Your images are underwhelming, with lacklustre colour vibrancy and dull tones overall. These problems most often occur in pictures captured on overcast days.

Analysis: Your camera may make conservative adjustments to a captured image. In addition, light that is lacking a full range of colours – for example, on overcast days – is weak in warm colours, resulting in a bluish colour cast that gives dull, cold images.

Solution: A sound first step is to correct the white balance if it is too blue or yellow. Then the simplest solution is to apply increased saturation to the whole image. But this often over-emphasizes some colours in the effort to make others more lifelike. It is better to analyze the image and decide which colours – the yellows, say – would most benefit from improving, then limit the increased saturation to yellows (*see pp. 136-41*).

► Selective saturation

The original image (top) suffers from dull colours. An overall increase in saturation brings the green of the cranes back to the remembered colour, but the face of the supervisor is too red (middle). We increase saturation limited to greens for the cranes, yellows - for the markings on the wharf, and cyans - for the sky, by amounts to match needs. This allows the skin tones to remain natural-looking (bottom).

HOW TO AVOID THE PROBLEM

- In bright, contrasting lighting conditions, it may help to underexpose by a small amount: set the camera override to -½ of a stop or -½ of a stop, depending on what the controls permit.
- To avoid computer-based image manipulation, try using camera modes that boost image saturation. These are typically called something like Landscape, Brilliant, or Vivid.
- Set your camera's white balance to a setting that is appropriate to the prevailing conditions – for example, "cloudy" on an overcast day.
- Avoid setting the camera to very high sensitivities, such as ISO 800 or above. And if you still work with a film camera, you should avoid using high-speed colour film of any type if colour accuracy is crucial.

LEVELS

The Levels control shows a representation, in the form of a histogram, of the distribution of tone values of an image. Levels offers several powerful options for changing global tone distribution. The easiest thing to do is to click on the Auto Level button. This, however, works effectively in very few cases. What it does is take the darkest pixel to maximum black and the brightest pixel to maximum white, and spreads everything else evenly between them. This, however, may change the overall density of the image.

Another control that may be available is Output Level. This sets the maximum black or white points that can be produced by, say, a printer. Generally, by setting the white point to at least 5 less than the maximum (in other words, to about 250) you prevent the highlight areas in your output image appearing totally blank. Setting the black point to at least 5 more than the minimum (in other words, to about 5) you will help to avoid the shadow areas looking overly heavy in your output image.

■ Auto Level

An underexposed image contains dark tones with few high-value ones (far left), confirmed in the Levels display (bottom far left). The gap on the right of the histogram indicates an absence of values lighter than three-quarter tone, with peak values falling in deep shadow. Applying Auto Level (left) spreads all available pixel values across the whole dynamic range. The new Levels display (bottom left) has a characteristic comb-like structure, showing gaps in the colour data. Auto Level not only brightens colours and increases contrast, it also causes a slight overall colour shift.

HOW TO READ LEVELS

The Levels histogram gives an instant check on image quality - perhaps warning of a need to rescan.

- If all values across the range are filled with gentle peaks, the image is well exposed or well scanned.
- If the histogram shows mostly low values (weighted to the left), the image is overall low-key or dark; if values are mostly high (weighted to the right), the image is high-key or bright. These results are not necessarily undesirable.
- If you have a sharp peak toward one or other

- extreme, with few other values, you probably have an image that is over- or underexposed.
- If the histogram has several narrow vertical bars, the image is very deficient in colour data or it is an indexed colour file. Corrections may lead to unpredictable results.
- A comb-like histogram indicates a poor image with many missing values and too many pixels of the same value. Such an image looks posterized (see pp. 142-3).

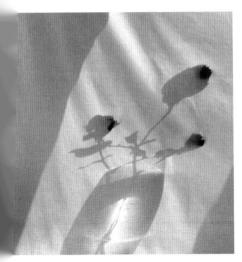

▲ Well-distributed tones

As you can see from this Levels histogram, a bright, well-exposed image fills all the available range of pixels, with no gaps. Since the image contains many light tones, there are more pixels lighter than mid-tone, so the peak of the histogram lies to the right of centre. This image would tolerate a lot of manipulation thanks to the richness of colour data it contains.

▲ Deficient colour data

An image with only a limited colour range, such as this still-life composition, can be turned into a very small file by saving it as an indexed colour file. In fact, just 55 colours were sufficient to represent this scene with hardly any loss of subject information. However, the comb-like Levels histogram associated with it indicates just how sparse the available colour data was. Any work on the image to alter its colours or tonality, or the application of filter effects that alter its colour data, would certainly show up artefacts and produce unpredictable results.

HISTOGRAM DISPLAY

The histogram for this image shows the mid-tones dominated by green and red, consistent with the strong yellows and browns of this warm, wood-dominated interior. Applications can be set to display histograms

for each RGB channel or combined, usually as luminance for an accurate view of brightness.

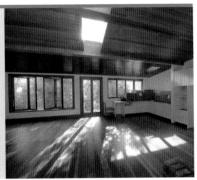

BURNING-IN AND DODGING

The two key techniques for manipulating the local density of an image in digital post-processing are known as burning-in and dodging.

Controlling density

Burning-in increases the density in the area of the image being worked on (it becomes darker), while dodging reduces it (a dodged area becomes brighter). Both techniques change the tonal reproduction of the original to correct either errors or imbalance, or for visual effect. For example, the highlights and shadows in any image are low in contrast, and to counteract this you can burn-in

and dodge to bring out what shadow and highlight detail does exist by increasing local image contrast.

The same techniques can be used in order to reduce contrast – to darken highlight areas, for example – to bring them tonally closer to image mid-tones. An often-used application of this is burning-in areas of sky to darken them while dodging the foreground. This helps match the sky tones to those of the foreground.

Precision work

Using the brushes available in all image-manipulation software, you can apply effects over as broad an area or with as much precision as you like – down to the individual pixel, if necessary. You can adjust brush size – the area over which an effect is applied – how cleanly the edge of the brush is defined, and also its "pressure", or strength of effect. Some software programs allow you to set "flow", or how quickly the effect is applied. The tools should also allow you to set the tool to limit its effect to the shadows, mid-tones, or highlights alone.

The Burn and Dodge tools in classic imagemanipulation applications are relatively crude compared to new tools. Some new brushes can

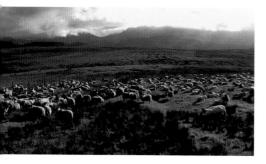

Correcting tonal balance

Looking at the original image (above), the temptation to burn-in the foreground and some of the background in order to "bring out" the sheep is irresistible. Brief applications of the Burn tool on the foreground (set to mid-tone at 10 per cent) and background hills, plus the Dodge tool on the sheep (set to highlight at 5 per cent) produced an image (right) that was very similar to the scene as it appeared at the actual time of shooting.

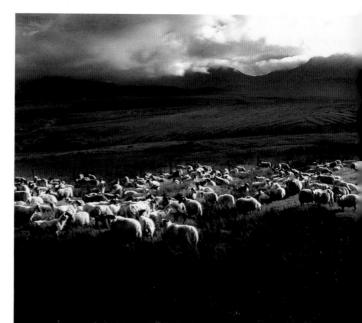

recognize edges and not apply an effect beyond the edge. Others can be set to adjust contrast as well as brightness when applied. Each tool is perfect for a different task, but you may need more than one software application to find the right tool.

You may also experiment with stronger effects by exploiting layer modes such as Color Dodge or Color Burn (see pp. 180-5). You create a new layer over your image, then apply tints: your choice of layer mode and layer opacity will control the density and contrast of whatever you apply.

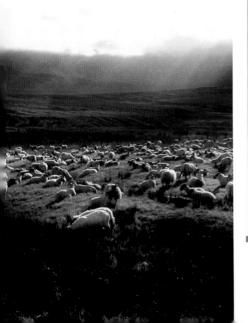

▲ Correcting exposure

An exposure biased for a tropical afternoon in Bali, Indonesia, rendered the shadows too dark (above left). By applying to the shadows a Dodging brush set to dodge mid-tones, a great deal of formerly hidden detail has been revealed (above right). Notice that colours emerge richer and brighter. Details in the open area were also burned in to extract more colour from the dull light of the rainy day.

HINTS AND TIPS

- Apply dodging and burning-in techniques with a light touch. Start off by using a light pressure or a low strength of effect – say, 10 per cent or less – and then build up to the strength the image requires.
- When burning-in image highlights or bright areas, set the tool to burn-in the shadows or mid-tones. Do not set it to burn-in the highlights.
- When burning-in mid-tones or shadows, set the tool at a very light pressure to burn-in the highlights or mid-tones. Do not set it to burn-in the shadows.
- When dodging mid-tones, set the tool at very light pressure to dodge the highlights or mid-tones. Do not set it to dodge the shadows.
- When dodging shadows, set the tool to dodge the highlights. Do not set it to dodge the shadows.
- Use soft-edged or feathered Brush tools to achieve more realistic tonal results.

DUST AND NOISE

Two factors are the "forever enemies" of image quality: dust and noise. Dust spots on the image result when material lands on the photosensor of a camera or on film to be scanned. It is a serious problem with SLRs as the debris is recorded on every image. Noise – usually seen as pixels markedly different to neighbouring pixels and not caused by subject features – arises from the electronic properties of the photosensor of a camera or scanner.

Noise control

You can reduce noise where the noise has a higher frequency than the image detail itself – in other words, if the specks are much smaller than the detail in the image. This is one advantage of increasing the pixel count of images. In low-resolution images, applying a noise filter smudges image information along with the noise signals. Digital filters such as Noise Ninja are effective at reducing noise only where required, and all raw converters can reduce noise. DxO Optics stands out by reducing noise before applying colour interpolation.

Dust-removal options

Some scanners provide features to mask dust damage, replacing the resulting gaps in the image with pixels similar to those adjacent to the problem areas. These can work well, although some may disturb the film's grain structure, while others work only on colour film.

Many cameras incorporate mechanisms to reduce dust, using, for example, rapid vibration to shake off particles or anti-static coatings to avoid attracting particles. Certain SLRs offer dust-removal software: you photograph a plain surface, have the result analyzed by the software, which then creates a "mask" that can be applied to images to remove the dust. You can also help the camera directly by cleaning the sensor using ultra-soft micro-porous swabs or ultra-fine brushes that sweep up the dust and reduce static charges.

Manual removal

The key image-repair technique is to replace the dust with pixels that blend in with neighbouring pixels. Depending on your tool of choice, you either

▲ Dust on sensor

A 300 per cent enlargement of the corner of an image shows a few faint specks of dust. They are blurred because they lie some distance above the sensor, which "sees" only their shadows. However, with manipulation, the pale spots will become more visible.

■ Dust revealed

The full extent of the dust spots is revealed when we apply an adjustment layer to increase contrast and decrease exposure of the image. This presents the worst-case scenario and makes it easy to identify and eliminate the spots.

▲ Dust removed

Use the Spot Healing Brush, Healing Brush, or Clone Stamp tool to remove the dust spots. Set the brush to just slightly larger than the average spot, with a sharply defined brush edge, and sweep systematically in one direction.

manually select the source for the pixels to cover the dust – this is Cloning – or you let the software sample from around the dust and apply an algorithm that blends local pixels with the dust to hide the spots – in Photoshop, this is called Healing. Where the spots are too numerous, a blurring filter may help, but this will also blur image detail that is the same size as the spots.

HINTS AND TIPS

- Clone with the tool set to maximum pressure, as lighter pressure produces a smudged clone.
- In even-toned areas, use a soft-edged or feathered Brush as the cloning tool. In areas with fine detail, use a sharp-edge Brush instead.
- You do not always have to eliminate dust specks
 reducing their size or contrast may be sufficient.
- Work systematically from a cleaned area into areas with specks, or you may find yourself cloning dust.
- If cloning looks overly smoothed, introduce some noise to make it look more realistic. Select the area for treatment and then apply the Noise filter.

▲ Noise in detail

In this close-up view of an image, it is clear there is more noise, or random pixels (seen as specks and unevenness of tone), in the darker areas than in the brighter ones. Compare the blue shadow area, for example, with the white plate. This is because noise in the photosensor is normally drowned out by higher signals, such as those generated by strong light.

▲ Noisy image

Poor noise-suppression circuitry and an exposure of ½ sec gave rise to this 'noisy" image. Long exposures increase the chance of stray signals, which increase noise in an image.

RCB Red Green Stue	962 963
Green	
(h)	364
Rive	
	M 5

▲ Screen shots

Examining the different channels (above) showed that the noisiest was the green one. This was selected and Gaussian Blur applied (top). The radius setting was adjusted to balance blurring of the specks while retaining overall sharpness.

▲ Smoother but softer

The resulting image offers smoother tones – especially skin tones – but the cost is visible in reduced sharpness of the orchids. You could select the red and blue channels to apply Unsharp Masking to improve the appearance of the flowers.

SHARPENING

The ease with which modern image-manipulation software can make a soft image appear sharp is almost magical. Although software cannot add to the amount of information contained in an image, it can put whatever information is there to the best possible use. Edges, for example, can be given more clarity and definition by improving local contrast.

Digitally, sharpen effects are true filters, as they hold back some components and selectively let others through. A Sharpen filter is, in reality, a "high-pass" filter – it allows high-frequency image information to pass while holding back low-frequency information.

Unsharp Masking

The most versatile method of image sharpening is Unsharp Masking (USM). This takes a grid of pixels and increases edge definition without introducing too many artefacts. Unsharp Mask has three settings. In Photoshop, they are called Amount, Radius, and Threshold. Amount defines how much sharpening to apply; Radius defines the distance around each pixel to evaluate for a change; Threshold dictates how much change must occur to be acceptable and not be masked.

It is possible to overdo sharpening. In general, assess image sharpness at the actual pixel level, so that each pixel corresponds to a pixel on the monitor. Any other view is interpolated and edges are softened, or anti-aliased, making sharpness impossible to assess properly.

As a guide, for images intended for print, the screen image should look very slightly oversharpened, so artefacts (such as halos or bright fringes) are just visible. For on-screen use, sharpen images only until they look right on the screen.

Sharpening makes deep image changes that cannot easily be undone, so it is generally best to leave sharpening to last in any sequence of image manipulations, except for combining different layers. However, if you are working on a scan with many dust specks and other similar types of fault, you should expect the final sharpening to reveal more fine defects, so be prepared for another round of dust removal using cloning (see pp. 124–5).

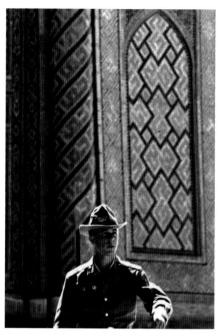

▲ Under-sharpening

In images containing large amounts of fine detail, such as this scene taken in Uzbekistan, applying a modest strength of USM filtering (55) and a large radius (22), with a threshold set at 11 does little for the image. There is a modest uplift in sharpness, but this is due more to an overall increase in contrast rather than any other effect.

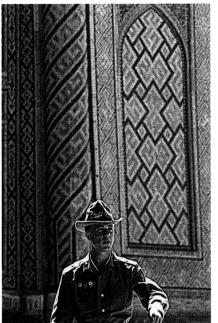

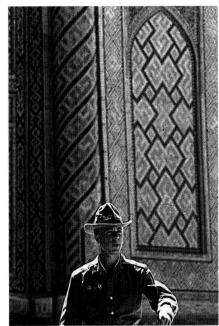

▲ Over-sharpening

The maximum strength setting used for this version results in over-sharpening – it is still usable and is arguably a good setting if you intend to print on poor-quality paper. The same setting applied to the Kashgar image (see pp. 128–9) would simply bring out all the film grain – a technique for increasing noise in the image.

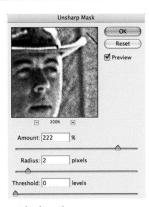

▲ Ideal setting

The best settings for images with fine detail is high strength with a small radius and a very low threshold: here, strength was 222, the radius was 2, and the threshold was kept at 0. Details are all well defined and if large-size prints are wanted, details are crisper than those obtained with sharpening using a larger radius setting.

SHARPENING CONTINUED

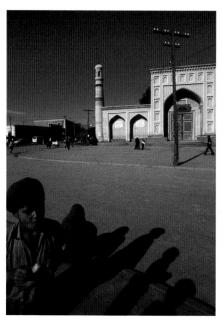

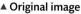

This photograph of the main town square in Kashgar, Xinjiang, China, has large areas of smooth tone with little fine detail, and it would clearly benefit from the effects of image sharpening.

HINTS AND TIPS

Using an advanced Photoshop technique for image sharpening, first mask off areas (such as a face) to be protected from oversharpening and any associated increase in defects. Next, produce a duplicate layer of the background and set it to Soft Light mode. This increases contrast overall. Then apply the High-Pass filter (found under the Filter menu in Other > High Pass). Increasing the radius strengthens the effect (passes higher frequencies, or more detail). You can now enter Quick Mask mode or add a layer mask to control which areas of the image will be sharpened by the High-Pass filter. This method is also effective for sharpening an image overall and can be controlled by direct settings and by opacity. However, the preview window in the dialogue box does not give an accurate view because it samples only the top layer.

▲ Over-sharpening

If you increase the sharpening effect (222 in this version) and reduce the threshold (0), but reduce the radius to 2, virtually everything in the image increases in sharpness. The result is that film grain and fine detail are sharpened to an undesirable extent. Compare the result of these settings with that of an image that contains a mass of fine detail (see p. 126).

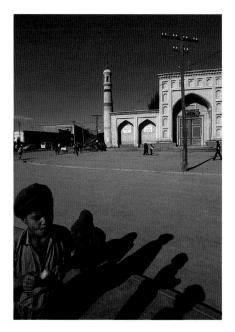

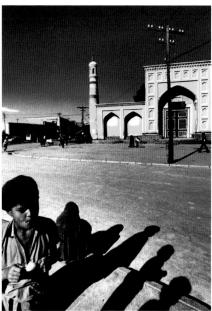

▲ Sharpening areas of tone

A moderate amount of sharpening (55) and a relatively wide radius for the filter to act on (22) improves sharpness where there is subject detail, without bringing out film grain or unwanted information, such as in the subject's skin-tones. A threshold setting of 11 prevents the filter from breaking up smooth tonal transitions, as the sharpening effect operates only on pixels differing in brightness by more than 11 units.

▲ Extreme settings

This version results from maximum amount and radius settings. The effect is extreme, but a threshold of 32 controls coloration. Even so, the image has highly saturated colours and brilliant contrast. In addition, film grain is emphasized. The random appearance of film grain gives more attractive results than the regular structure of a digital image, so if you want to use this effect introduce image noise first.

BLURRING

Blur can be introduced by lowering contrast to give boundaries a less-distinct outline. This is the opposite of sharpening (*see pp. 126–9*). Paradoxically, blurring can make images look sharper, for if you throw a background out of focus, then any detail in front looks sharper in comparison.

Blur options

Blur effects are seldom effective if applied to the whole image, since they often fail to respond to the picture's content and character. The Median and Dust & Scratches filters produce an effect like

looking through clear, moving water. For some subjects this is appropriate, but for blur with some clarity, other methods are better. One approach depends on the data-loss caused by interpolation when reducing file sizes. First, increase the image size by, say, 300 per cent, using Resampling, and then reduce it to its original size. Check its appearance and repeat if necessary. This does take time, but it can give well-detailed, softly blurred results. A quicker, though less-adaptive, method is to reduce the file size, and then increase it, repeating this step as necessary.

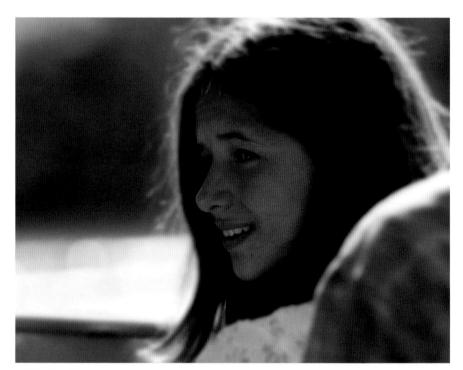

▲ Selective blur

Although you will not often want to blur an image in its entirety, selective blurring, and thus the softening of subject detail, can be extremely useful on occasion. To take one example, the blurred areas of an image could become the perfect background for typography – perhaps on a web page – as the wording would then be easier to read. Another example could be to introduce digital selective blur to simulate the appearance of using

a special effects, soft-focus lens filter. This type of glass filter is designed to soften all but a central region of the image in order to help concentrate the viewer's attention on a particular feature. In the example shown here – an informal portrait of a traveller on a ferry on the River Danube, Hungary – the high-contrast sunlight and the sharpness of background detail was softened to emphasize the girl's features.

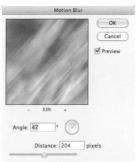

▲ Motion Blur

This filter simulates the effect of rapid movement across the field of vision. Usual controls for this filter include altering the angle of the "smear" as well as its length: greater lengths suggest higher speed motion. For unusual results apply different angles to different parts of the image.

▲ Dust & Scratches

While it is not strictly a blurring filter, at large radius settings the Dust & Scratches filter does an excellent job of blurring details while retaining outlines to give a watery effect. Setting the Threshold to higher values retains more details. Reduce saturation to create a water-colour look.

▲ Radial Blur

Use this filter to apply the blur along lines radiating out from the centre of the image. This can simulate the effect of speeding into the distance. For best results, apply in steps to selectively smaller areas. In Adobe Photoshop, the filter also offers an option for simulating a zoom blur.

BLURRING CONTINUED

Having spent a fortune on lenses that deliver super-sharp images, it seems madness to introduce blur into your images. But targeted blur is an essential part of the visual language: it can depict movement, it can be used to indicate centres of interest, and it can imitate effects created by articulated lens movements. The key to targeted blur is combining masks with blur filters.

Motion parallax

Blur is the result of an image moving a visible distance across the sensor. As nearby objects appear to move much more than distant objects, even if they are actually travelling at the same speed, they always appear more blurred. You see this when travelling on a train: the trees nearby are always blurred, but the mountains in the distance are

CREATING MOVEMENT BLUR

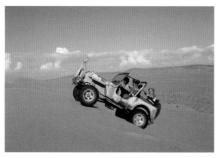

Original image
This travel shot is clearly taken in an exotic location, but lacks energy and a sense of movement. The four-wheel-drive vehicle looks as though it is stuck in the sand or about to roll backwards. We need a sense of forward movement.

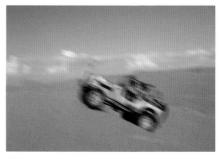

Motion Blur
On a duplicate layer, we apply a Motion Blur
filter: we line up the motion blur with the long axis of
the vehicle, adjusting its strength to avoid losing too
much detail.

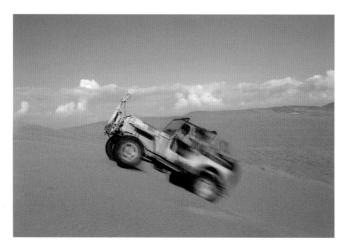

Mask
We now apply a
mask over the majority
of the image – the sky,
the landscape, and the
front of the vehicle. It
now appears that the
exposure time was too
long to capture a sharp
image. But a reality
check will show that this
is a manipulated image:
the difference in
sharpness in the vehicle
gives the game away.

sharp. You can simulate this effect by applying blur to the objects close to the camera while keeping distant parts of the scene relatively sharp.

Lens movements

A blur effect that is completely different from motion is created by movement of the lens: this means that the lens is articulated so it can rotate at

right-angles to its optical axis. A forward tilt can increase apparent depth of field, while a reverse tilt strongly reduces depth of field, making a scene resemble a small scale model. The strength of the effect depends on the angle of tilt and the working aperture set. You can simulate this effect by using graduated masks to control a blur applied to the whole image.

REVERSE TILT EFFECT

High-angle original
Tilt shift gives the impression of a model, so it works best on shots taken from a high angle, and is effective with objects such as people and cars. This street scene taken from a hotel window is perfect for this effect.

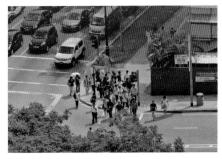

Quick Mask
In Quick Mask mode, select the gradient tool,
draw a gradient from the centre of the part you want
to be in focus to the edges of the image. A few attempts
may be needed to get the right area. The Quick Mask
mode allows you to see clearly what will be blurred.

Apply blur Back in standard mode, the lens blur filter can be applied; again this may take a few attempts to get it right. You are able to preview the amount of blur before you actually apply it. Although the effect will look finished now, using the unsharp mask filter makes the people more clearly defined and adds to the toy model effect.

QUICK FIX IMAGE DISTRACTIONS

Unless there is a fundamental problem with your image, most minor distractions can be removed, or at least have their pictorial impact reduced, in image-manipulation software.

Problem: While concentrating on your subject, it is easy not to notice distracting objects or colours in the picture area. This could be anything from a passer-by or street litter, to patches of strong colour.

Analysis: The small viewfinders or screens of many cameras make it difficult to see much subject detail. Furthermore, although something is distant and looks out of focus, it may still be within the depth of field of your set aperture (see pp. 18–21). At other times, you simply cannot avoid including, say, telephone wires in the background of a scene.

Solution: You may not need to remove a distraction completely; simply reducing the difference between it and adjacent areas may be enough. The usual way to achieve this is with cloning – duplicating part of an image and placing it into another part (see pp. 186–7). For example, blue sky can be easily cloned onto wires crossing it, as long as you are careful to use areas that match in brightness and hue. Clone from as close to the distraction as possible (see also pp. 186–7).

You could also try desaturating the colour: select the area of strong colour, and lower it using Color Saturation to reduce its impact. You could also paint over the colour by using the Saturation or Sponge tool set to desaturate.

Another method is to blur the background to render details less visible. This helps push the details in the main subject into visual prominence. Select the background directly, or if the main subject is easier to select, make your selection and invert it. Then apply a Blur filter (see pp. 130-1) that is appropriate to the detail you wish to blur; try different types of blur to evaluate their effect. Select a narrow feather edge to retain sharpness in the subject's outline. Use caution with strong Blur effects, because the selected region could be left with a distinct margin.

HOW TO AVOID THE PROBLEM

Check the viewfinder image carefully before shooting. This is easier with SLR cameras and those with large viewfinders. Long focal length lenses (or zoom settings) reduce depth of field and tend to blur backgrounds. And, if appropriate to the subject, use a lower viewpoint and look upward to increase the amount of non-distracting sky.

▲ Distracting movement

During a shoot in Manila, in the Philippines, the model's best expression coincided with passers-by in the background. Fortunately, there were many alternatives with a clean background that could be cloned.

▲ Cloning

The clean background of one image was first made the source for the clone. The Clone tool was then very carefully aligned with the destination image and the cloned pixels applied, making the passers-by disappear.

▲ Background distractions

In the chaos of a young child's room, it is neither possible nor desirable to remove all the distractions, but toning them down selectively can help centre the viewer's attention on the main subject.

▲ Desaturated elements

A large, soft-edged Brush tool was chosen, and pressure was set to desaturation at 100 per cent and applied to the background. With a lighter setting of 50 per cent, the desaturation was also brushed over the clothes.

▲ Selective blur

Despite using a large aperture, the high-contrast blur of a tree is still obtrusive. By selecting the background and applying a large blur setting (see right), the impact of the tree can be reduced. Care needs to be taken to ensure the model's face is not blurred and that the fringe around the model is not left too sharp. You may need to experiment with different feathering settings (see pp. 172-5) until you get the best results.

WHITE BALANCE

The basis of accurate colour reproduction is neutrality in the whites, greys, and blacks in the image. When you ensure these tones are not tinted with colours, you establish the accuracy of the hues you record. The white balance control on digital cameras helps neutralize tints in whites and greys. When you open the image, you may take the process further and adjust other dimensions of colour, such as the lightness and saturation.

What balance?

An image that is colour balanced is one in which the illuminating light offers all hues in equal proportion – in other words, the illumination is white and not tinted with colour. Colour balance is not to be confused with colour harmony. Thus, a scene can be full of blues or greens yet still be colour balanced, while another scene that features a well-judged combination of secondary colours

may appear harmonious, but may not be colour balanced at all.

The aim of colour balancing is to produce an image that appears as if it were illuminated by white light; this is achieved by adjusting the white point. However, there are different standards for white light, and so there are different white points. For example, it would not look natural to correct an indoor scene lit by domestic lamps in order to make it look like daylight, so a warm-toned white point is called for instead.

Color Balance control

This control makes global changes to the standard primary or secondary hues in an image. In some software, you can restrict the changes to shadows, highlights, or mid-tones. This is useful for making quick changes to an image that has, for example, been affected by an overall colour cast.

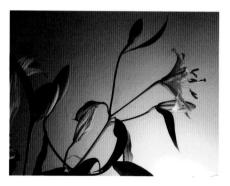

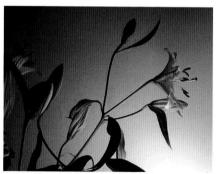

▲ Warm white point

The original picture of a simple still-life (above left) has reproduced with the strong orange cast that is characteristic of images lit by domestic incandescent lamps. The corrected image (above right) was produced using Color Balance. It is still warm in tone because a fully corrected image would look cold and unnatural.

DROPPER TOOLS

A quick method of working when you wish to colour-correct an image is to decide which part of the picture you want to be neutral – that part you want to be seen as without any tint. Then find the mid-tone dropper, usually offered in the Color, Levels, or Curves controls in image-manipulation software. Select the dropper, then click on a point in your image that you know should be neutral. This process is made easier if you used a grey card in one of your images – all images shot under the same lighting as the grey card will require the same correction. Clicking on the point samples the colour data and adjusts the whole image so that the sampled point is neutral: the dropper maps the colour data of all the image pixels around the sampled point.

When working with raw files, the choice of colour temperature (blue to red) and of tint (green to magenta) is yours. Usually, you choose colour temperature and tint to ensure neutral (achromatic or colourless) colours are truly neutral.

Balancing channels

While the Curves control is most often used to adjust image tonality, by altering the Curves or Levels of the individual colour channels, you apply a colour balance to the high tones that is different from that of the shadows. This is helpful, for

■ Original image

This original image has not been corrected in any way, and it accurately reproduces the flat illumination of a solidly cloudy sky.

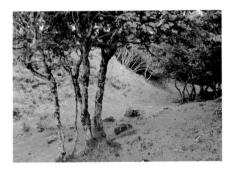

▲ Color Balance control

Strong changes brought about via the Color Balance control, mainly by increasing yellow in the mid-tones – which is the lowest slider in the dialogue box here – make the scene look as if it has been lit by an early evening sun.

example, when shadows on a cloudless day are bluish but bright areas are yellowish from the sun. It is easiest to work by eye, adjusting until you see the result you wish for, but for best control you can analyze the colour in neutrals and manually put in corrections to the curve. Working in CMYK, using Curves gives a great deal of control and the best results for print. The Color Balance control is essentially a simplified version of using the component RGB channels in Curves.

Channel mixing is effective where a small imbalance in the strengths of the component channels is the cause of colour imbalance, due to, for example, using a coloured filter or shooting through tinted glass.

The Hue/Saturation control can also be used, as it shifts the entire range of colours en masse. This can be useful when the colour imbalance is due to strong colouring of the illuminating light.

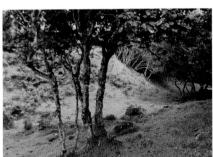

▲ Levels control

A golden tone has been introduced to the image here by forcefully lowering the blue channel in the Levels control – the middle slider beneath the histogram – thus allowing red and green to figure more strongly. Red and green additively produce yellow, and this colour now dominates the highlights of the image.

COLOUR ADJUSTMENTS

One of the most liberating effects of digital photography is its total control over colour: you can control effects from the most subtle tints to the most outrageous colour combinations.

Curves

Manipulating Curves, either all at once or as separate channels, is a potent way to make radical changes in colour and tone. For best results, work in 16-bit colour, as steep curve shapes demand the highest quality and quantity of image data.

Hue/Saturation

This control globally adjusts hues, as well as colour saturation, and brightness. You may also select narrow ranges of colours to change, thus altering the overall colour balance. Beware of oversaturating colours, as they may not print out.

Replace Color

This replaces one hue, within a "fuzziness" setting or wave-band, with another. Select the colours you wish to change by sampling the image with the Dropper tool, and then transform that part via the Hue/Saturation dialogue box (see opposite). By setting a small fuzziness factor, you select only those pixels very similar in colour to the original; a large fuzziness setting selects relatively dissimilar pixels. It is best to accumulate small changes by repeatedly applying this control. Replace Color is good for strengthening colours that printers have trouble with (yellows and purples), or toning down colours they overdo (reds, for example).

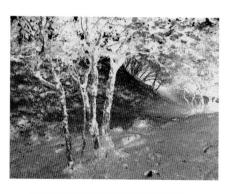

▲ Curves control

A simple inversion of colour and tone leaves dark shadows looking empty and blank. Manipulating tonal reproduction via the Curves dialogue box, however, gives you more control, allowing you to put colour into these otherwise empty deep shadows (the bright areas after inversion). In the dialogue box here you can see how the curve runs top left to bottom right – the reverse of usual – and the other adjustments that were made to improve density in the image's mid-tones.

COLOUR TEMPERATURE

The colour temperature of light has, in fact, nothing to do with temperature as we traditionally think of it; rather, colour temperature is measured by correlating it to the colour changes undergone by an object as it is heated. Experience tells us that cooler objects, such as candles or domestic lights, produce a reddish light, whereas hotter objects, such as tungsten lamps, produce more of a blue/white light.

The colour temperature of light is measured in degrees Kelvin, and a white that is relatively yellow in colouration might be around 6,000 K, while a white that is more blue in content might be, say, 9,500 K.

While colour slide film must be balanced to a specific white point, digital cameras can vary their white point dynamically, according to changing needs of the situation.

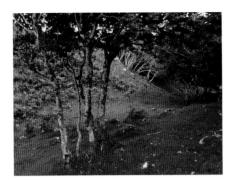

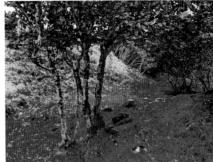

▲ Hue/Saturation control

In this dialogue box you can see that image hue has been changed to an extreme value, and this change has been supported by improvements in saturation and lightness in order to produce good tonal balance. Smaller changes in image hue may be effective for adjusting colour balance. Bear in mind that colours such as purples look brighter and deeper on a monitor than in print because of limitations in the printer's colour gamut.

▲ Replace Color control

Four passes of the Replace Color control were made to create an image that is now very different from that originally captured (see p. 137). The dialogue box here shows the location of the colours selected in the small preview window, and the controls are the same as those found in the Hue and Saturation dialogue box (above left), which allow you to bring about powerful changes of colour. However, for Hue and Saturation to have an effect, the selected values must indeed have colour. If they are grey, then only the lightness control makes any difference.

WORKING IN RGB

The most intuitive colour mode to work in is RGB. It is easy to understand that any colour is a mixture of different amounts of red, green, or blue, and that areas of an image where full amounts of all three colours are present give you white. The other modes, such as LAB and CMYK, have their uses, but it is best to avoid using them unless you have a specific effect in mind you want to achieve. When you are producing image files

to be printed out onto paper, you may think you should supply your images as CMYK, since this is how they will be printed. However, unless you have the specific data or separation tables supplied by the processors, it is preferable to allow the printers to make the conversions themselves. In addition, CMYK files are larger than their RGB equivalents and so are far less convenient to handle.

SATURATION AND VIBRANCE

Technically, saturation is the colourfulness of something judged in relation to brightness. Light, low-saturated colours become darker as they increase in saturation, while well-saturated colours look brighter and livelier when their saturation is raised. This change in quality helps explain why we love to make highly saturated images: they look gorgeous on the screen. In image manipulation, Vibrance, rather than meaning "full of energy", is a saturation control that adapts to certain colours.

Saturation

One of the most common enhancements made to images is an increase in saturation: colours look richer, images look brilliant and, indeed, greatly enhanced. Camera manufacturers deliberately process images conservatively because oversaturation is hard to recover: variations of hue take on the same values, so any differences in hue are lost forever. However, global increases in saturation rarely lead to better images. The most effective way

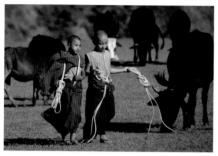

Original

Young monks in Bhutan chat as they run an errand on a sunny day – a delightfully photogenic scene. But overexposure in the capture leads to poor saturation after adjusting Levels. The yellows and reds are acceptable, but the greens are too dull.

2 High saturation

Increasing saturation globally renders the grass rich and lively, and the robes and ropes stand out in brilliance. But the flesh tones look too tanned, and notice how the cattle have become more prominent in the image.

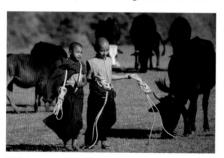

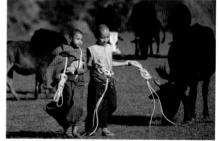

High vibrance

Returning to the Levels-adjusted original, the vibrance setting is increased: the result is a marked improvement over both the original and the high-saturation version, with rich colours in the robes and grass and natural skin tones.

▲ Minimum vibrance

If we set minimum vibrance we see that colours around flesh tones are reduced to almost grey-scale: different applications vary in how strongly they reduce saturation of non-flesh tone colours and the effect also varies with white balance.

is to be selective: identify the colours that appear weakest. If you would like a bluer sky, for example, instead of increasing saturation over the whole image, select Blues in your software's saturation control and increase saturation only for blues. The result is powerful, yet subtle.

Vibrance

The Vibrance control adjusts saturation to minimize clipping, that is, loss of definition at high values.

Less-saturated colours increase their saturation more than the colours that are already saturated. Most importantly, Vibrance produces a flatter response with skin tones, which prevents them from becoming over-saturated. Vibrance is very useful for reducing the saturation of other colours while leaving flesh tones relatively unaltered. The cool pallor that results can be effective in a wide range of people-based photography – from fashion to photojournalism.

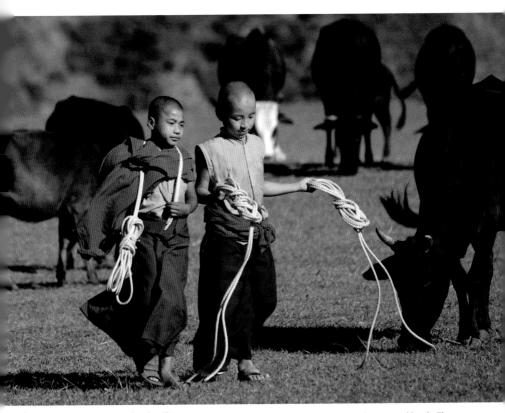

Low saturation, high vibrance Combining the two controls can produce highly effective results, that balance delicate coloration with a strong sense of realism. If we set a low saturation, all colours are globally made greyer. Adding a high vibrance setting restores

red-yellow colours closer to their natural levels. The difference in saturation helps the flesh tones to stand out against the naturally tinted background. Notice too how the cattle now "recede" into the background.

MANIPULATION DEFECTS

Post-processing techniques are brilliantly powerful. But it is good practice to avoid creating unintended defects while making corrections in some other part or aspect of the image.

Working methods

Like many other craft skills, post-processing proceeds most smoothly when you work methodically and steadily. Plan what you want to do with an image before you start working on it: you will make white balance, exposure, and tonal adjustments before tackling deeper changes to the image, such as

cloning or working with layers. If you are using direct-working software such as Photoshop, make adjustments on Adjustment Layers where possible, to help preserve quality.

The majority of images will need only subtle or soft changes to make a vast improvement to their appearance: these types of change are unlikely to cause unwanted side effects. It is the application of strong changes that gives rise to the most problems. One useful trick that may help to reduce side effects is to make a series of smaller changes to achieve the same result.

▲ Pixellation

The disruption of image detail caused by using too few pixels to create the image is relatively rare, now that cameras use high-resolution sensors. However, it is possible to use an icon or low-resolution version of the image by mistake. Re-open with a larger file.

▲ Over-sharpening

Sharpening filters such as USM (UnSharp Mask) improve the appearance of sharpness but cannot make up for poor focusing or blur from movement. High levels of sharpening may improve blurred images but at the cost of creating haloes and unnatural tones.

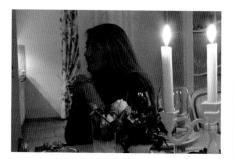

▲ Poor white balance

Scenes lit by coloured lights such as candles or nightclub spots gain a strong colour cast. Even if the overall colour cast can be removed to create neutral whites, other colours – such as flesh tones – may be inaccurate. Record in RAW (see pp. 158-61) for the best chance of full correction.

Cloning or healing defects

While cloning and healing tools for removing defects are very powerful, they can introduce defects of their own, such as the blurring of neighbouring boundaries and multiplying detail. Work at high magnification – at least 100 per cent – and use brushes just larger than the defects.

Principle of loss

A basic principle of digital photography is that loss of data from an image can never be recovered. Many manipulations, from adjusting levels and increasing sharpness or blur, to cloning – all destroy data. In recognition of this, if you are using applications such as Photoshop, Photo Painter or Paint Shop Pro, always work with a copy of the image, never the sole image file. If you wish to create a completely new version of an image, open up a new copy of the original; do not re-use one that has already been heavily manipulated.

▲ Boundaries with haloes

Sharpening filters such as USM (UnSharp Mask) and adjustments such as Shadows/Highlights can cause contrasting bands, or haloes, to appear around edges when used with too high a setting (USM), or too small a radius combined with high settings (Shadow/Highlights).

Banding

Caused by having insufficient data to define smooth transitions, banding is seen as stepped changes as the result of applying strong tonal change via, for example, Curves, Levels, or Shadow/Highlights controls. It is less of a problem than it used to be, thanks to improved sensor processing.

DEEP POCKETS

A class of image defects, including highlight clipping, shadow clipping, and banding, can be avoided by working with the data reserve of RAW format. The data in RAW may be extended by outputting the image in high bits per channel. Instead of the usual 8 bits per channel, RAW converters allow images to be coded with 10 bits, 12 bits, even 32 bits per channel. This results in large files that are capable of being very extensively processed.

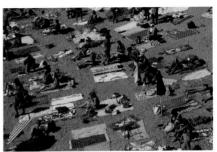

▲ Out-of-gamut colours

Brilliant colours can be made even more brilliant on the monitor screen. The result is eye-catching, but some colours may be impossible to print out, and some may lead to solid blocks of colour that look unnatural. Use the saturation control conservatively (see pp. 140–1).

▲ Noiseless

In the eagerness to eliminate all signs of noise from the image, you can cause the image to look too smooth, with silky textures that blur details. Where detail is near the size of the noise, for example, the fine wires in this image, noise reduction also smears the details.

CURVES

The Curves control found in image-manipulation software may remind older photographers of the characteristic curves published for films. This is a graph that shows the density of sensitized material that will result from being exposed to specific intensities of light. In fact, there are similarities, but equally important are the differences. Both are effectively transfer functions: they describe how one variable (the input either of colour value or of the amount of light) produces another variable (the output or brightness of the image).

The principal difference is that when it comes to image-manipulation software the curve is always a 45° line at the beginning. This shows that the output is exactly the same as the input. However, unlike the film curve, you can manipulate this directly by clicking on and dragging the curve or by redrawing the curve yourself. In this way, you force light tones to become dark, mid-tones to become light, and with all the other variations in between. In addition, you may change the curve of each colour channel separately.

▲ Original image and curve

Since the original negative was slightly underexposed, the image from the scan is tonally rather lifeless. You cannot tell anything about exposure by looking at the curve in the screen shot (*above*) because it describes how one tone is output as another. As nothing has been changed, when it first appears the line is a straight 45°, mapping black to black, mid-tone to mid-tone, and white to white. It is not like a film characteristic curve, which actually describes how film is responding to light and its processing.

▲ Boosting the mid-tones

The bow-shaped curve displayed here subtly boosts the mid-tone range of the image, as you can see in the resulting image (top). But the price paid is evident in the quarter-tones, where details in the shadows and the details in the highlights are both slightly darkened. The result is an image with, overall, more tonal liveliness – note, too, that the outline of the subject's face has been clarified. With some image-manipulation software, you have the option of nudging the position of the curve by clicking on the section you want to move and then pressing the arrow keys up or down to alter its shape.

What the Curves control does

The Curves control is a very powerful tool indeed and can produce visual results that are impossible to achieve in any other way. By employing less extreme curves you can improve tones in, for example, the shadow areas of an image while leaving the mid-tones and highlights as they were originally recorded.

And by altering curves separately by colour channel, you have unprecedented control over an image's colour balance. More importantly, the

colour changes brought about via the Curves control can be so smooth that the new colours blend seamlessly with those of the original.

Explore the image by running your cursor over the image: the majority of manipulation software give a "running commentary" of colour values and will also show the position of the point under the cursor as a point on the curve. Click on the curve when you hit a tone you wish to alter, then use the arrow up/down keys to adjust the position of this curve. Make small changes progressively: this helps

Output 135 | Figure 15 (6) | # # # | Show Clipping 15 Curve Display Options

▲ Emphasizing the highlights

The scan's flat, dynamic range suggests that it could make an effective high-key image by changing the curve to remove the black tones (the left-hand end of the curve in the screen shot is not on black but is raised to dark grey) and mapping many highlight tones to white (the top of the curve is level with the maximum for nearly a third of the tonal range). The result is that the input mid-tone is set to give highlights with detail. Very small changes to the curve can have a large effect on the image, so if you want to adjust overall brightness, it is easier to commit to the curve and then use Levels to adjust brightness (see pp. 120–1).

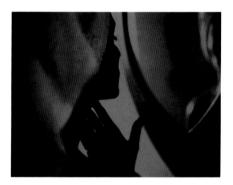

▲ Emphasizing the shadows

The versatility of the original image is evident here, as now it can be seen working as an effective low-key picture. The mood of the picture is heavier and a little brooding, and it has lost its fashion-conscious atmosphere in favour of more filmic overtones. The curve shown in the screen shot has been adjusted not simply to darken the image overall (the right-hand end has been lowered to the mid-tone so that the brightest part of the picture is no brighter than normal mid-tone). In addition, the slight increase in the slope of the curve improves contrast at the lower mid-tone level to preserve some shadow detail. This is crucial, as too many blank areas would look unattractive.

CURVES CONTINUED

ensure you do not make dramatic changes which look impressive but usually lead to loss of quality.

Extreme curves

Curves are also a powerful and simple way to obtain extreme tonal effects, such as reversal of tones to imitate Sabattier effect. In general, the subjects that react best to the application of extreme Curve settings are those with simple outlines and large, obvious features. You can try endless experiments with Curves, particularly if you start using different curve shapes in each channel. The following examples show the scope of applying simpler modifications to the master curve, thereby changing

The image you select for manipulating Curves does not have to be of the highest quality, but it should offer a simple shape or outline, such as this church. In addition, the range of colours can be limited – as you can see below, dramatic colours will be created when you apply Curves with unusual or extreme shapes.

▲ Reversing dark tones

A U-shaped curve reverses all tones darker than mid-tone and forces rapid changes to occur – an increase in image contrast, for example. The deep shadows in the church become light areas, giving a negative type of effect, but the clouds have darkened and greatly increased in colour content. The effect of using this shape curve is similar to the darkroom Sabattier effect, when exposed film or paper is briefly re-exposed to white light during development.

all channels at the same time. Note how seemingly even areas of tone can break up into uneven patches when an extremely steep curve is applied: this is due to a lack of data, which leads to aliasing or posterization.

The turning point of a curve also makes a great of demand on image data. If you wish to maintain

smooth tonal transitions, you need access to as much image data as possible. Where extreme adjustments are anticipated, record your images in RAW format, then convert to RGB applying 16 bits per channel, or even more. With modern high resolution cameras and image processing, high-bit images are very resistant to break-up of the image.

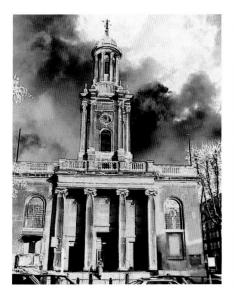

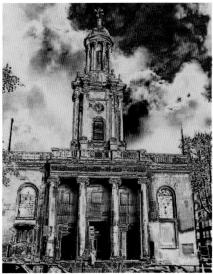

An arc-shaped curve reverses the original's lighter tones, giving the effect shown here. Although it looks unusual, it is not as strange as reversing dark tones (left). Note that the curve's peak does not reach the top of the range – the height of the arc was reduced to avoid creating overbright white areas. The colour of the building changes as the red-green colour in the normal image was removed by the reversal, allowing the blue range to make its mark.

▲ Tone/colour reversal

Applying an M-shaped curve plays havoc with our normal understanding of what a colour image should look like. Not only are the tones reversed as a result, but areas with dominant colour whose tones have been reversed will also take on a colour that is complementary to their own. And since parts of the tonal range are reversed and others are not, the result is a variegated spread of colours.

COLOUR TO BLACK AND WHITE

Creating a black and white picture from a colour original allows you to change the shot's emphasis. For example, a portrait may be marred by strongly coloured objects in view, or your subjects may be wearing clashing coloured clothing. Seen in black and white, the emphasis in these pictures is skewed more towards shape and form.

The translation process

A black-and-white image is not a direct translation of colours into greyscale (a range of neutral tones ranging from white to black) in which all colours are accurately represented – many cameras favour blues, for example, and record them as being lighter than greens.

When a digital camera or image-manipulation software translates a colour image, it refers to a built-in table for the conversion. Professional software assumes you want to print the result and so makes the conversion according to a regime appropriate for certain types of printing press and paper. Other software simply turns the three colour channels into grey values before combining them – in the main giving dull, murky results.

There are, however, better ways of converting to black and white, depending on the software you

have. But before you start experimenting, make sure you make a copy of your file and work on that rather than the original. Bear in mind that conversion to black and white loses colour data that is impossible to reconstruct.

Before you print

After you have desaturated the image (see box below), and despite its grey appearance, it is still a colour picture. So, unless it is to be printed on a four-colour press, you should now convert it to greyscale to reduce its file size. If, however, the image is to be printed in a magazine or book, remember to reconvert it to colour – either RGB or CMYK. Otherwise it will be printed solely with black ink, giving very poor reproduction.

Four-colour black

In colour reproduction, if all four inks (cyan, magenta, yellow, and black) are used, the result is a rich, deep black. It is not necessary to lay down full amounts of each ink to achieve this, but a mixture of all four inks (called four-colour black) gives excellent results when reproducing photographs on the printed page. Varying the ratio of colours enables subtle shifts of image tone.

DESATURATION

All image-manipulation software has a command that increases or decreases colour saturation, or intensity. If you completely desaturate a colour image, you remove the colour data to give just a greyscale. However, despite appearances, it is still a colour image and looks grey only because every pixel has its red, green, and blue information in balance. Because of this, the information is self-cancelling and the colour disappears. If, though, you select different colours to desaturate, you can change the balance of tones. Converting the image to greyscale at this point gives you a different result from a straight conversion, since the colours that you first desaturate become lighter than they otherwise would have been.

▲ Saturation screen shot

With the colour image open you can access the Saturation control and drag the slider to minimum colour. This gives a grey image with full colour information. In some software you can desaturate the image using keystrokes instead (such as Shift+Option+U in Photoshop, for example).

▲ Colour saturation

While the original colour image is full of light and life, the colours could be seen as detracting from the core of the image – the contrasts of the textures of the water, sand, and stones. This is purely a subjective interpretation, as is often the case when making judgments about images.

▲ Colour desaturation

By removing all the colours using the Saturation control to give an image composed of greys, the essentials of the image emerge. The Burn and Dodge tools (see pp. 122–3) were used to bring out tonal contrasts – darkening the lower portion of the picture with the Burn tool, while bringing out the sparkling water with the Dodge tool.

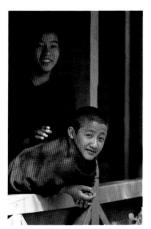

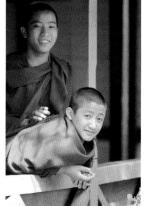

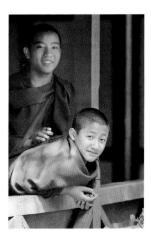

▲ Overcoming distracting colour

The strong reds and blues (above left) distract from the friendly faces of these young monks in Gangtok, Sikkim. However, a straight desaturation of the image gives us a tonally unbalanced result. Attempts to desaturate selectively by hue will founder because the faces are a pale version of the red habits. We need to compensate for the tonally unattractive product of desaturation

(middle) by redistributing the tones to bring attention to the boys' faces. This involves reducing the white point to control the sunlit area in the foreground, plus a little burning-in to darken the light areas of the habit and the hand of the monk behind. Then, to bring some light into the faces (right), we use the Dodging tool set to Highlights.

■ Levels screen shot

With the desaturated image open, move the white point slider in the Levels dialogue box to force the brightest pixels to be about a fifth less bright: in other words, to have a value no greater than 200.

COLOUR TO BLACK AND WHITE CONTINUED

Channel extraction

Since a colour image consists of three greyscale channels, the easiest way to convert the colour to greyscale is to choose, or extract, one of these and abandon the others. This process is known as "channel extraction", but it is available only as part of more professional software packages.

When you view the image on the monitor normally, all three colour channels are superimposed on each other. However, if you look at them one channel at a time, your software may display the image as being all one colour – perhaps as reds of different brightnesses, for example, or as a range of grey tones, according to the software preferences you have set. If your software gives you the option, choose to view the channels as grey (by selecting this from the preferences or options menu). Then, simply by viewing each channel, you can choose

the one you like best. Now when you convert to greyscale, the software should act on the selected channel alone, converting it to grey.

Some software may allow you to select two channels to convert to grey, thus allowing you a great deal of experimentation with the image's appearance. In general, the channels that convert best are the green, especially from digital cameras, because the green channel is effectively the luminance channel, and the red, which often gives bright, eye-catching results.

Another method, available in Photoshop, is to use Split Channels to produce three separate images. With this, you save the image you like and abandon the others. Note, however, that this operation cannot be undone – the extracted file is a true greyscale, and is just a third of the size of the original file.

▲ Red-channel extraction

While the colours of the original image are sumptuous (above left), black and white seemed to offer more promise (above right). It is clear that the sky should be dark against the mane and cradling hand, so the green and blue channels (right) were of no help. Neither was the lightness channel (opposite), as it distributes tonal information too evenly. The red channel, however, presented the blues as dark and the brown of the horse as light. So, with the red channel extracted, no extra work was needed.

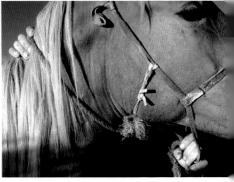

Olympia				44
LAYERS	CHANNELS	PATHS		=
	RGB		% 2	
9	Red		% 3	
	Green		% 4	
	Blue		% 5	
	0	0 3	3	

▲ Channels screen shot

If your software allows, select colour channels one at a time to preview the effects of extraction. Turn off the colour if the software shows channels in their corresponding colours.

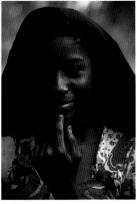

Comparing channels

RGB colour images comprise three greyscale images. Here, the B channel is dark while the R is too light, but the green is well balanced, as it carries the detail. This is confirmed by the L channel in LAB mode (far right).

Blue channel

Red channel

Green channel

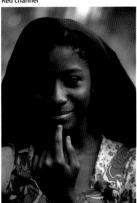

LAB (with Lightness channel extracted)

LAB MODE

When you convert an RGB colour image to LAB, or Lab, mode (a shortened form of L*a*b*), the L channel carries the lightness information that contains the main tonal details about the image. The a* channel values represent green when negative and magenta when positive; the b* represents blue when negative, yellow when positive. Using software, such as Photoshop, that displays channels, you can select the L channel individually and manipulate it with Levels or Curves without affecting colour balance. With the L channel selected, you can now convert to greyscale and the software will use only the data in that channel. If your software gives you this option, you will come to appreciate the control you have over an image's final appearance, and results are also likely to be sharper and more free of noise than if you had extracted another of the channels to work on. The extracted file is a true greyscale, and so it is only a third of the size of the original colour file.

▲ LAB channels

In the Channels palette of Photoshop, you can select individual channels, as shown above. In this example, the screen will display a black-and-white image of the girl (as above, right).

COLOUR TO BLACK AND WHITE CONTINUED

▲ Original image
A simple conversion of this image could make colours look lifeless - a problem avoided by using the Channel Mixer control (below).

▲ Working in RGB mode In RGB, the blue channel was reduced, making the sky dark, and the red was increased to compensate. Results of using these settings are contrasty and dramatic, but the foreground is too bright.

▲ Working in CMYK mode With the original image translated into CMYK mode, results are noticeably softer than those achieved via the Channel Mixer in RGB mode.

BLACK-AND-WHITE CONTROL

This conversion method offers the greatest control by separating the additive and subtractive primaries so that each can be individually adjusted. This means that, for example, the band of magenta colours in an image can be made dark while the red band can be made lighter. This gives a fine degree of control that enables you to separate tonalities of different colours with more accuracy than using Channel Mixer, and is more convenient than methods based on using layers. Adjacent bands should not be adjusted to be very different, however, as this can cause posterization or break-up of the image.

The workflow is to capture in full colour.

Optimise the image for exposure and tone, then adjust the Black and White settings to obtain the results you like. Ensure that you save the settings as a preset that can be applied to other images: this will save you a great deal of time. You may need to make final tweaks with curves and levels.

▲ Black and White control

The default setting renders a natural-looking blackand-white version of a colour scene. In this control, from Photoshop, you can easily add a tint by ticking the box, and adjusting the hue and saturation sliders.

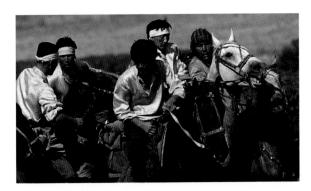

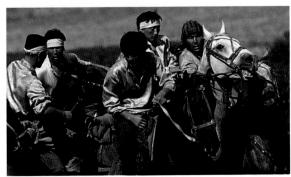

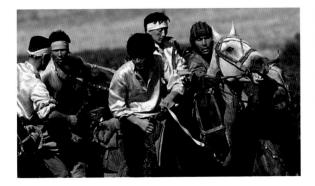

▲ Separating tones

Starting with this colour image (top left), a standard greyscale conversion gives acceptable results (middle left), but channel mixing separates out the tones more effectively, particularly in shadow areas (bottom left). The settings required were complicated, and arrived at by trial and error (screen shot above). The work done reduces the need for further processing of the image, but if you wish to refine the results further, a channel-mixed image makes such techniques as burning-in and dodging (see pp. 122-3) easier to apply, since, as you can see, the shadows on the shirts are far more open and susceptible to local density control.

TRY THIS

To help learn how to isolate colours using the tools available in your software, start by selecting a bright, multicoloured image – perhaps a collection of fruit, a flower stall, or something similar. Working on a copy of the image, now decide which colour you wish to emphasize by making it light after conversion to greyscale. Use Color Balance, Replace Color, Hue and Saturation,

or Channel Mixer tools to obtain the required result. If your first try does not work, return to the image and try a series of new settings. When you have a result you are happy with, note the settings. Use this information to replace another colour in the image, and see if you can get to the desired result more quickly than the first time.

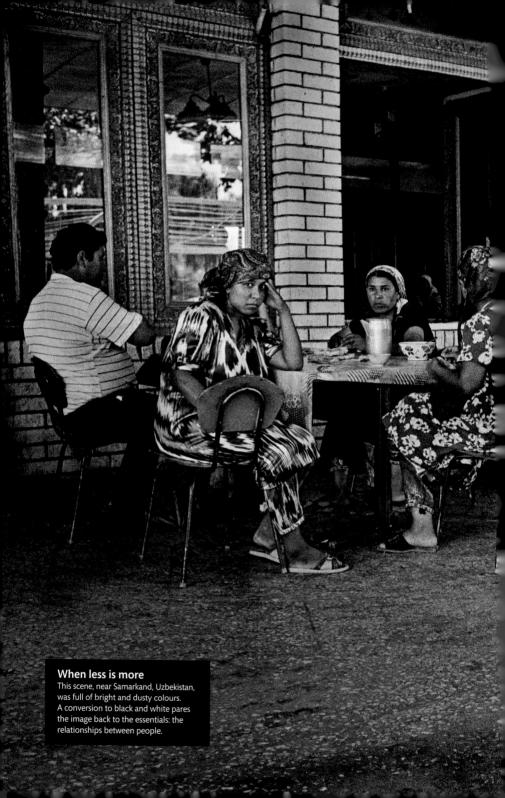

VINTAGE EFFECTS

The popularity of vintage effects, such as the look of distressed film, irregular blurs and flare, darkened corners, and distorted colours is, perhaps, a natural reaction against the modern, clinically-clean colour image. These effects have found huge favour with casual snappers, particularly those using camera phones or Holga film-using cameras. For them, part of the appeal is in the way that the effects help to "fill in" empty areas in the image, immediately "improving" snapshots. At the same time vignetting

serves to tighten picture composition, an effect that has been recognized since the dawn of photography.

Filters or apps

The traditional way to create vintage effects is to capture an image normally, then apply filter effects using image manipulation software. This allows you to apply different effects to the same image and to undo any effects you do not like. You can create your own vintage looks from scratch or use presets

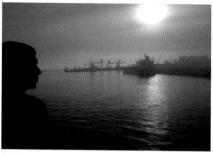

Original image A passenger on a ferry sliding slowly into the port of Brindisi, Italy looks full of wistful thoughts. It is an image that suggests itself for a nostalgic treatment to convey the timelessness of the mixed feelings experienced when arriving at a new port.

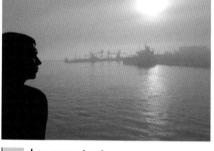

Lower contrast
Open the image and lower contrast with the
Levels or Curves control, then reduce the black and
white points. Vary the balance of colour channels
in Levels or use a colour balance control to produce
an overall tone.

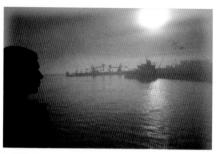

Apply irregular overlay
Open another image that has tones you like,
select the portion that you want to use, and copy
and paste it onto your original image. Resize to fit,
then choose a layer mode (here it is Overlay) that
gives your image the tone that suits your purpose.

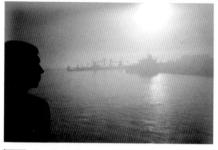

Apply lighting effects
Using a lighting filter in your image
manipulation applications, apply a lens flare
or vignette effect on the top layer. Or use a Brush
set with an irregular head, such as rough bristles –
loaded with a light colour to paint on lighting effects.

for software such as Adobe Lightroom and Apple Aperture, or plug-ins such as Topaz Adjust or Alien Skin Exposure. Apps for iPhone such as Instagram apply a limited set of effects but are very easy to use. A more recent approach is to make the image through an application such as Hipstamatic, which applies the effects during image processing, saving the image in its final "vintage" form. This is more challenging as you need to be able to pre-visualize the results, but it is fun and saves on post-processing.

Suppose you would like an image with a vintage sepia look: a low-contrast brownish tone with some lens flare, vignetting, and a "hand-crafted" appearance. By adding effects systematically you will understand how the image is created and can refine the process, for example, by adding an irregular border that mimics brushed-on emulsion. If you use an application that can record the steps as a script or "action", do so, so that you can apply them to another image.

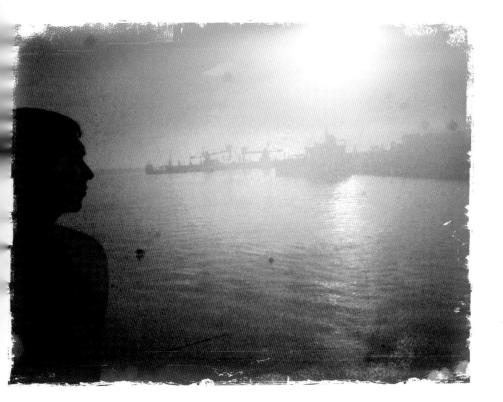

Create an irregular border Select the Eraser tool with irregular "bristles", and set to a wide diameter with a low Flow setting. Run the eraser along the edge of the image. If you wish to have repeatable results create a layer mask using the Paint tool. An alternative option is to

copy an image that has an irregular border and use this as the new border. For this image, I pasted one of my Hipstamatic shots on top, adjusted its shape, inverted its tone, then set the layer to Divide mode. A little extra erasing refined the final effect.

WORKING WITH RAW

It is a popular notion that RAW files offer the best possible image quality. However, some in-camera processing can produce results that are unobtainable with RAW. The real advantage of recording in RAW is that it provides the largest reserve of data for image manipulation.

Extracting colour

Before opting for a RAW workflow, it is sobering to consider the JPEG alternative. All sensors produce raw image data. When a camera saves the image as a JPEG (or, rarely, as a TIFF) it first extracts the full colour information from the sensor, then applies adjustments regarding contrast, colour saturation, sharpness, and so on. These parameters have been designed by experts in colour science and sensor technology. If you think you can do better than them, by all means work with RAW files. But a common complaint is of RAW processing producing images inferior to camera JPEGs.

Advantages of RAW

Nonetheless, while working with RAW requires a great deal more time and effort than with JPEG files, the rewards are there for those who truly require the quality – because they need to enlarge images to their limits, or publish them in top-class print media.

RAW processing preserves the maximum amount of original image data – particularly in shadow and highlights – which helps to ensure the highest possible image quality from each file. It offers you maximum flexibility with image brightness, white balance, and colour space. However, remember that if you make prints smaller than the maximum recommended for your files, many of the advantages of RAW processing will be lost in the print.

Batch conversion

The job of a RAW file converter, then, is to apply all the processing that the camera would normally do to deliver vibrant, sharp, and well-exposed images. All RAW conversion software allows you to save settings then apply the same setting to entire folders full of images: this is known as batch processing, and clearly it can save a great deal of manual

effort and time-consuming supervision. However processing large numbers of images will take some time, even on fast computers, because of the large files involved.

You can go further than any camera by tailoring the presets to different conditions. With landscapes, for example, you may aim for higher sharpness and saturation than you would when making portraits. You can create presets to suit different subjects and styles: high saturation, contrast, and sharpness for landscapes and urban views; low vibrance for documentary photography; sepia tone and soft contrast for portraits, and so on. This workflow is flexible yet it saves a great deal of time.

RAW styles

Not all RAW conversion software is created equal. Indeed, not only do the interface design, ease and speed of operation, support for your camera, and cost vary, but each application applies subtly different philosophies to image processing; for example, noise reduction being preferred over detail preservation. Nonetheless, where output has been expertly processed, it is very hard to identify any significant differences. With modern solutions, it is safe to select an application based on what you find easiest to use, but first ensure that your camera's specific RAW format is supported.

DNG

Adobe Digital Negative (DNG) is an attempt to bring order to the proliferation of RAW formats by creating a common "wrapper", or structure, for the data. Introduced in 2004, it is based on a standard format known as TIFF-EP. It is designed to accommodate metadata (such as MakerNotes for the camera) in order to allow for any DNG-compliant RAW converter to work on raw data irrespective of its source. As of 2010, DNG was supported by over 300 non-Adobe products and software – but is by no means universally adopted, particularly among the larger camera manufacturers. Suffixes for files are .dng or .DNG.

▲ Bright and dark

A hot desert sun burns through the clouds over Utah, USA while shadows in the foreground are rich in detail. Faced with such a subject, the best course is to record in RAW in the expectation of needing much remedial post-processing.

▲ Top and bottom

Strong recovery in the high values as well as darkening of blues brings the sky under control without banding (aliasing) artefacts. At the same time a great deal of digital "fill light" recovers lots of detail from the shadows.

▲ Detailed promise

In addition to tonal recovery and repair, the other reason for working with RAW is to capture as much detail as possible. This means we need to do more than resolve the fine, spikey cactus needles convincingly. We also need the resolving power for accurate tone reproduction – here, to

render with accuracy the extremely soft tonal transitions within the clouds and in the sky. In this enlargement – equivalent to a print about 84 cm (33 in) wide – there is smoothness as well as fair micro-contrast that should satisfy all but the most critical viewer.

WORKING WITH RAW CONTINUED

When you first open a RAW file in a converter, the image will have been processed using the default conversion settings. The software will have identified the camera used, looked up its database of RAW formats and applied the appropriate settings.

RAW flow

If you use proxy-working, non-destructive software such as Adobe Lightroom or Apple Aperture, the workflow is very simple. After downloading the images through the software, you work on the images and export only as you need: the applications provide an accurate preview of the output image. In addition, all the enhancements you make to images are automatically saved (see also p. 106).

If you use stand-alone RAW converters, such as Adobe Camera Raw, DXO Optics, Phase One or Nikon Capture NX, open your RAW image from the back-up copy, then:

■ Make settings – exposure, contrast, white balance,

Tough conditions

An overcast, stormy day produces dull lighting, but the luminance range – between the sky and the shadows behind the window – is nonetheless very wide. At the same time, there are subtle skin tones that we will wish to preserve.

JPEG roughness

The importance of working in RAW is most evident in transitions from dark mid-tones with detail to the deepest shadows. Manipulation of this JPEG version results in unattractive, sudden changes of tone and colour, due to poverty of data.

Conversion fine tuning

Assess the image in detail: you may need only small changes in brightness, hue, or sharpness, to perfect it. Some converters have a moiré control that applies a filter to reduce artefacts resulting from a clash between regular patterns and the sensor.

Colour temperature

The potential of the image emerges when we decrease colour temperature, that is, warm the white balance. This also brings out shadow detail because it is largely composed of dark reds. But it has the effect of making the greens dull, which we need to correct.

and colour adjustments; correction for chromatic aberration; and sharpening – or load and apply saved settings to the image.

- Set pixel dimensions, bit-depth, output resolution, and colour profile for the output.
- If you made a new set of settings, save it to use on other images made in similar conditions.
- Output or export the image in a standard TIFF or JPEG file, with a new name, to a new or work-inprogress folder.

TRY THIS

Get familiar with the different RAW converters before you purchase. Modern software allows you a trial – some give a generous 30 days full function, others are less generous – so take full advantage of it. Download and install the converters, collect some of your RAW images, then convert them with each trial version. Allow yourself at least four hours using the software before making any judgments about its suitability and quality of conversion.

Data mining

The image resulting from the RAW conversion is entirely usable, but we can do better. The warming of the white balance improved the skin tones but compromised the greens and also reduced the brilliance of the raindrops. So we need to top up

vibrance to improve the greens, leaving the skin tones alone. Burning-in set to Shadow darkens the shadows around the raindrops, which has the effect of accentuating them. A final touch is to use the Clone tool to remove the window catch by the model's face.

DUOTONES

Much of the art of traditional black and white printing lay in making the most of the limited tonal range inherent in the printing paper. A common tactic was to imply a wider tonal range than really existed by making the print contrasty. This suggested that shadows were really deep while highlights were truly bright. The success of this depended on the subtleties of tonal gradation between these extremes. A further technique was to tone the print, adding colour to the neutral grey image areas.

Modern digital printers have opened up the possibilities for toning well beyond that possible in the darkroom. The range of hues is virtually unlimited as you can simulate all those that can be created with the four-colour (or more) process.

◄ Simple duotones

This view of Prague (*left*) has been rendered in tones reminiscent of a bygone era. After turning the image to greyscale, two inks were used for the duotone, neither of them black. This gave a light, low-contrast image characteristic of an old postcard.

▲ Duotone Options screen shot

The curve for the blue ink (above) was lifted in the highlights in order to put a light bluish tone into the bright parts of the image and also to help increase the density of the shadow areas.

Creating a duotone

Starting with an image, even a colour one, first turn the file into a greyscale (see pp. 148–53) using, in Photoshop, the Image > Mode menu. This permanently deletes colour information, so you need to work on a copy file. Similar results can be obtained in the Sepia Tone effect, a menu option in almost all image-manipulation applications.

Now that you have a greyscale image you can enter the Duotone mode, where you have a choice of going it alone or loading one of the preset duotones. If you are not familiar with the process, use the Duotone Presets (usually found in the "Presets" folder of Photoshop). Double-click on any one to see the result.

Clicking on the coloured square in the dialogue box (see opposite) changes the colour of the second "ink". Bright red could give an effect of gold toning; dark brown, a sepia tone. This is a powerful feature – in an instant you can vary the toning effects on any image without any of the mess and expense of mixing chemicals associated with the darkroom equivalent.

If you click on the lower of the graph symbols, a curve appears that tells you how the second ink is being used, and by manipulating the curve you can change its effect. You could, for example, choose to place a lot of second ink in the highlights, in which case all the upper tones will be tinted. Or you may decide to create a wavy curve, in

which case the result will be an image that looks somewhat posterized.

In Photoshop, you are able to choose to see Previews. This updates the image without changing the file, thereby allowing you to see and evaluate the effects in advance.

You need to bear in mind that a duotone is likely to be saved in the native file format (the software's own format). This means that to print it you may first have to convert it into a standard RGB or CMYK TIFF file, so that the combination of black and coloured inks you specified for the duotone can be simulated by the coloured inks of the printer. This is the case whether you output on an ink-jet printer or on a four-colour press.

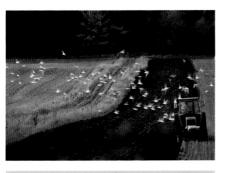

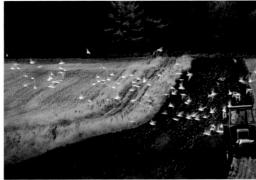

▲ Retaining subject detail

In the original image (above left), there was so much atmosphere it was a pity to lose the colour. But the resulting duotone, with a green second ink, offers its own charms (above right). To reduce overall contrast and allow the green ink (chosen via the Color Picker dialogue box, bottom left) to come through, it was necessary to reduce the black ink considerably - as shown by the Duotone Curve dialogue box (centre left). The low position of the end of the curve in the dialogue box (centre left) indicates a low density of black, but the kinks in the curve were introduced to increase shadow contrast and retain subject detail. The lifted end of the curve shows that there are no real whites: the lightest part still retains 13.8 per cent of ink, as shown in the top box labelled "0:" in the Duotone Curve dialogue box.

CROSS-PROCESSING

Of the numerous unorthodox ways to process colour film, perhaps the most popular was developing transparencies in chemicals designed for colour negatives, and processing colour negatives in chemicals designed for colour transparency film.

Cross-processing techniques made fundamental and irreversible changes to the image, so there is much to be said for simulating the effects using digital image-manipulation techniques. There is a further advantage to working digitally. Colour negative film was overlaid with an orange-coloured mask whose job it was to correct inherent deficiencies in the colour separation or filtering

process during exposure. Before the final print could be made, this mask had to be replaced or neutralized.

Colour negative film to transparencies

Results from this type of cross-processing had flat tones and muted colours due to the fact that colour negative film was low in contrast, and transparency processing chemicals compress highlights. Colour was also unpredictable, resulting in colour balance in the highlights being different from that in the lower mid-tones and shadows.

Digitally, the Curves control is the best way to simulate this effect, though do not be alarmed if your

Processing negatives as transparencies

The flattening out of image contrast and the semblance of colour toning that resulted from processing colour negative film in chemicals intended for transparencies can create an interesting portraiture effect. By applying different curves to each colour channel (above), the colour balance was shifted away from the red (above left) toward the yellow-green colouration that is typical of this form of cross-processing (left). The curves that are given here are for your guidance only: you can start with these but you are likely to want to adjust them, particularly the master RGB curve, to suit the particular images you are working on.

image becomes too dark or light – you can adjust overall brightness later. Another possible image outcome is posterization. If you find this effect unattractive, then the quality of the scan may not be good enough. If that is the case, your only option is to rescan the original image, possibly to a higher bit-depth.

From transparencies to colour negatives

Results from processing transparencies as colour negatives were often contrasty, with colour shifts toward cyan. They also had an open tonality, often with highlights reproducing as featureless white. This occurred because of the need to print inherently high-contrast transparencies on paper meant for the lower contrast of colour negatives.

The best way to create this effect digitally is to manipulate the separate channels in the Curves control. When you have a set of curves that work, you can save and reapply them to any image.

If you find it hard to concentrate on the overall lightness of the image while juggling with different channels, leave overall density to the end and work just on the colours and contrast. Once you are satisfied with these, call up the Levels control (see pp. 120-1) to adjust overall brightness.

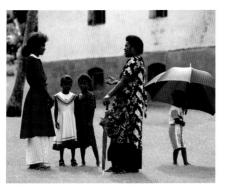

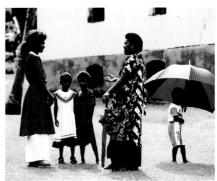

▲ Processing transparencies as negatives

The high-contrast effect that resulted from cross-processing colour transparency film in colour negative chemicals works with subjects that have strong outlines and punchy colours (above left). By applying the set of curves shown here (right), the result is brilliant colour and the type of washed-out highlights typical of this form of cross-processing (above right). As the highlight areas are tonally balanced by the full shadows and strong colours, they are more acceptable than in an image with a normal tonal range. The curves given here are for your guidance only: you can start with these but you are likely to want to adjust them, particularly the master RGB curve, to suit your particular images.

TINTS FROM COLOUR ORIGINALS

It is not necessary for colour images to be strongly coloured in order to have impact. You can, for example, use desaturated hues – those that contain more grey than actual colour – to make more subtle colour statements. In addition, selectively removing colour from a composition can be a useful device for reducing the impact of unwanted distractions within a scene (see pp. 134–5).

For global reductions in colour, you need only turn on the Color Saturation control, often linked with other colour controls, such as Hue, in order to reduce saturation or increase grey. By selecting a defined area, you can limit desaturation effects to just that part of the image.

Working procedure

While working, it may be helpful to look away from the screen for each change, since the eye finds it difficult to assess continuous changes in colour with any degree of accuracy. If you watch the changes occur, you may overshoot the point that you really want and then have to return to it. The resulting shuffling backwards and forwards can be confusing. Furthermore, a picture often looks as if it has "died on its feet" when you first remove the

colour if you do it suddenly – look at the image again after a second or two, and you may see it in a more objective light.

For an extra degree of control, all image-manipulation software has a Desaturation tool. This is a Brush tool, the effect of which is to remove all colour evenly as it is "brushed" over the pixels. Work with quite large settings – but not 100 per cent – in order to remove colour quickly while still retaining some control and finesse.

Another way of obtaining tints of colour from your original is to select by colour, or range of colours. If you increase the saturation of certain colours, leaving the others unchanged, and then desaturate globally, the highly saturated colours will retain more colour than the rest of the image, which will appear grey in comparison.

Bear in mind that many pixels will contain some of the colour you are working on, even if they appear to be of a different hue. Because of this, it may not be possible to be highly selective and work only over a narrow waveband. Photoshop allows you to make a narrow selection: you can use Replace Color as well as the waveband limiter in Hue/Saturation.

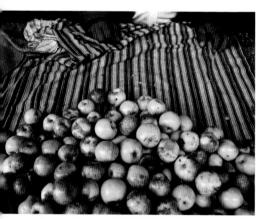

▲ Global desaturation

For a selective desaturation of the original (above left), the whole image was slightly desaturated, while ensuring that some colour was retained in the apples and hands (above right). The process was paused so that the apples and hands

could be selected, and then the selection was inverted, with a large feathering setting of 22. This is easier than selecting everything apart from the hands and apples. Desaturation was again applied, but this time just to the selected area.

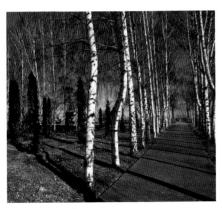

▲ Selective colour

The original shot of a park in Kyrgyzstan (above left) was too colourful for the mood I wanted to convey. In preparation for a selective desaturation based on colourband, I first increased the blues to maximum saturation in one action by selecting blues in the Saturation sub-menu. Then I opened Saturation again and boosted yellows (in order to retain some colour in the leaves on the ground and the distant trees in the final image). The result of these two increases produced a rather gaudy interpretation (above right). Normally, a 40 per cent global desaturation would remove almost all visible colour, but when that was applied to the prepared image, the strengthened colours could still be seen while others, such as greens, were removed (right).

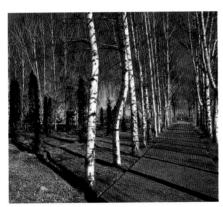

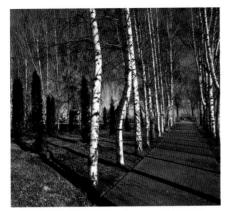

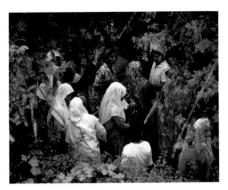

▲ Partial desaturation

The best way to desaturate the original highly colourful image (above left) was to use the Desaturation tool (also known as Sponge in the Desaturation mode), as it allowed the effects to be built up gradually and for precise strokes to be applied. Although the intention was to desaturate the trees completely, in order to emphasize the glorious colours of the women's clothes, as the strokes were applied it

became clear that just a partial removal and toning down of the green would be more effective (*above right*). The image was finished off with a little burning-in to tone down the white clothing.

HIGH DYNAMIC RANGE

The dynamic range of a scene is the difference in brightness between its lightest (or brightest) part and the darkest (or blackest) shadow; formerly it was known as the scene luminance range. Dynamic range is high relative to the recording method we use: we say it is "high" where the scene's range of brightness is too large to record all the details we want, given the equipment being used. For this reason, a scene in which the dynamic range is "high" to a camera phone could be easily accommodated by a large-sensor SLR camera.

Capture range

Typical high-dynamic range (HDR) scenes are, for example, a landscape that contains bright sky or sun with deep shadows under trees, or a portrait by a window in which we wish to record skin tones in shadow as well as the sunlit garden beyond.

One way to consider a scene in which the dynamic range exceeds the recording capacity of our equipment is that the bright parts need one exposure setting, such as f/22 at 1/40 sec, while the darker parts need another, say f/2 at 1/45 sec. A full range of tones can be captured by blending two or more different exposures: one correctly exposed for the lower mid-tones and one for the upper high tones. There are various HDR techniques available, which calculate the blending in different ways, but the majority of "HDR images" are created through tone mapping. This compresses the range of tones

▲ Highlight/Shadow effect

By using controls that bring out shadow and highlight details, you can simulate the appearance of HDR; indeed, these controls work by compressing an

HOW TO TONE MAP

To create tone-mapped images, you need to take a series of shots at different exposures that cover the dynamic range, without moving the camera between each. Note that tone mapping works best on static subjects.

- Set the exposure mode to Aperture Priority: this ensures there are no changes in focus or depth of field with each exposure.
- Lock the camera on a tripod, rest it on a stable surface, or turn on image stabilization.
- Set the camera to bracket exposures: best results come from making more exposures (5 is ideal, 3 is the minimum for good results), and having smaller differences between exposures (1 stop differences are better than 3 stops).
- Make the bracketing exposures: wait for a still moment when there is no wind or movement.
- Open the set of images in software such as Photomatix or Photoshop (File > Automate > Merge to HDR), and blend your images.
- Experiment with using different settings.

into the compass of a normal monitor or print image. At the same time, details can be smoothed, saturation raised, and curves adjusted to create an attractive image. These can range from the realistic in appearance to images that are strongly painterly, with bold colours expressed in only mid-tones.

image's tonal range. However, the effect usually looks unnatural and is further marred by halos around the subject (*above*).

▲ Limits to blending

A raw image of an unlit room taking in the sunny view outside can be darkened to bring colour to the window (top left), while another version may be lightened to bring out detail in the flowers in the foreground

(above left). Blending the images using Blend Options partially succeeds (above), but transitional mid-tone areas, such as those around the window, are not well blended.

MFRGF TO HDR

This shot of two friends by the sea originally came out as a silhouette, with poor details in the shadows. I wanted to retain some feeling for the silhouette, but extract some shadow detail, too. From the RAW file, I made some versions that darkened the bright light on the sea, and some that opened up the shadows. In Merge to HDR, the best result was from the Exposure and Gamma option. A little adjustment in Levels improved the overall contrast (see below).

In Photoshop, Merge to HDR offers four different algorithms for combining images: the "best" option depends on the characteristics of your image. In most cases, Exposure and Gamma is the most useful, and it offers fine-tuning controls that are not available in the other methods. Local Adaptations produces highly graphic results and offers radius-based fine-tuning.

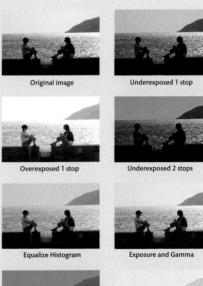

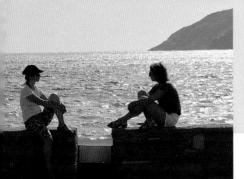

Local Adaptations

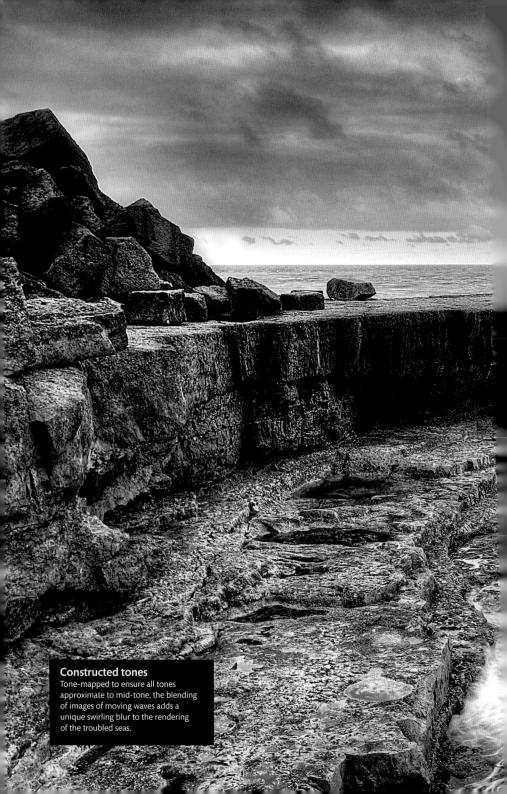

SELECTING PIXELS

There are two methods of localizing the action of an image-manipulation effect. The direct way is to use a tool that applies the effect to a limited area, such as the Dodge tool or any Brush. The other method is to first select an area or certain pixels within the image, then apply the effect. This ensures that only the selected pixels will be affected. Selection is founded on a continuous boundary of difference between two areas. This means that, with a bit of guidance from you, the software can compute the rest.

Masks and selections

It is important to understand that fundamentally there are two different ways of applying effects to a limited area of an image. Both define the areas that you can edit or in which you can apply an effect: these are called editable areas. A mask works by protecting an area from an effect – like an umbrella keeping you dry while all else gets rained on.

A selection does the opposite: it limits an action to the area it encloses – like watering only on a flower bed but not outside it.

There are also other differences. First, a selection is essentially a temporary mask – it disappears as soon as you click outside the selected area (some programs allow you to save a selection, to reapply it later or to use it on another image). If it can be saved for re-use, it is known as an alpha channel (technically a mask). Second, in software with Layers, the selection applies to any layer that is active. Third, you can copy and move selected pixels – something that cannot be done with a mask. In practice you will switch frequently between masks and selections.

Selections

A selection defines the border of the editable area, usually by showing a line of "marching ants" or moving dots. In fact the line joins the mid-points

▲ Selecting clean shapes

This view of a church in New Zealand shows the clean lines of the wooden windows, but they look too dark and colourless. In order to make the windows lighter, but without affecting the pale wooden walls, we need to select the windows individually.

▲ Making a selection

Using Photoshop's Lasso, with a feathering width set to 11 pixels, I selected the dark glass within the window frames. To start a new area to be selected, hold down the Command key (for Macs) or the Control key (for PCs) – the selected area is defined by moving dashes, known as "marching ants". When the Levels command is invoked, settings are applied only to the selections.

▲ Final effect

In some circumstances, the somewhat uneven result of using the Lasso selection can produce more realism than a perfectly clean selection would give. The dark areas remaining towards the bottom of the right-hand windows correspond to the area omitted from the selection in the previous image (above left).

between pixels that are wholly selected and those that are fully ignored - others lie on a transitional zone, which is known as the "feather" region. It follows that selections are most accurate when the feather region is not wider than a few pixels; with a wide feather region it becomes difficult to know exactly where the editable area starts and stops. An important option is the ability to partially select a pixel near the edge of a selection. This is called "feathering". It creates a gradual transition across the boundary from pixels that are fully selected, through those that are partially selected, to those that are unselected, thus smoothing out the effect you apply. A feathering of 0 means that the transition will be abrupt; more than 1 pixel will give a more gradual transition. Note that the effect of increased feathering is to smooth out any sharp angles in the selection.

The appropriate feather setting depends on the subject and type of selection you want. Cleanly

bounded subjects, such as buildings against the sky or a figure against a white background, benefit from a narrow feather range. On the other hand, a wide feathering suits images with blurred outlines due to limited depth of field.

Quick mask

When you make a selection it is very useful to be able to judge its effect – to see what has been blocked out and what is left in. The quick mask mode, available in many applications, switches between showing the selection and showing the equivalent mask – usually as a red overlay. In this mode, you can adjust the mask by erasing parts you wish the selection to reach, or painting to increase the reach of the selection.

Make a choice

There are two fundamentally different ways of making selections. Some, like the Lasso or Marquee

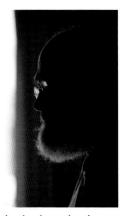

▲ Selecting irregular shapes
This back-lit portrait is rather harshly lit
by the open window, although the
darkness behind the curtains softly
rim-lights the face. Clearly, removing
the face from the background will be a
challenge because of the man's beard.

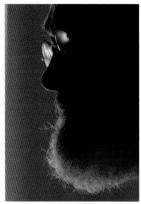

▲ Quick selection The Quick Selection too

The Quick Selection tool in Photoshop selected the head swiftly, but as the darkness at the top blended into the background, the selection extended too far, so had to be reduced. Then, zooming in, a small Brush was used to apply Quick Selection to individual hairs. In Quick Mask mode you can see that the background will be removed so we can apply the face to a different background.

▲ Layer over

When you have masked away the original background, you are free to apply any other image as the background. I chose an alleyway in Greece at night, as the lighting matches that of the portrait yet provides a much softer backdrop one which makes the most of the sparkle in the spectacles.

SELECTING PIXELS CONTINUED

tool, indiscriminately gather up all the pixels within the area they define, taking no account of pixel values. On the other hand, value-sensitive selections, such as Magic Wand or Color Range, look at values and the location of pixels – for example, whether they are touching similar pixels or not – when calculating the selection.

The basic Lasso tool is best for selecting disparate areas with different colours and exposure. Where you have clearly defined objects that are distinguished by colour and exposure from the background, Magnetic Lasso or the equivalent, is a good choice. If you need to select irregular areas with straight-line borders, the Polygonal Lasso is the obvious tool.

Tools that select like pixels include the Magic Wand tool; you can click directly on the image to select pixels that are similar to the sampled area. With the Color Range command you click on a preview to select all related pixels. The control is useful for locating out-of-gamut colours in order to

bring them into gamut. More sophisticated tools can select pixels by computing their degree of similarity, which can give excellent results, even for the unskilled.

Computed choice

Some boundaries are extremely complicated or subtle, or both, with hair and glass commonly regarded the trickiest subjects. Tools in software such as Topax Remask and Adobe Photoshop have eased the problem. All work by first defining a transition region, such as the edge of a wine glass. Then you define the region to keep and the region to cut. The boundaries do not have to be drawn with great precision, but the tighter and more accurately drawn the transition area – so that unwanted colours are not included – the more accurate the selection will be. The software then computes the mask to apply; the best create soft and hard edges as demanded by the image.

▲ Transparent choice

A wine-glass of water presents the paradox of a transparent edge. Colour shows through the glass, but if we want to add another glass to the table we do not want to lose the edge. A combination of personal judgement and computation will be needed.

Remasking

Using a masking plug-in, such as Remask (illustrated) or Perfect Mask, takes several stages. After defining the transition area - the areas to keep and areas to lose - you need to refine it. Here, parts of the glass will be lost (red) but other parts will be kept. The transition area is not perfect but computation will clean it up.

Double or dare

The masked image is placed on a layer over the original, so it can be moved easily. Here, it was moved to occupy the empty space, the water was turned to wine with a brush loaded with yellow, and the glass was made slightly smaller than the original as it is a little further away.

HINTS AND TIPS

- Learn about the different ways of making a selection. Some are obvious, such as the Lasso or Marquee tool, but your software may have other less-obvious methods, such as Color Range in Photoshop, which selects a band of colours according to the sample you choose.
- Use feathered selections unless you are confident you do not need to blur the boundaries. A moderate width of around 10 pixels is a good start for most images. But adjust the feathering to suit the task. For a vignetted effect, use very wide feathering, but if you are trying to separate an object from its background, then very little feathering produces the cleanest results. Set the feathering before making a selection.
- Note that the feathering of a selection tends to smooth out the outline: sudden changes in the direction of the boundary are rounded off.
 For example, a wide feathering setting to a rectangular selection will give it radiused corners.

- The selected area is marked by a graphic device called "marching ants" a broken line that looks like a column of ants trekking across your monitor screen: it can be very distracting. On many applications you can turn this off or hide it without losing the selection: it is worth learning how to hide the "ants".
- In most software, after you have made an initial selection you can add to or subtract from it by using the selection tool and holding down an appropriate key. Learning the method provided by your software will save you the time and effort of having to start the selection process all over again every time you want to make a change.
- Examine your selection at high magnification for any fragments left with unnatural-looking edges.
 Clean these up using an Eraser or Blur tool.
- Making selections is easier to control with a graphics tablet (see p. 216) rather than using a mouse.

▲ Selecting like colours

The brilliant red leaves of this Japanese maple seem to invite being separated out from their background. However, any selection methods based on outlining with a tool would obviously demand a maddening amount of painstaking effort. You could use the Magic Wand tool but a control such as Color Range (above right) is far more powerful and adaptable.

▲ Color Range screen shot

In Photoshop, you can add to the colours selected via the Eye-dropper tool by using the plus sign, or by clicking the Eye-dropper tool with a minus sign (beneath the Save button). However, you can refine the colours selected. The Fuzziness slider also controls the range of colours selected. A medium-high setting ensures that you take in pixels at the edge of the leaves, which will not be fully red.

▲ Manipulated image

Having set the parameters in the Color Range dialogue box (above left), clicking "OK" selects the colours – in this case, just the red leaves. By inverting the selection, you then erase all but the red leaves, leaving you with a result like that shown here. Such an image can be stored in your library to be composited into another image or used as a lively background in another composition.

MASKS

Masks allow you to isolate areas of an image from colour changes or filter effects applied to the rest of the image. Unlike real-life masks, digital types are very versatile: you can, for example, alter a mask's opacity so that its effects taper off allowing you to see more or less clearly through it. Using imagemanipulation software you can alter a mask until you are satisfied with it and then save it for reuse. When you do so, you create what are known as "alpha channels", which can be converted back to selections. Technically, masks are 8-bit greyscale channels – just like the channels representing the colours – so you can edit them using the usual array of painting and editing tools.

If your software does not offer masks, don't worry – it is possible to carry out a good deal of work by the use of selections. But remember that selections are inclusive – they show what will be included in a change; masks work the opposite way, by excluding pixels from an applied effect.

Software takes two approaches to creating masks. First is Photoshop's Quick-mask, which gives direct control and allows you to see the effect of any transitional zones. Or, you can create a selection that is turned into a mask. This is quick, but transitional zones cannot be assessed.

Quick-mask

In Photoshop and Photoshop Elements you hit the Q key to enter Quick-mask mode. You then paint on the layer and hit Q again to exit, but in the process, you turn the painted area into a selection. You can also invert your selection (select the pixels you did not first select) – sometimes it is easier to select an area such as bright sky behind a silhouette by selecting the silhouette and then inverting the selection. You then turn the selection into a mask by adding a layer mask.

The layer mask makes all the underlying pixels disappear, unless you tell it to leave some alone. When applying a layer mask, you can choose to mask the selected area or mask all but the selected area. The advantage of Quick-mask is that it is often easier to judge the effect of the painted area than it is to make many selections. It also means that an accidental click of the mouse outside a selection does not cancel your work – it simply adds to the mask. Use Quick-masking when you have many elements to mask out at once.

Turning selections into masks

Some methods of selecting pixels have already been discussed (see pp. 172-5). If you need a sharp-

USING QUICK MASK

Bottom layer

Quick-mask, or any method where you "paint" the mask, is best when you are not attempting to enclose a clearly defined shape, such as a person's silhouette. It is best first to place the image that will be revealed under the mask - here, an Islamic painting.

Creating the mask

Next, the mask is applied to the main leaves in this negative image. The red colour shows where the freehand masking will be created. When it is turned into a mask, this is the area that will allow the base image to show through.

edged selection whose scale you can change without losing crispness of line, then you need to create a clipping path.

Although almost anything you can do with masks you can do with selections, it is convenient to turn a selection into a mask as it is then easier to store and reuse – even for other images. It is good practice to turn any selection you make into a mask (just in case you wish to reuse it), particularly if it took a long time to create.

ALPHA CHANNELS

Alpha channels are selections stored as masks in the form of greyscale images. The convention is that fully selected areas appear as white, non-selected areas are shown black, while partially selected areas appear as proportionate shades of grey. In effect, an alpha channel is just like a colour channel, but instead of providing colour it hides some pixels and allows others to be visible. An alpha channel can be turned into a selection by "loading" the selection for that channel. The term "alpha" refers to a variable in an equation defining the blending of one layer with another.

▲ Limiting filter effects

Here (top), the mask "protects" the child's face from the effect of the Stylize/Extrude filter. Note that when you turn the painted area into the selection, the mask would be applied only to that selection, so you have to invert the selection to take in everything but the face. When the filter was applied (above), it worked only on the pixels that were not protected.

Quick-mask Layers screen shot
This dialogue box shows that the painting
forms the bottom layer (but not the background, as
masks cannot be applied to the background). The
top layer consists of the grass and, to the right, the
mask is also shown.

Final effect

You can move the underlying image around until you are happy with the results – in other words, when the most effective areas are showing through within the areas defined by the masking.

QUICK FIX REMOVING BACKGROUNDS

One of the most common image-manipulation tasks is the elimination of backgrounds. There are two main methods: one is to remove the background directly by erasing it (which is time-consuming); the other is to hide it under a mask.

Problem: The main problem is how to separate a foreground object from its background while retaining fine edge detail, such as hair, or maintain the transparency of a wine glass and retain shadows and blurred edges.

Analysis: Almost all edges in images are slightly soft or fuzzy – it is more the transitions in colour and brightness that define edges. If a transition is more sudden and obvious than others in the locality, it is seen as an edge. If you select the foreground in such a way as to make all its edges sharp and well defined, it will appear artificial and "cut-out". However, much depends on the final size of the foreground: if it is to be used small and hidden by a lot of other detail, you can afford a little inaccuracy in the selection. If not, you must work more carefully.

Solution: Make selections with edge transitions that are appropriate to the subject being extracted. The usual selection methods – Lasso or Magic Wand – are sufficient most of the time, but complicated subjects will need specialist tools, such as Corel KnockOut, Extensis Mask Professional, or the Extract Image command in Photoshop.

HOW TO AVOID THE PROBLEM

With objects you expect to separate out, it is best to work with a plain backdrop. However, while a white or black background is preferable to a varied one, even better is a coloured ground. The aim is to choose a colour that does not appear anywhere on the subject – if your subject is blond, has tanned skin, and is wearing yellow, a blue backdrop is perfect. Avoid using rimlighting, as this imparts a light-coloured fringe to the subject. In addition, avoid subject-movement blur and try to keep an extended depth of field so that any detail, such as hair behind the subject's head, is not soft or fuzzy.

▲ Low tolerance

With simple tasks, such as removing the sky from this image, the Magic Wand or similar tool, which selects pixels according to their colour and is available in almost all imagemanipulation software, is quick to use. It has just one control – the tolerance – which allows you to set the range of colours to be selected. If you set too low a tolerance (here the setting was 22) you obtain a result in which only a part of the sky is selected, seen by the marching ants occupying just the right-hand portion of the sky and small, isolated groups.

▲ Removing the sky

Adjusting the tolerance setting in small, incremental steps allows you to see when you have captured just the right area to be removed. Then, pressing "OK" removes your selection. The edges of the selection may be hard to see in a small image, but are clearly visible on a large monitor screen.

▲ High tolerance

If you set too high a tolerance, you will capture parts of the building where it meets the sky. Here, notice the result of setting a large feathering (111 pixels) to the selection – pixels a long way either side of a target pixel are chosen. As a result, the selection is smoothed out and the boundary is very fuzzy.

Original image
This original image of a young Afghan girl –
an expert carpet weaver – shows her taking to the
floor to dance. Unfortunately, the distracting
background does not add to the image as a whole.

Defining fore- and background
Using Corel KnockOut, I drew inside the girl's
outline to define the foreground and then outside it to
define the background. Between is the transition area
that allows soft boundaries to be smoothly masked.

Making the mask
Using the information from step 2, a mask was
created. This outlines the foreground and hides the
background: the black shows the hidden area and the
white where the image will show through.

Knocking out the background
Now, while the mask hides part of the image
on its own layer, it does not affect images on another
layer (below left). Therefore, if you place an image
behind the mask, you will see that image appear.

Layers screen shot
The Layers dialogue box shows the girl and
the associated mask lying over the introduced image.
Because the mask was produced by extracting the
girl, the original background is gone, awaiting a new
background image to be introduced.

Masked combination
The background was lightened to tone in with the colours of the girl. The mask has preserved the softness of her outline, and now she appears to be in front of the wall-hanging. An extra refinement may be to soften the background so that it appears less share.

LAYER BLEND MODES

The "layers" metaphor is fundamental to many software applications, such as desktop publishing, video animation, and digital photography. The idea is that images are "laid" on top of each other, though the order is interchangeable. Think of layers as a stack of acetate sheets with images; where the layer is transparent, you see through to the one below. However, not all software layers have the same resolution, start with the same number of channels, or have the same image mode. The final image depends on how layers blend or merge when they are "flattened", or combined, for final output. Before then, however, they allow you to make changes without altering the original data, while each remains independent of the others.

Colour as layers

A key point to remember is that the basic colour image is comprised of red, green, and blue layers – normally called channels. In essence, the terms "layers" and "channels" are interchangeable. Masks, too, are channels, as they work with a layer to affect the appearance of an underlying layer.

By analogy, if you see a face through a layer of misted glass it looks soft or diffused. Now, if you clean off part of the glass, the portion of face lying directly under the cleaned-off area becomes clearly visible, without being obscured as it is under other parts of the glass. So the glass is a layer over the underlying layer – the face – and by doing something to part of it, but not the whole, you have applied a mask, which is, in effect, another layer.

Using layers

The main use for layers (also known as "objects" or "floaters" in some applications) is to arrange composite images - those made up of two or more separately obtained images. You can place images on top of one another - varying the order in which they lie; duplicate smaller images and place them around the canvas to create a new image; or change the size of the individual components or distort them at will. At the same time, the ways in which one layer interacts or blends with the underlying layer - known as the blend modes - can also be altered. Finally, you can control the transparency or opacity of the layers, too - from high opacity for full effect (or low transparency), to barely visible, when you set a high transparency (or low opacity).

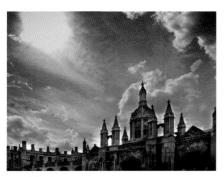

▲ Original 1

The dreamy spires of a Cambridge college in England offer the clean clarity of shape and line that are ideal for work with superimposing images. The actively clouded sky also adds variety without too much detail. Prior to use, the image had its colours strengthened by increasing saturation and the towers were straightened so that they did not lean backwards.

▲ Original 2

The outline of wintry trees in France provides fascinatingly complicated silhouettes for the image worker. Taken on a dull day, the sky was too even to be interesting for this exercise, so a rainbow-coloured gradient was applied across the whole image. Finally, the colours were strengthened and the outline of the trees sharpened to improve their graphic impact.

▲ Normal

The Normal blend is often ignored but it is a proper blending mode – provided you lower the opacity of the top layer below 100 per cent, the lower layer then becomes progressively more visible. Here, the top layer at 50 per cent shows a useful blend is possible – one that cannot be replicated by other blend modes – and it does not matter which is the topmost image.

▲ Screen

Adding together the lightness of corresponding pixels is like projecting one slide from a projector onto the projected image of another slide – the result is always a lighter image. By reducing the opacity of the top layer, you control image darkness. This mode is useful for lightening an overly dark image (the opposite of Multiply). Simply duplicate the image onto another layer and set the top to Screen, then adjust opacity.

▲ Multiply

This mode is the digital equivalent of sandwiching two colour slides – densities multiply and the image darkens. Here, the upper layer was reduced to 60 per cent opacity to stop the trees turning black. Multiply mode can be used to recover images that are too light (overexposed slides or underexposed negatives). Duplicate the image into another layer and set this new layer to Multiply.

▲ Overlay

This mode is able to mix colours evenly from both layers, and is very responsive to changes in opacity. It works by screening light areas in the upper layer onto the lower and by multiplying dark areas of the upper layer onto the lower, which is the opposite effect of Hard Light (see p. 182). At lowered opacities, its effect is similar to that of the Normal blend but with more intense colours. It is useful for adding textures to an image.

LAYER BLEND MODES CONTINUED

▲ Soft Light

Soft Light blending darkens or lightens image colours, depending on the blend colour. The effect is similar to shining a diffused spotlight on the image. Now, painting with pure black or white produces a distinctly darker or lighter area but does not result in pure black or white. This is a very effective way of making local tonal adjustments. It is a softer, and generally more useful version of the Hard Light blending mode.

▲ Hard Light

This mode is similar to Soft Light: it darkens image colour if the blend layer is dark, and lightens it if the blend is light, but with greater contrast. It simulates the contrasty projection of the image onto another image. It is generally less useful than Soft Light but can prove valuable for increasing local contrast – particularly if applied as a painted colour at very low pressures and lowered opacity.

BLENDING MODES

Interactions between layers are tricky to learn, as their precise effect depends on the value of a pixel on the source (or blend, or upper) layer compared with the corresponding pixel on the destination (or lower) layer. The most often-used method is simply to try them out one by one (hold the shift key down and press "+" or "-" to step through the menu) until the effect looks attractive. This can distract from your initial vision by offering effects you had not thought of – but that is part of the fun of working with powerful software. With experience you will get to know the Blend modes that are most pleasing and plan your images with them in mind.

One key point to remember is that the effectiveness of a mode may depend to a great extent on the opacity set on the source layer – sometimes a small change in opacity turns a garish result into one that is visually persuasive. So if you find an effect that does not look quite right, change the opacity to see what effect this has.

Of the many blend modes available in such software as Adobe Photoshop or Corel Painter, some of the most useful are:

- Soft Light: Offers a useful approach for making tonal adjustments (see above).
- Color: Adds colour to the receiving layer without changing its brightness or luminance – useful for colouring in greyscale images.
- Difference: Produces dramatic effects by reversing tones and colours.
- Color Burn/Dodge: Useful for greatly increasing contrast and colour saturation or, at lower opacities, making global changes in tone and exposure (see opposite).

Dissolve Oarken Multiply Linear Burn Darker Color Color Dodge Linear Dodge (Add) Lighter Colo Soft Light Hard Light Vivid Light Linear Light Hard Miv Difference Exclusion Color

▲ Interaction modes

The different ways in which layers can interact also apply to other situations, such as painting, fading a command, and cloning. Experience with different effects helps you to previsualize results.

▲ Color Dodge

At first glance, Color Dodge appears like Screen mode (see p. 181) in that it brightens the image, but its effect is more dramatic. Black in the upper layer has no effect on the receiving layer, but all other colours will tint the underlying colours as well as increasing colour saturation and brightness. This mode is useful when you want to create strong, graphic results. Note that when you change the order of the images you get markedly different effects.

▲ Color Burn

This blend mode produces very strong effects as it increases colour saturation and contrast. At the same time, it produces darkened images by replacing lighter underlying pixels with darker top pixels. Be aware that both Color Burn and Color Dodge modes often produce colours that are so extreme they cannot be printed – in other words, they are out-of-gamut for printers.

▲ Darken

The Darken mode applies only darker pixels from the top layer to the bottom layer. Here, the black branches of the trees overshadow anything that lies under them, showing the importance of using clear but interesting shapes. This mode does not strongly change colours. If, for example, there is no difference between the corresponding pixels on the top and bottom layers, there is no change – so this mode cannot be used to darken an image (but see Multiply, p. 181).

▲ Difference

The Difference mode is one of the most useful for giving dramatic and usable effects, since it reverses tones and colours at the same time – the greater the difference between corresponding pixels, the brighter the result will be. Notice how the dark forms of the trees are rendered in the negative, while the blues of the sky turn to magenta. Therefore, where top and bottom pixels are identical, the result is black, and if one is white and the other black, the result is white.

LAYER BLEND MODES CONTINUED

Exclusion

A softer version of Difference mode (see p. 183), Exclusion returns grey to pixels with medium-strong colours, rather than strengthening the colours. A useful variant is to duplicate the top layer and apply Exclusion to the duplicate layer – now topmost. This creates something similar to the Sabattier effect.

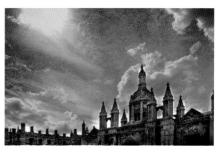

▲ Hue

In this mode the colours of the top layer are combined with the saturation and brightness (luminosity) values of the lower layer. The result can be a strong toning effect, as seen here, or it can be weak, depending on the images used. It is worth comparing the effect of this mode with that of the Color mode (below).

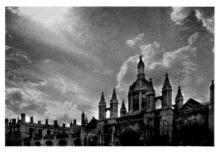

▲ Saturation

Here, the saturation of the underlying layer is changed to that of the corresponding pixel in the top, or source, layer. Where saturation is high, the lower image returns a richer colour. It is useful where you wish to define a shape using richer or weaker colours: create a top layer with the shape you want and change saturation only within the shape, then apply Saturation mode.

▲ Color

Both hue and saturation of the upper layer are transferred to the lower layer, while the luminosity of the receiving layer is retained. This mode simulates the hand-tinting effect of black and white prints. Note that the receiving layer does not have to be turned to a greyscale image for this mode to be effective. Compare this with Hue mode (above).

■ Luminosity

This blend mode is a variant of Hue and Color: this time, the luminosity of the top layer is retained while the colour and saturation of the underlying layer are applied. It is always worth trying the layers in different orders when working with these modes, particularly with this group consisting of Hue, Color, and Luminosity. In this image, reducing the opacity of the top layer produces a soft, appealing image, in contrast to the more high-contrast result when both layers are left at full strength.

▲ Vivid Light

This both burns and dodges: lighter blend colours decrease contrast and lighten the receiving layer (dodges), while darker ones increase contrast and darken the lower colour.

▲ Pin Light

Blend colours lighten or darken the underlying layer according to the blend colour and underlying colour. The results are tricky to predict, but visually appealing effects are often produced.

▲ Linear Burn

The receiving colours are darkened to match the blend colour. This burns or darkens the image without increase in contrast. The strong darkening effect is best tempered through opacity control.

▲ Linear Light

Similar to Vivid Light, this burns or dodges in response to the blend colour by changing brightness. Its effect is to increase contrast – as darker colours are darkened, lighter ones are lightened.

▲ Linear Dodge

Similar to Color Dodge (see p. 183), this blend mode brightens the base or receiving layer to match that of the blend layer, thus blends with black produce no change. It is an effective way of brightening an image to a high-key effect but has a tendency to produce too much blank white.

▲ Lighten

This mode chooses the lighter of the two colours being blended as the result of the combination. This blend tends to flatten or reduce contrast, but it is effective for producing pastel tones. Images that originally have subtle tones respond very well to this mode.

CLONING TECHNIQUES

Cloning is the process of copying, repeating, or duplicating pixels from one part of an image, or taking pixels from another image, and placing them on another part of the image. First, you sample, or select, an area that is to be the source of the clone, and then you apply that selected area where it is needed. This is a basic tool in image manipulation, and you will find yourself constantly turning to it whenever you need, say, to replace a dust speck in

the sky of an image with an adjacent bit of sky, or remove stray hairs from a face by cloning nearby skin texture over them.

This is only the start, however. Such cloning makes an exact copy of the pixels, but you can go much further. Some applications, such as Corel Painter, allow you to invert, distort, and otherwise transform the cloned image compared with the source you took it from.

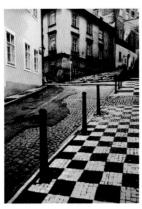

▲ Original image

An unsightly tarred area of road left by repairs marred this street scene in Prague. All it will take is a little cloning to bring about a transformation.

▲ History palette

The screen shot of the History palette shows the individual cloning steps that were necessary to bring about the required transformation.

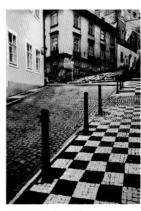

▲ Manipulated image

The result is not perfect, since it has none of the careful radial pattern of the original, but it is far preferable to the original image. It was finished off by applying an Unsharp Masking filter plus a few tonal adjustments.

HINTS AND TIPS

The following points may help you avoid some of the more obvious cloning pitfalls:

- Clone with the tool set to maximum (100 per cent). Less than this will produce a soft-looking clone.
- In areas with even tones, use a soft-edged, or feathered Brush as the cloning tool; in areas of fine detail, use a sharp-edged Brush.
- Work systematically, perhaps from left to right, from a cleaned area into areas with dust specks - or else you may be cloning the specks themselves.
- If your cloning produces an unnaturally smoothlooking area, you may need to introduce some

- noise to make it look more natural: select the area to be worked on and then apply the Noise filter.
- You can reduce the tendency of cloning to produce smooth areas by reducing the spacing setting. Most digital Brushes are set so that they apply "paint" in overlapping dabs - typically, each dab is separated by a quarter of the diameter of the brush. Your software may allow you to change settings to that of zero spacing.
- If you expect to apply extreme tonal changes using, say, Curves settings, apply the Curves before cloning.
 Extreme tonalities can reveal cloning by showing boundaries between cloned and uncloned areas.

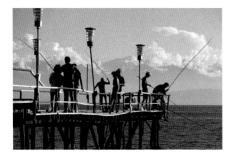

■ Original image

Suppose you wished to remove the lamp on the far left of this image to show an uninterrupted area of sky. You could use the cloning tool to do this, but it would be a lot of work and there would be a danger of leaving the sky's tones unnaturally smoothed-out in appearance.

Marquee tool The Marquee tool was set to a feather of 10 pixels (to blur it

to a feather of 10 pixels (to blur its border) and placed near the lamp to be removed to ensure a smooth transition in sky tones.

Removing the lamp

By applying the Marquee tool, you can see here how the cloned area of sky is replacing the lamp. Further cloning of sky was needed in order to smooth out differences in tone and make the new sky area look completely natural.

Looking at details

The final removal of the lamp was done with a smaller Marquee area, with its feather set to zero (as sharp as possible). Finally, the lamp behind the one removed was restored by carefully cloning from visible parts of the lamp.

As a finishing touch, a small area of cloud was cloned over the top of the lamp and its lid was darkened to match the others left on the pier.

SIMPLE COMPOSITE

Composite images bring together disparate elements from different images. The resulting combination could be fantastical – an underwater tea-party for lions – or it could be prosaic – a tea-party on the lawn with a few extra people. Sketch out an idea in your mind before starting work. You will then find it easier to trawl your picture library for suitable elements. Before you start work, collect all the working images at their full size into one folder, then create a canvas of the size you wish to create.

Big match

Whatever kind of image you work on, the key to success is the match: the final image will work best when all the elements blend well. Images should share lighting (shadows should fall consistently), and tone and contrast should be appropriate – that is, elements that are further away should be lower in contrast. The detail resolution of different components should match, and, finally, colour balance across the image should be consistent.

Original image
A rather lack-lustre image of the Plaza Blanca,
New Mexico, USA, is asking for some added pizazz.
The sky could be more exciting, and the foreground is woefully lacking in active interest.

Choosing a dramatic sky
The skies of the American Midwest famously
yield a rich variety of formations. The choice is
restricted by the lighting in the original, in which
the pale sun comes from the left of the image.

Qutting out
We could cut out the rocky skyline using a
selection tool or, because it is a very easy outline, we
can exploit the precision of the pen tool. We increase
contrast and decrease exposure using an adjustment
layer to give the sky more impact.

Finding a contrasting subject
A sleek dog strolling in the Moroccan port of
Essaouira makes an outstanding candidate to occupy
the foreground of the landscape. The shape is easily
cut out, and the black colour means there will be no
problems with tonal matching.

▲ FINAL SHOT

Adding in dog and shadow
We cut out the dog and paste it. We then
select the dog's shape, then fill with black to make
the shadow. We adjust opacity for a natural-looking
density, then use the Free Transform tool to flip and
position the shadow to make it look realistic.

Making colour adjustments
Using adjustment layers for Hue/Saturation
and for Color Balance, we tone down the colours to
produce a soft, tinted look. The sky is masked in order
to apply stronger adjustments to the foreground to
subdue the strong orangey/pink colour.

IMAGE STITCHING

Panoramic views can be created by "stitching", or overlaying, images side-by-side (see pp. 92–3). Essentially, a sequence of images is taken from one side of the scene to the other (or from the top to the bottom). The individual images are then overlapped to create a seamless composite.

You do not need specialist software to achieve panoramas if the original shots are taken with care. You simply create a long canvas and drop the images in, overlapping them. However, small errors in framing can make this a slow process, since you must blend the overlaps to hide the joins.

Appropriate software

Specialist panoramic software makes joining up component shots far easier, especially if they were

taken without a tripod. The available software packages offer different approaches. Some try to match overlaps automatically and blend shots together by blurring the overlaps. The results look rather crude, but are effective for low-resolution use. Other software applications are able to recognize if the overlaps do not match and try to accommodate the problem – some by distorting the image, others by trying to correct perspective. Many digital cameras are supplied with panoramacreation software.

For more unusual effects, experiment with placing incongruous images together, or deliberately distort the perspective or overlaps so that the components clash rather than blend. There is a great deal of interesting new work still to be done.

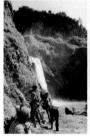

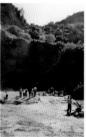

HINTS AND TIPS

- A panorama resulting from, say, six average-size images will be a very large file, so reduce the size of the component images first to avoid stretching your computer's capacity.
- If you want to create a panorama that covers half the horizon or more, it may be better to stitch it in stages: three or four images at a time, then stitch the resulting panoramas. Keep an eye on the image size.
- Place all the component images together into one folder: some software will not be able to access images if they are in different folders.

Assembly

To start the assembly (left), move the component images into a single folder where the software can access them. With some software, you will be able to move images around to change their order, while in others you will have to open the images in the correct order. To merge the images, the software may need extra instructions, such as the equivalent focal length of the lens used.

▼ Final version

The component images show very generous overlaps, which make it easier for the software to create smooth blends. Once the component images are all combined on one canvas, you can use the facilities offered by the particular software to blend and disguise the overlaps to create a seamless, single image (below). Once you are happy with your work, save the file as a TIFF, not as a JPEG, for best-quality results.

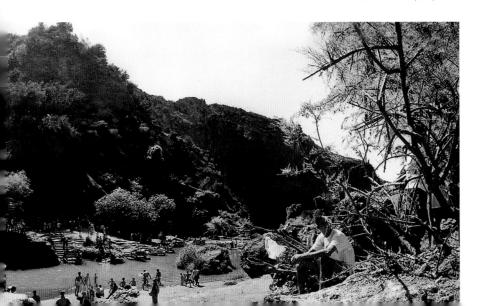

4 BUYING GUIDE

CAMERA PHONES

The capabilities of camera phones range from handsets that simply make phone calls and snap pictures to those that can apply image manipulations, upload images to remote websites, and more. The so-called "smart phone", with multimedia capabilities and multiple functions, is invariably equipped with a camera, and one with increasingly respectable performance that is able to rival that of simple point-and-shoot cameras.

The camera in your pocket

When the emphasis is on being ready to grab a shot whenever it may occur – particularly in a dramatic, once-in-a-lifetime situation – the best camera, without doubt, is the one that is in your pocket. That is most likely to be the camera on your phone.

The differences between camera phones and point-and-shoot cameras has narrowed to the extent that camera phones can start up, respond, and shoot almost as rapidly as point-and-shoot cameras. However, flash is much weaker on camera phones and they are not usually equipped with either fast (large-aperture) or zoom lenses. Lowlight capabilities of camera phones are much

weaker than those of compact cameras. Most use a combination of ISO selection and exposure time to adjust exposure.

The largest weakness of camera phones is their unprotected lens. Even when they are recessed for protection, lenses easily attract dust and fingerprints. Keep the lens clean by regularly using a micro-fibre cloth to remove grease and dust.

DIGITAL 700M

This feature takes the image produced by the lens's longest focal length setting and progressively enlarges the central portion. The camera appears to offer a zoom range that is longer than that of the lens alone, but this comes at the price of a reduction in image quality.

Longest zoom setting

Digital zoom enlargement

▲ High resolution

Camera phones offering high resolutions – of 23 megapixels or more – can make a good substitute for a point-and-shoot camera if they offer fast autofocus. Modern cameras can also record 4K (Ultra HD) video.

▲ Multifunction

Some designs are famed for the quality of their cameras, which may include image stabilization, as well as many built-in filters. High-end camera phones offer high-resolution screens and 4K (Ultra HD) as standard.

▲ Accessorizing

A camera phone's built-in lens may be supplemented by attaching converter lenses. Ranging from fish-eye lenses to telephoto, these vary greatly in quality, but generally speaking, the more you pay, the better the results.

Camera phone features

While a simple camera phone, offering essentially no more than a shutter button, may seem restrictive, many photographers enjoy the return to absolute basics. With nothing to adjust, you can concentrate fully on the subject and respond with uninhibited spontaneity. Many smartphones allow you to touch the screen to select the focus or exposure point, which is useful for back-lit conditions and off-centre subjects. Some provide digital zoom to increase the reach of the view; these work best with high-resolution cameras (see box opposite).

Choosing your camera phone

Fitting a camera into the tiny space of a cellphone demands compromises, so it is best to look on the camera element as pared-down and simplified. Choose a phone that works well for you, before checking that the camera part performs well. You should be able to access the camera in a single movement; it should be able to take pictures at a rate of at least one frame per second; and uploading images to your computer should be easy – through USB or wirelessly through Bluetooth.

EXTENSION BY APP

A most significant aspect of camera phone technology is the ability to extend what they can do by downloading and installing applications on the camera phone itself. They do this by running with standard operating systems such as Android or iOS. Essentially they are computers that can be expanded if you supply more and more applications.

You can install applications that link GPS (Global Positioning System) data with your images, or that can even send the images to your computer or photo-sharing site automatically. There are numerous applications that make it easy to post-process your images, giving them vintage or other special effects. You can install apps to add grids to your screen to aid composition, add anti-shake features to reduce blurry pictures, or even add a self-timer. Other apps make it easy to share your images with social networks or dedicated photo-sharing sites. All these extend the feature-set of a camera phone without physically changing the phone.

▲ Stereoscopic

Camera phones with two lenses can capture stills and video in stereo, and also play back in stereo. Modern systems do not need special glasses: the stereo effect is built into the screen, giving impressive results.

▲ True zoom

Some camera phones are true hybrids: cameras that can make phone calls, and vice versa. Equipped with a zoom lens, flash, and many camera-like controls, these may be ideal for the keen, connected photographer.

▲ Tablets

Many tablets are equipped with both backward- and forward-facing cameras but they do not make the most convenient cameras. They are ideal for showing pictures, and for monitoring views thanks to their large screens.

COMPACTS

Palm-sized and as easy to use as to carry around, compact point-and-shoot cameras did more than take photography to the masses – they took photography into every corner of modern life. From the most private and prosaic tasks, such as brushing your teeth or cooking last night's meal, to the most important occasions, from births to weddings, anything and everything was caught on camera.

Point-and-shoot cameras

Compact point-and-shoot cameras are so ubiquitous and widely used that it is easy to take them for granted. With more computing power and high-grade optics in each camera than took man to the moon, they are capable of amazingly good

results in a wide range of conditions. And no longer are the colour choices black or silver: many models offer body colours ranging from pink to purple through yellows and blues.

- Ensure the camera is not too small: you should be able to use the controls while holding it.
- Compacts are high-precision optical instruments: they will not survive for long in the bottom of a handbag, and will need to be looked after.

Enthusiast or advanced compacts

When images from camera phones can make it on to newspaper front pages and be seen all round the world, keen photographers should not dismiss simple point-and-shoot cameras too quickly. But if

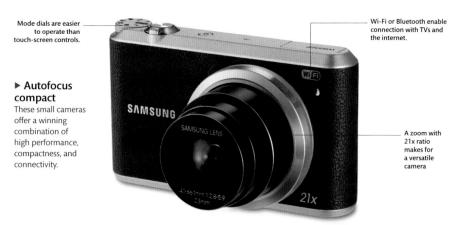

▲ Stylish compact

Sleek and beautifully made and finished, today's compact cameras can be very stylish yet still give excellent results. Extensive use of touch-screen controls eliminates virtually all buttons, and compact dimensions make for easy portability.

▲ Entry-level compacts

Basic cameras are very easy to use and can produce very good results despite their low cost. Although perfect as a back-up camera, they may not be ideal for a beginner as their basic controls limit experimentation.

Rugged camera

A compact camera can be made very rugged by the addition of rubber bumpers all round, sealing against dust and water to allow underwater operation, and with over-sized controls to allow for use with gloves in cold weather conditions.

you enjoy cameras with many features, such as fully manual controls plus a choice of capturing in raw or JPEG, then enthusiast compacts will fit the bill. Some models offer zooms that are wider than usual (for example, 24 mm or 25 mm), some offer fast lenses with maximum apertures of f/2 or better and, as a class, every aspect of handling and image quality can be expected to be superior to that of less costly point-and-shoot models.

- If you wish to shoot raw format images, check how quickly the camera works with the resulting large files.
- If your camera is a back-up to a larger model, ensure that you can share the same type of memory cards and cables.
- Check the availability of a hot-shoe if you may wish to use an accessory flash-gun.

Super-zoom cameras

Advances in lens technology have enabled extremely long-range zooms to be squeezed into very compact housings. Ranges of 20x are common, and 50x is possible. The wide-angle end is as short as 20 mm (usually 24 mm to 35mm), while the long end of the range can reach an amazing 1,000 mm or more. This means you can expect a lion's head to fill the frame at usual viewing distances on a safari.

To ensure that you can obtain sharp images at the longest zoom settings, built-in image

stabilization is a must. Maximum apertures at the long end may be limited to as small as f/8; this is a severe limitation on working in low light or if you wish to obtain short depth-of-field effects. These cameras are ideal for travel and holiday photography as they are very compact yet highly versatile.

- Check the sturdiness of the lens housing at full extension: it will be a little loose, but should not bend visibly.
- Limit use of the zoom in very dusty conditions to avoid sucking up dust into the mechanism.

RESOLUTION AND OUALITY

The word "resolution" is used in several different senses in photography. Applied to camera sensors, it measures the number of photo-sites used to capture the image. The resolution of the image itself is often equated with image size, or its number of pixels. In the context of lens performance or image quality, it is a measure of how well a system separates out fine detail.

These measures are related, but not directly. For example, the resolution of a sensor sets the upper limit of image quality, but not the lower limit: a high-resolution sensor may deliver a poor-resolution image if the quality of capture, lens, or image-processing is poor.

▲ Enthusiast zoom

Even in a compact body, modern cameras can offer extensive zoom ranges of 14x or greater. However, maximum aperture at the telephoto end may be limited to f/8 or less, which restricts photography in low-light conditions.

▲ Super zoom

By compromising on a slightly larger camera, the lens can be of larger aperture and focal range. Modern super-zooms offer very wide-angle performance, for example from 24 mm to 350 mm extreme telephoto with full camera controls.

▲ Prime-lens compact

For the enthusiast or purist who does not need a zoom lens, a compact such as this model, with a fixed zoom (28 mm or 35 mm equivalent), may be an acceptable option. It is easy to operate and places an emphasis on the quality of image capture.

MIRRORLESS COMPACTS

Within a few years of its introduction in 2010, the mirrorless interchangeable lens compact camera proved to be an innovative development. By disposing of the mirror used by SLR cameras (see pp. 200–1), this new design could be made slimmer and more compact. By offering an interchangeable lens mount that is very close to the sensor, these cameras can offer compact lenses of their own and also make use of virtually any lens in existence simply by fitting an appropriate lens adapter to interface between lens and camera.

The right camera for the job

Mirrorless cameras exploit a range of sensor sizes – from Nikon's 13.8 x 10.4 mm, through the popular Micro 4/3 and 4/3 sizes, to "full-frame" 24 x 36mm. If you need the most compact designs, choose cameras fitted with smaller sensors. The lenses will also be more compact than those for larger sensors. If you fit a lens designed for a larger sensor, you will multiply the effective focal length, giving extra telephoto reach but reducing wideangle views (see also p. 203).

▲ Compact interchangeable

By including an APS-C sensor size and only a rear LCD screen, models of this type can be very light and compact. Interchangeable lenses – ranging from wide angles to long zooms – and flashes extend its versatility.

▲ Modern retro

The controls may look old-fashioned, but their chunkiness improyes handling and usability, complementing touch-screen controls. These compact and light cameras use a CX-format sensor (just 14 mm on longest side).

▲ Top-end siblings

You don't have to pay big money to benefit from the superior technology of top-end models. By sacrificing a few features, such as optical rangefinder, you can still capture high-quality images with a mid-budget camera.

Picture quality is not necessarily inferior with smaller sensors, given the high quality of modern signal processing. For the best compromise between size and image quality, choose cameras with APS-C sized sensors or similar – that is, about 24 x 15 mm.

These cameras are all absolutely packed full of functions, so they offer users extreme versatility. Their capabilities may be extended by installing apps from the internet, and many models offer the ability to connect wirelessly to the Web or to computers and printers.

Using the EVF

In addition to the monitor screen included on the backs of all cameras, the more advanced models offer users an electronic viewfinder (EVF). This is a small but very high-resolution screen that is looked at through an eyepiece. The EVF gives you the best image for evaluating and framing your subject. It works well in the dark and can give fairly accurate representations of colour balance and exposure override, as well as special effects. The EVF can display camera settings clearly, too, so you do not need to take your eye away from the viewfinder in order to check the camera's settings.

Interchangeable lenses

As sensors improved in quality, the search began for camera designs that could combine the image quality and versatility of single-lens reflex (SLR) cameras with the compactness and portability of point-and-shoot models.

The 4/3 (Four Thirds) format is an open standard for single-lens reflex cameras – they have a mirror box and reflex optical viewfinder behind a standard lens mount. The sensor has an imaging area of 17.3 x 13.0 mm (21.63 mm diagonal), with a 4:3 aspect ratio. This results in a focal-length factor of 2x – for example, a 25 mm lens on 4/3 format is equivalent to a 50 mm lens on full-frame (see p. 200).

Video capable

Almost all modern models are capable of capturing video, and when possible they will capture HD (high definition). Some can even record at 4K (Ultra HD). These cameras can produce footage of filmstudio quality and are, indeed, even used in the motion-picture industry. These cameras helped revolutionize independent film-making. For best results, ensure you equip the camera with high-quality, high-speed memory cards.

▲ SLR look-alike

It may seem like an SLR, but this model is considerably smaller and lighter. Thanks to its Micro 4/3 lens mount, it accepts a wide range of excellent optics to give professional-grade imaging in the mid-price range.

▲ Compact capable

Cameras that do not offer the highest resolution or fastest lenses benefit users who wish to balance high quality with convenience and speedy operation.
These cameras are also suited to smaller budgets or those just starting out.

▲ Advanced CIL

High-specification compact interchangeable lens (CIL) cameras with APS-C sensors bridge the gap between truly professional models and others. The most recent models also offer 4K video recording.

SLRs

At one time, the dominance of the digital singlelens reflex (SLR) camera seemed unassailable. It gives the clearest, most precise view of the subject with accurate feed-back on focus. But the SLR has lost ground to compact interchangeable lens cameras using high-resolution electronic viewfinders. lenses and accessories that can be used on larger SLRs but are smaller, lighter, and generally offer lower specifications than their professional equivalents. Therefore, they make good back-ups to professional gear. All current models offer HD video recording in addition to a full range of stills settings.

Entry-level SLRs

The entry-level SLR is fully capable of professional quality results but is built to offer many features at low cost, using the APS-C or Four Thirds sensors. These cameras will accept most, if not all, of the

Professional SLRs

There is no clear line between entry-level SLRs and professional-level SLRs, as different models are used by both amateurs and professionals. The larger cameras – such as the EOS-1D series from Canon,

▶ SLR

The most reliable, sturdy, and consistent performance can be expected from today's SLR cameras. All the technology used is highly refined and all controls are easy to access, allowing for fluid, versatile photography at professional levels for affordable prices.

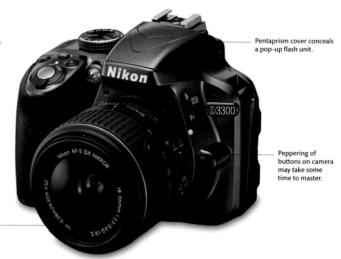

Some systems offer more than 50 interchangeable lenses.

SENSOR SIZE AND FIELD OF VIEW

A camera lens projects a circular image. The sensor captures a rectangular area centred on this image. If the rectangle extends to the edge of the circle of light, the sensor captures the full field of view. But if the capture area falls short of the edge, the field of view is smaller. Many SLR cameras accept conventional 35 mm format lenses but use sensors that are smaller than the 35 mm format (around APS, or about 24 x 16 mm). The result is that the field of view is reduced, which in turn means the focal length is effectively increased, usually by a factor of around 1.5x. This means that a 100 mm lens used on full-frame 35 mm is effectively a 50 mm lens when used with an APS-sized sensor. The convention is to relate the actual focal length to the 35 mm format equivalent.

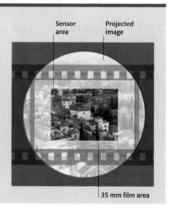

the D3 series from Nikon, and certain models from Sony and Olympus – are designed for the professional. They feature high-specification shutters, a sturdy build, seals against dust and moisture, as well as superior-quality viewfinders and features. Some cameras use a full-frame, 36 x 24 mm sensor; others use smaller ones, with resolutions ranging from 10 MP (megapixels) to 25 MP or more, depending on whether the emphasis is on quality or speed of operation.

Choosing an SLR

For the beginner, the best-value cameras are those that have been supplanted by a new model or two. Their price will be much lower than when they were first introduced, yet their performance will be more than satisfactory. This is because, by 2010, technological development had reached a plateau with all camera models capable of producing image quality that easily matched the professional levels of a few years earlier.

- Choose a camera that you find easy to hold, comfortable to use, and easy to set up.
- You almost certainly do not need the highest resolution camera: 12 MP is ample for most image uses, such as in websites and publications.

LIVE VIEW AND VIDEO

The normal way to view through an SLR is to examine the image reflected onto the focusing screen by the mirror. In some models, you can view the image via the LCD display, just like using a compact camera: this is called live view, and it gives you more viewing options. To enable this, either the mirror is raised and the shutter is opened, to allow light to fall on the sensors, or the focusing screen image is reflected onto a sensor.

When live view is enabled, the sensor receives light continuously. This makes it possible for the sensor to record video – an advantage fully exploited by today's cameras. The result is that modern SLRs can now capture high-definition video – of 720 or 1080 lines in resolution. However, SLR lenses are not as well made as cinematic lenses, so zooming, aperture control, and focus are not as smooth. SLR cameras also capture lower-quality sound than professional HD video cameras. Furthermore, SLR cameras tend to capture highly compressed video, which limits post-processing. However, video quality can be excellent, and at a fraction of the cost of professional HD cameras.

▲ Entry level

SLR cameras designed for amateurs are the best value cameras ever made. They deliver excellent-quality images with accurate focus, colour, and tonality while being able to accept a wide range of new and older lenses.

▲ Multifunction

Cameras that use semi-reflecting mirror technology can capture high-definition video with full autofocus conveniently - that is, without having to flip up the mirror. High-resolution still images can also be captured at fast frame rates.

▲ Large professional

Top-resolution cameras are not necessarily large and heavy. Models offering over 50 MP sensors can be similar in size to other SLR cameras. Some offer very high-quality video capture at 4K (Ultra HD) resolution.

CHOOSING LENSES

Modern camera lenses benefit from the adoption and merging of several technologies to deliver high performance with good quality in compact form and at low prices. Nonetheless, it remains as true now as ever that larger lenses with heavier construction, modest specifications, and built from costlier materials will perform better and more reliably than small, lightweight lenses or those with ambitious specifications. The most popular type of lenses are made to zoom – that is, to be able to vary their focal

length (see opposite) while remaining focused on the image. Lenses are also designed with fixed focal length (prime lenses), wide aperture, extreme focal length, or with an emphasis on specialist use.

Fixed lenses

Compact cameras and many EVF (electronic viewfinder) cameras use a permanently mounted lens. This arrangement saves weight, allows a compact design, and virtually eliminates problems from dust

▶ 35 mm lens

This lens is very fast and offers top-class image quality in low light, but is large and heavy.

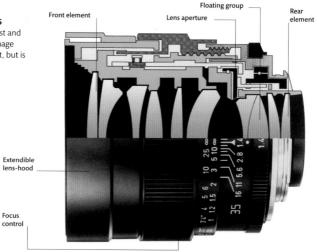

▲ Ultra-fast telephoto

Fixed focal length lenses, such as this 85 mm optic offering an ultra-fast f/1.4 full aperture, can produce fine effects with superb quality but at premium costs.

▲ Ultra wide-angle

An ultra wide-angle lens for APS-sized sensors must offer very short focal lengths, such as this 10–20 mm optic, but can be surprisingly bulky due to complicated construction.

▲ Standard lens

A growing appreciation of the value of fixed focal length lenses has given rise to exquisitely compact, high-quality lenses for compact interchangeable lens camera systems.

on the sensor. While it is tempting to opt for a fixed lens with a very large zoom range, such as 26–520 mm, bear in mind that more modest ratios are likely to give higher overall image quality, with less vignetting at long focal lengths and less distortion at wide-angle settings.

Lens specifications

The main specification for a camera lens is its focal length, or range of focal lengths if a zoom. Focal length measures the distance between the point from which the image is projected by the lens

to the sharp image at the sensor, where the subject is very far away (at infinity). In practice, we use it to indicate the magnification and field of view of the lens: longer focal length lenses magnify a small portion of the view, whereas shorter focal lengths reduce a larger portion of the view.

Zoom lenses shift elements within the optics to change the focal length without changing the focus setting. From this we obtain the zoom range, or ratio, measuring the longest to shortest focal length, or vice versa. For example, a 70–210 mm lens offers a zoom ratio of 1:3.

EQUIVALENT FOCAL LENGTH

The focal length of a photographic optic tells you if a lens is wide-angle, normal, or telephoto. A "normal" lens is one in which focal length is about equal to the length of the diagonal of the format. With the 24 x 36 mm format, the diagonal is about 43 mm, which is usually rounded up to 50 mm. Because the sizes of sensors, and therefore format, of digital cameras vary so greatly, the accepted approach is to quote the equivalent focal length for the 35 mm format (35efl). For example, on one camera the 35efl of a 5.1 mm lens is 28 mm, but it may be 35 mm on another. The equivalence is only an approximation, because the proportions of picture rectangles also vary.

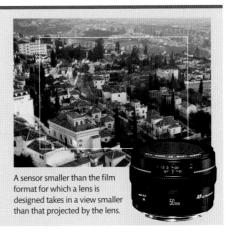

▲ High-quality standard zoom For a standard lens – such as this zoom covering the 35 mm equivalent of 24–120 mm – you should buy the best quality you can afford, because you will use it extensively.

▲ High-ratio zoom

A zoom lens that offers high ratios between wide and telephoto settings, such as the 15x of this model, is a tempting option, but performance may be compromised for convenience.

▲ Telephoto zoom

A zoom limited to the telephoto range, such as this 70-300 mm model, can produce results almost equal to those of fixed focal length lenses but with greater versatility.

CHOOSING LENSES CONTINUED

The other key measure is the maximum aperture. Lenses with a large maximum aperture – such as f/1.4 – are said to be fast. They collect more light than lenses with a small maximum aperture – for example, f/4 – allowing for shorter exposure times.

Comparing focal lengths

As a result of the earlier dominance of the 35 mm format, the focal length of a lens is usually related to that of the equivalent 35 mm format lens. For example, the 35 mm equivalent of a 10–22 mm lens for APS format is 15–33 mm. Note that the maximum aperture of the lens does not change; only the field

of view changes. Therefore, a 135 mm f/1.8 lens for 35 mm is effectively a 200 mm f/1.8 lens for APS-format sensors. (See also the box on p. 203.)

Match to format

The growth of SLR cameras using APS-sized sensors (around 24 x 16 mm) has resulted in the development of two lines of interchangeable lenses. Generally, full-format (also called full-frame) lenses – that is, those designed for the 35 mm format – can be used on APS-sensor cameras, but not vice versa. Some full-frame cameras automatically match the active sensor to the type of lens in use. The Four

POINTS TO CONSIDER

- Use a lens-hood: stray non-image-forming light within the many internal lens elements can seriously degrade otherwise excellent image quality.
- Avoid using the maximum aperture or the minimum aperture. With most zoom lenses, at least one stop less than maximum is required to obtain the best image quality.
- Adjust focal length first and focus on the subject just before releasing the shutter. Avoid altering focal length after you have focused as this can cause slight focusing errors to occur.
- When using a wide-ranging zoom remember that a shutter setting that will ensure sharp results at the wide-angle setting may not be sufficiently short for the telephoto end of the range.

WHAT IS LENS APERTURE?

The terms lens aperture, f/number, and f/stop all mean roughly the same thing: they measure the size of the aperture sending light to the film or sensor. The actual size of the aperture depends on a control called a diaphragm – a circle of blades that open up to make a large hole (letting in lots of light) or overlap each other to reduce the aperture and restrict (stop down) the amount of incoming light. The maximum aperture is the setting of the diaphragm that lets in the most light. Lens aperture is measured as an f/number and is a ratio to the focal length of the lens. For example, with a lens of 50 mm focal length, an aperture of 25 mm gives f/2 and an aperture of 3.125 mm gives f/16.

▲ Macro lens

Invaluable not only for close-up work and copying flat originals, macro lenses offer the very best image quality, with high resolution, excellent contrast, and freedom from distortion.

▲ Fish-eye lens

An ultra wide-angle lens that distorts any line not running through the centre of the lens, the fish-eye is excellent for special effects. The most useful type fills the frame with the image.

▲ Converter lens

The focal length range of permanently attached lenses can be increased by using a converter lens. The telephoto increases, and the wide type decreases, the basic focal length settings.

Thirds format is a third line of interchangeable lenses, and it uses its own unique mount.

Lens accessories

The zoom ranges of permanently attached lenses may be extended by using supplementary lenses. Those marked, for example, 1.7x will increase the zoom-set focal length by 1.7x to improve telephoto reach. Those marked 0.6x will decrease it by 0.6x, with the effect of increasing wide-angle views.

Interchangeable lenses accept accessories such as filters that mount on the front of the lens, as well as accessories that mount between camera and

HIGH IQ

The three main ways to ensure high image quality from your lens is steadiness during exposure, accurate focus, and use of the optimum lens aperture. Focus manually with SLRs, guided by the focusing screen. Manual fine-tuning as a supplement to auto-focus gives good results. All but the best lenses perform only adequately at full aperture and provide sharpest results two to four aperture stops smaller. For example, if the full aperture is f/4, best results are found between f/8 and f/11. With smaller apertures, quality falls. Shooting the same target at different apertures will soon show you the best apertures to use.

Moving views

With the camera held level, the use of lenses with tilt or shift or swivel joints allows you to move the lens assembly to point at and focus on different parts of the image.

▶ Adjustable lens

The Lensbaby mounts a lens on a swivel joint allowing you to point the lens freely to produce tilt and unusual blur effects with a wide range of lens mounts. lens. Converters, also called extenders, are rearmounted accessories that multiply the focal length of a lens. A 2x extender doubles the focal length of the lens – from 135 mm to 270 mm, for example, or giving a 100–300 mm zoom a 200–600 mm capability. But light transmission is also reduced: a 2x extender causes a 2-stop loss in aperture. Extension rings are just like converters but without a lens: they increase the focusing extension of the lens so that it can focus on very close subjects.

Specialist lenses

Lenses can be designed for specialist photographic tasks such as close-up dental photography, architectural or photogrammetric (measuring) work.

Lenses offering shift and tilt movements are very useful tools. Shifting allows you to reduce or increase, say, foreground coverage without moving the camera. Tilting the lens allows you to position the plane of best focus, to give very deep or shallow depth of field, without adjusting the aperture – ideal for architectural and landscape work, and invaluable for still-lifes and portraiture.

The most popular specialist lens is the macro lens, designed for high-performance close-ups. A 50 mm macro lens is good for copying work; the 100 mm focal length is useful for general macro photography. A long telephoto lens is essential for photographing wildlife from a distance.

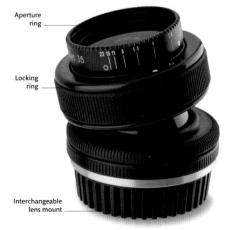

PHOTOGRAPHIC ACCESSORIES

Carefully chosen accessories can make a big difference to the quality and enjoyment of your photography. It is very tempting to load up with numerous accessories, but too many items can slow you down more than they aid you.

Tripods

Tripods can make the biggest single contribution to improving the technical quality of your photography. The best are heavy, large, and rigid, while small, lightweight ones can be next to useless. As a rough guide, a tripod should weigh twice as much as the heaviest item you put on it.

Carbon-fibre tripods offer the best balance between weight and rigidity, while aluminium alloy models are heavier but less expensive. Models that telescope with four or more sections are very compact when folded but less rigid when extended compared to those with fewer sections. Collars that twist to lock a section are compact, and do not snag

> on clothes, but slower to use than lever locks. Very small table-top

steadying the camera on flat surfaces. Where space is limited, and you need to be able to move easily, the monopod is a popular compromise: the single leg helps steady the camera, reducing movement in two axes, and it also helps take the weight of the equipment. Shoulder stocks, which enable you to brace the camera against your shoulder, can help reduce camera shake and work well in combination with a monopod.

Tripod head

The choice of tripod head is as important as the choice of tripod itself. Choose one that is quick and easy to use but that holds the camera firmly.

Ball-and-socket heads are quick to adjust with smaller cameras and lenses as you have to control just one locking knob. The most convenient also feature a panning lock, allowing you to turn the head about the vertical axis.

3-D heads are easy to adjust with fair precision but are slow to operate, as you have three separate

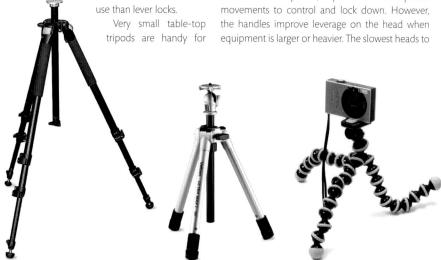

▲ Telescopic tripod

A bulky and heavy tripod is the best way to ensure that images are free from camera shake. Carbon-fibre models are expensive but lighter than metal types.

▲ Travel tripod

A lightweight, compact tripod is useful for lighter equipment and to supplement supports such as table tops. Press the camera down on the tripod to improve stability.

▲ Gorillapod

Unconventional supports, such as this design with flexible legs or those using clamps, are handy for compact cameras and quick set-ups that do not call for long exposures.

operate are those driven by gears, but the reward is very precise adjustment. For extremely heavy lenses, use centre-of-gravity pivots or gimbal heads such as the Wimberley head. The camera and lens assembly is balanced so that only finger-tip pressure is needed to adjust the aim and tilt of the camera.

Quick change

Attach your camera to the tripod head with a quick-release mount: this is a plate locked to the camera

that "mates" with a trap on the tripod. The result is the swift and sturdy interchange or disassembly of cameras. While adding the plate adds a little to the weight and bulk of the camera, it can help improve hold on the camera and also protects the base. Ensure the plate is big enough for your largest equipment. For heavy lenses, affix the plate directly to the lens. There are many designs on the market; the Arca-Swiss is widely used, and excellent versions are available from Gitzo and Manfrotto.

I FNS FILTERS

Filters that attach to the front of lenses are not obsolete in the era of image manipulation. At their simplest, a plain or UV filter protects the vulnerable front element from dust and scratches. Plastic moulded filters with prismatic or diffraction lines can give special effects that are very hard to recreate in post-processing. Graduated filters – with denser colour at the top fading to clear at the bottom – help to capture landscape images that reduce the need for highlight/shadow or tone-mapping manipulations. Polarizing filters can reduce

reflections and intensify sky colours. When you need to reduce the light entering the lens to work at full aperture, you can use a neutral density filter.

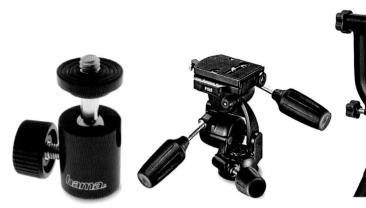

Lightweight versions are ideal for travel where long exposures are not needed. For more serious work and heavier equipment, use heavy-weight models that work very smoothly.

▲ 3-D head

Excellent for the flexible control of a heavy camera and lens combination, a 3-D head is easy to control and easiest to use with a quick-release plate. Some models are equipped with levels.

▲ Gimbal head

An off-axis head balances extreme telephoto lenses and large cameras, making it effortless to line up shots. But the units themselves are large, heavy, and almost as expensive as a tripod.

PHOTOGRAPHIC ACCESSORIES CONTINUED

Exposure control

Image previewing on digital cameras has not made separate light-meters obsolete. The best practice is to make exposures as accurately as possible, which reduces the time needed to make post-processing corrections. Handheld meters are also the best way to make incident-light readings – that is, readings of the light falling on the subject. Some hand-held meters also offer far greater accuracy, especially in low-light conditions. And spot meters, which read reflected light from a very narrow field of view – commonly 1° or less – offer unsurpassed accuracy in tricky lighting.

Flash meters enable speedy work in the studio, without the need to refer to previews again and again. Most modern hand-held meters can measure flash exposures as well as ambient light and, indeed, indicate the balance between the two. A flash meter is an essential accessory for serious still-life and portrait work.

Another aspect of exposure control is the use of standard targets such as grey cards, standard colour targets, and other aids. By including these in a test shot under the same lighting as the subject, you create an invaluable reference of guaranteed neutral tones and colours which improve the accuracy of any post-processing.

TIMER REMOTE RELEASE

The mechanical cable release to trip the shutter without disturbing the camera has been replaced by the electronic switch. These range from models that simply trip the shutter to those that can open the shutter for a pre-set time, which is useful for making accurately timed exposures. More sophisticated models also work as intervalometers: you set a time interval – for example, 5 seconds – and every 5 seconds the timer makes exposures as the basis for creating time-lapse movies. Some releases are corded and plugged into a camera; more recent models use wireless connections, such as Bluetooth or radio.

▲ Neutral target

This ingenious target, from Datacolor, combines specular highlight (top) and deep shadow (bottom) with five neutral grey tones.

▲ Advanced exposure meter

Professional exposure meters can measure flash as well as ambient light, and some models also function as a spot-meter.

▲ Camera bag

Back-pack designs are best for comfort and carrying awkward loads, but are slower to use than shoulder-hung models.

Bags

Modern, padded soft bags combine high levels of protection with lightweight construction. Bags hung over the shoulder are easiest to access but can be tiring to carry for long distances. Shoulder bags tend to be the lightest designs, so may be best for use as cabin luggage.

Back-pack styles are easy to carry for long distances, and comfortable even with quite heavy and awkward loads such as a tripod. However they tend to be slower to use as you have to take them off your back before getting into them.

A working compromise is to use a shoulder bag with a waist-strap that is tightly strapped to your body. This displaces some mass onto the hips and relieves your shoulders.

For work in highly challenging conditions, or if you fear your precious lenses and laptop might have to travel in cargo holds or be slung into the backs of trucks, a hard case with a waterproof and dustproof seal is essential. However, even when empty they are heavy, so expect to have to pay excess-baggage charges.

Waterproofing

A waterproof camera housing is not only needed if total immersion is likely, but also in situations such

as shooting from a canoe or when sailing. Camera housings are also ideal for particularly dusty conditions, such as industrial sites and deserts. Housings vary from flexible plastic cases for shallow water, to sturdy cases for deep water. They are available for compact cameras through to professional models, but they may cost at least as much as the camera they are made to protect. The key to their maintenance and longevity is to keep the O-ring seals meticulously clean and lubricated with silicone grease.

CAMERA RAINCOAT

For sports and nature photographers, the invention of camera raincoats has been a boon. There are generic models and those made for specific cameras, and they usually come in plain grey or in camouflage patterns.

▲ Equipment case

Rigid cases can be waterproof and provide sturdy protection for rough conditions. Rolling models equipped with wheels are easiest to transport.

▲ Waterproof housing

Extend the life of your camera by protecting it from the elements. Use a waterproof housing specific to your camera to ensure water-tightness.

▲ Underwater housing

For serious diving, an underwater housing keeps your camera safe and offers the best image quality, as well as access to all necessary controls.

DIGITAL ACCESSORIES

The modern digital camera has to work with a retinue of digital accessories to ensure that it is powered and has the capacity to record images.

Memory cards

Memory cards use banks of memory registers that hold their state – on or off – without needing power. They can hold data indefinitely yet can easily write new or altered data. Their compact size, low power requirements, and large capacity make them ideal for image data. When an image is written to them, the registers are flipped on or off according to the data. To read the memory, the registers are turned into a stream of data. Modern cards can hold more than 100 GB of information and read or write 300x faster than a standard CD.

There are many card types in circulation: some are extra-compact for use in mobile phones, others are optimized for speed or sturdiness. If you own

CARD CARE

- Keep memory cards well away from magnetic fields, such as in audio speakers.
- Keep cards dry.
- Keep cards away from extreme heat.
- Keep cards dust-free.
- Keep cards in protective cases when not in use.
- Do not bend or flex cards.
- Avoid touching the contacts with your fingers.

MEMORY CARD READERS

There are two ways of transferring images taken on your digital camera to your computer. You can connect the camera to your computer and instruct the camera's software to download images, or you can take the memory card out of the camera and read it to the computer. To do this, you need a memory card reader, a device with circuitry to take the data and send it to the computer, via a USB or FireWire cable. There are many card readers on the market that can read almost every type of memory card.

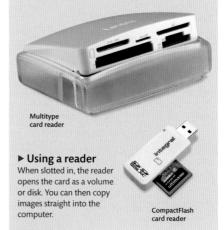

▲ CompactFlash

Very widely used in dSLR cameras and others, this is a sturdy card in a range of capacities, up to at least 100 GB, and read/write speeds to suit different budgets and camera requirements.

▲ Secure Digital

Very widely used in compact and dSLR cameras, SD (and SDHC) cards are very small yet offer capacities of 64 GB and over with low draw on current. They are also sturdy and reliable.

▲ Micro SD

These cards are widely used in mobile-phone cameras but their small size restricts capacities from reaching over 64 GB. Via an adaptor, they can also be used in devices that take the larger Mini SD and SD cards.

▲ MemoryStick

Proprietary to Sony, this family of cards is used in a variety of digital equipment, including Sony video cameras, allowing interchange with good capacities and performance.

Video viewfinder

Video viewfinders use a tinv camera to capture the image of the focusing screen to display on a larger, outside screen They can also he used for automatic remote release: the system trips the shutter when it detects movement

more than one camera or want to use another device, try to ensure intercompatibility.

CompactFlash and SD

The most widely used memory cards for digital photography are the CompactFlash (CF) and Secure Digital (SD) cards. SD cards are more compact and less prone to failure as the pins are flat and less numerous than those in CF cards. You can remove the card from the camera at any stage before it is full and slot it into a reader to transfer files to a computer but do not remove it while the camera is trying to read the card, usually indicated by a red light blinking. You can also erase images at any time to make room for more.

Digital image storage

When travelling with a digital camera it is often impractical, and always inconvenient, to carry a laptop computer for storing image files. One option is what is essentially a portable hard-disk equipped with an LCD screen and card-reading slots. The screen may be colour for reviewing images on the device, or it may simply show the copying status and basic file data. Some of these units can hold several terabytes (TB) of data and are equipped with slots for reading memory card devices. Data can be copied straight from the card devices onto the drive, then the drive can be connected to your computer to transfer your images once you are back at home.

Viewing images

It is as important to view and show images as it is to capture them. You can use tablets, such as the iPad, and photo frames to display your images, and use simple transitions such as fading between images and even add a suitable sound-track.

▲ Mobile storage

Freeing you from taking a computer outdoors, these small hard-disk drives allow you to back up photos and so continue using your memory cards. They also allow you to review and show images as you shoot.

USB drive

As small as a key ring, a USB drive is a most convenient way to transfer quantities of files from one machine to another. USB drives are solid-state memory devices with storage capacities of 64 GB and more.

▲ Photo frame

These devices display a single image or a slide show of images downloaded from a memory card or picture store. They are useful for personal use, such as in living rooms, or for shop displays and gallery exhibitions.

ELECTRONIC LIGHTING

The invention of portable flash had a tremendous impact on photography: it opened the night world to the camera, with compact, easily carried equipment. Today, electronic flash is standard to all compact digital cameras, found on many mobile phone cameras, and fitted to the majority of dSLRs. However, the position of the fitted flash is just about the worse possible, in terms of the quality of lighting. Accessory lighting units are a necessity for versatile and attractive lighting.

Power and recycling

A further problem is that flash built into a camera relies on the camera's own batteries for power. To curb their hunger for energy, built-in flashes are designed to be low-powered – usually sufficient to light to a distance of 1–2 m (3–7 ft) but little further. In addition, the recycling rates – how quickly the flash can be fired in sequence – is also limited.

Flash power

Portable, or accessory, flash units overcome the limitations of built-in flash by carrying their own power and circuitry; this makes the units much larger than compact cameras. Accessory flash units

also offer more control over flash power, direction of flash, and angle of coverage.

Accessory flashes fit onto the hot shoe, which combines electrical contacts with a slot that "mates" with a corresponding, locking part on the bottom of the flash unit. While the majority of cameras use a standard hot-shoe design, the contacts may be specific to the camera producer, and some manufacturers – such as Sony – use proprietary hot-shoe designs.

Adjustable angle

Many portable flash units place the flash on a swivelling turret so that it can be directed to the sides, or even backwards, according to the nearest surface for bounce flash (see pp. 42–9). Some offer a tilting head so that you can point the flash upwards, or downwards for close-up work. A fully adjustable head increases flexibility, so is a must for wedding and paparazzi photography.

Adjustable coverage

On many flash units you can also adjust the coverage, or the angle over which light is spread. This ensures that when you use a wide-angle lens or

▲ Small supplementary flash

Units like this can augment the power of built-in flash units. It is triggered by the camera's own flash, so it does not need a hot-shoe, and adds its output to that of the camera's unit. It is an inexpensive solution to lighting problems, but control is limited.

▲ Slave flash unit

Slave units can add to the power of built-in flash units. This unit synchs with the on-camera flash for the most accurate exposure, after which operation is fully automatic. Position it to one side of the camera to improve modelling effects.

▲ Powerful on-camera flash

Accessory flash mounted on a camera's hot shoe can be sufficiently powerful for all normal needs, offering a tilt-and-swivel head for bounce, multiple-exposure facilities, and focusing aids for working in complete darkness.

setting, the flash coverage is sufficient to light the angle of view: this causes a lowering in the maximum power of the flash. When you make a telephoto setting or use a long focal length lens, the coverage is narrowed to match, approximately, the angle of view. This causes a gain in the maximum power of the flash, since the light is concentrated into a narrower beam.

Adjustment may be carried out automatically, with the camera instructing the flash according to the zoom setting on the lens, or it can be manually set. Zoom-like optics in the flash tube alter coverage, and a diffuser may be used for ultra wideangle coverage.

Red-eve

The unsightly red dot in the middle of eyes lit by flash – commonly known as red-eye – is caused by two factors: the flash being so close to the optical axis that the light reflects off the blood-rich retina of the eye, while, at the same time, the eye's pupil is dilated in dark conditions. Accessory flash mounted on the hot shoe or to one side moves the source of flash relatively far from the optical axis, with the result that red-eye is avoided.

GUIDE NUMBER

The light output of accessory flash units is usually measured by the Guide Number (GN). The figure is for a specific film/sensor speed - usually ISO 100 - in either metres (m) or feet (ft), and for a specified angle of coverage. The GN for a unit will be higher for narrow coverage - suitable for medium-telephoto lenses - and lower for wide coverage - suitable for wide-angle lenses. A Guide Number may be quoted as, for example, GN45 (m), indicating the distance scale is metres. A typical small camera GN is 5-10 (m); accessory flash units offer 30-50 (m). The standard practice is that the GN figure is quoted for the coverage of a standard lens but may be inflated in specifications by being quoted for a narrow coverage. The Guide Number scale is defined:

Guide Number = subject distance x f/number

The f/number for a correct exposure is the result of dividing the GN of your unit by the distance between the flash/camera and the subject. Using GN to set an f/number is generally more accurate than relying on automatic systems.

▲ Macro ring-flash

For shadowless flash photography of insects, flowers, and other small objects, a ring-flash is ideal. The brief flash can stop inadvertent movement, and very small apertures can be set for maximum depth of field.

▲ Adjustable macro flash

For controlled lighting in macro work, units with two or more small flash units that can be set to different positions around the lens give the most flexibility. They can be set to different power levels and point in different directions.

▲ LED unit

Lightweight LED lights produce a daylight-balanced, continuous beam of light that is ideal for video recording. But it also provides a source of easy visible light that can be used off-camera and precisely positioned to control modelling.

COMPUTERS

The serious digital photographer spends at least as much time at the computer as he or she does taking pictures. Not only has the computer replaced the darkroom, it is now effectively the photographer's library as well as their communication and media centre. The computer will also drive the scanner, printer, and perhaps the camera, too.

What to look for

All modern computers can work with digital images. The differences lie in three main areas: the operating system, the system performance (which depends on video graphics and memory), and the storage capacity. The latest operating system may offer the most features, but other software and hardware upgrades may need to be up-dated to work with them, and they may need extra RAM to run digital photography software. You should consider 2GB of RAM to be the minimum.

Mouse and keyboard

The quality of the mouse and keyboard can make a big difference to your enjoyment and comfort. If the keyboard is not to your liking or you find the mouse uncomfortable to use, change them. Such replacements are inexpensive, and if made at the time of purchase, they may even be cheaper.

Software packages

When budgeting, do not forget software costs. A full suite of software for image manipulation as well as desktop and web publishing can cost more than a computer, so use modest applications until your skills develop. Professional software can be very hard to master, while simpler, cheaper packages still produce good results.

Connections

When buying a computer, ensure its interfaces match those of the equipment you wish to use. Note that you may need to install some software to make a connector work.

- Universal Serial Bus (USB) is widely used in its various forms for data transfer between computers and hard-disk drives, card readers, and cameras. Note that some peripherals, such as keyboards and screens, may offer USB connections. To be most useful, these should be powered but many are unpowered, which limits the accessories that can be used.
- FireWire is a high-speed standard suitable for professional work. It offers an excellent choice for removable drives, extra hard-disks, and digital cameras. FW800 is comparable to USB 3.0 for speed of data transfer.

CONTROLLING REFLECTIONS

Sidelight reaching monitors can reflect into the user's face, causing uncomfortable glare (left). The use of a deep hood (right) reduces this problem.

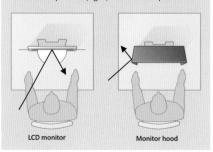

▲ General-purpose LCD monitor

High-quality modern LCD screens offer the best balance of ergonomic features and image quality, as well as minimizing eye-strain. Images are stable, geometry perfect, and colour rendition sufficient for most colour-checking needs.

■ eSATA (External Serial Advanced Technology Attachment) connects external drives to computers and is up to twice as fast as USB 2.0 or FW800. Cable length is limited to 2 m (7 ft).

Laptop or desktop?

Desktop machines may cost less than laptops, but can offer more power in return for the loss of portability. However, modern laptops have more than enough power for digital photography. Some, like the Apple MacBook Pro, are not only more powerful than many desktop computers, their screens are also of sufficient quality and large enough for serious work. The best Windows machines also make excellent work-horses for digital photography. Against the premium cost of miniaturizing is the convenience of a computer that takes up no more desk space than an open magazine. Laptops are essential for the digital photographer on the move. At base, they can be supplemented by attaching a large monitor.

Monitors

Except for colour specialists, LCD or LED monitors are universally used in photography. Modern LCD monitors are backlit (a panel of light shines through the LCD) to improve visibility and contrast. Screens using LEDs (Light Emitting Diodes) as the backlight are energy-efficient and provide excellent colour reproduction. Both types of screen can be slim, consume little electricity, cause minimal eye-strain, and are suitable for all but the most colour-critical viewing.

For image manipulation, the minimum screen size recommended is 50 cm (120 in). The screen resolution should be 1,600 x 1000 pixels or better. All modern monitor screens can display millions of colours, but the accuracy and extent of the colour gamut varies considerably. Broadly speaking, you need to spend more for colour-critical work. The surface of LCD screens may be matte or glossy. Matte screens are less prone to stray reflections and display images similar to print reproduction. Glossy screens give much better image quality but are prone to stray reflections.

▲ Laptop for photographers

Wide-screen laptops with 43-cm (17-in) screens and powerful graphics are ideal for digital photography. More power may mean less compact, but they can easily replace a desktop machine.

MONITOR CALIBRATION

As viewers, we are tolerant of quite wide variations in colour balance in an image. However, to make the most of the superb images produced by today's digital cameras, you should work with a calibrated monitor.

Modern operating systems offer software calibration as part of the setting up. For Apple Mac, the calibration process is in the Displays section of System Preferences: select Color and click on the Calibrate button, then follow the instructions. There are different approaches for Windows users, according to the version installed. Windows Vista uses a new, powerful colourmanagement system that addresses limitations

of older systems. The best solution is to use a hardware calibrator. This instructs the monitor to display standard colours, which are measured and compared with the target values: the differences between actual and target values enables a monitor profile to be created. (See also pp. 174–5 on colour management.)

Monitor calibrator

COMPUTER ACCESSORIES

As your expertise in digital photography increases and the quantity of images you produce grows, you will wish to invest in accessories that make life easier and increase your enjoyment.

Mobile storage

Digital photography produces vast amounts of data, and removable media provide the essential storage space you need. In general, the greater the capacity of the device, the cheaper the cost per gigabyte of available space.

Portable hard-disk drives are, all round, the best solution for the digital photographer. Not only are their capacities ample for most workers – offering up to 1 TB and more – they are also very costeffective and can transfer files rapidly. Models of about the size of electronic personal organizers are extremely portable and ideal for working on location with a laptop computer, since they can be powered from the laptop.

There are two types of hard-disk drives: those specifically designed for transferring and storing digital images, with their own card reader and controls (see also pp. 210–1); and drives that require the use of a computer. Drives use different interfaces, such as USB 3.0 or FireWire, so make sure you select

the type that connects with and best suits your computer. The most versatile offer two ports – for example, one USB 2.0 and one FireWire; the second port enables you to connect another device while the drive is hooked up.

Larger, desktop hard-disk drives are the fastest and can offer capacities over 3 TB (3 terabyte, or 3,000 GB) yet, at the size and weight of this book, are still relatively portable; however, this type does need a separate mains power supply.

For heavy-duty work and the highest reliability, consider using RAID (Redundant Array of Inexpensive Disks), in which data is copied or striped over two or more disks so that if one should fail, data can be easily be recovered from the other drives. NAS (Network Attached Storage) is also invaluable when more than one person in a studio needs access to the image data.

Removable media

Optical disk media such as CD and DVD offer reliable storage that can be universally accessed. The CD, with its 650 MB capacity, is still used for small-scale transfer, while DVD, carrying up to about 7.5 GB in dual-layer form, is the current standard for large amounts of data. In 2008, Blu-ray

▲ Hard-disk drives

Portable hard-disk drives are becoming smaller and lighter with capacities of 1 TB or more, but their desktop cousins offer even greater storage. Portable disks are powered from your laptop via their USB or FireWire port but they do run slower than mains-powered desktop units.

▲ Graphics tablet

Graphics tablets come in a range of sizes – starting with models smaller than a mouse mat – to suit different ways of working. Large sizes can take up the entire desk area. The pen and mouse tools also cover a range, from simple devices to those sporting several buttons to access various functions.

Disc (BD) won the high-density format war with HD-DVD. A BD carries up to about 48 GB in dual-layer form and will increasingly be the standard for archiving data. However, in comparison with hard-disk drives, optical media are slow to write and slow to access

Graphics tablet

These input devices are an evolutionary step up from the mouse. Comprising a flat tablet, like a solid mouse mat, and a pen-like stylus, graphics tablets give you excellent control over hand-drawn lines

because of their high spatial resolution – that is, they can detect tiny changes in position. They also allow you to increase the width of a line or the depth of a colour by varying the pressure of the stroke – something that is impossible to do with a mouse. A tablet can be small, about the size of a mouse mat, or large enough to need a desk to itself. It is good practice to interchange the use of graphics tablet and mouse to help avoid repetitive strain injuries – for example, by using the graphics tablet for image manipulation and the mouse for the internet and word processing.

UPS, SURGE PROTECTORS, ADAPTORS, AND CABLES

Computer systems are highly susceptible to even very small fluctuations in the amount of electrical current powering them. Because of this, you may want to consider protecting your equipment from power surges and failures – something that is even more worthwhile if you live in areas with uncertain power supplies. Saving your work frequently as you go ensures that, if the worst happens and your machine does crash, then at least not too much of it will be lost. However, apart from the frustration and wasted time involved in restarting your computer, an uncontrolled shut-down does carry with it the risk of damage to your hard-drive. To safeguard against this, an uninterruptible power

supply (UPS) is essential, although they can be expensive to buy. This is a battery that powers the computer and monitor for a short period in case of a power loss, giving you time to quit the application and shut the computer down safely.

Another useful piece of equipment is a surge protector, which prevents sudden rises in power from damaging your delicate equipment. This is well worth its relatively low cost.

Other accessories that you will accumulate are leads to connect devices to your computer and to each other, and adaptors that allow older equipment, such as those based on SCSI, to be used with newer systems, such as FireWire.

eSATA to USB adaptor

▲ Adaptors

With the multiplicity of different standards, there is an accompanying proliferation of adaptors that convert one to another, such as eSATA to USB.

and connector

▲ USB ports

USB (Universal Serial Bus) is a widespread protocol allowing devices to be plugged straight into a working computer and be recognized and connected.

FireWire 400

▲ FireWire cables

Second to USB in popularity, FireWire is equally easy to use and carries power, but connectors come in many different shapes and sizes.

▲ eSATA cable

SATA drives are designed for high data throughput – up to three times that of FireWire 400. eSATA connectors are used to connect SATA drives to other devices but do not carry power.

PRINTERS AND OTHER DEVICES

With the demise of film and the attendant redundancy of the darkroom, photographers need few items to supplement their camera equipment. And with the growth of online services, from printing to file archiving, it is not obvious that equipment such as printers or even hard-disks are necessary. While owning your own equipment allows you to work at your own convenience, it does mean that you have to maintain it, which can be costly in the case of printers.

Printers

Desk-top ink-jet printers are able to match the quality of colour prints of the past when used with high-quality papers. There is a slight loss in subtlety of shading and delicacy of hues compared to a laboratory colour print, but that is fully compensated for by the convenience of being able to make a print directly from your computer. If you make prints for presents or to display, it is worth buying the best printer you can afford that prints at the size you require. Printers for A3/A3+ offer a good balance between being able to output usefully large prints, purchase and running costs, and the amount of desk area they take up. If you only occasionally make poster-size prints, it is more economical to order these online.

Check that the printer takes separate ink cartridges for each colour and uses a minimum of six different colours. If you intend to make black-and-white prints, look for printers using grey and black inks. A paper path that is straight – feeding from the back to the front of the machine – will be able to accept thick papers such as water-colour or hand-made papers. If the printer can accept rolls of paper, you can make banner or panoramic format prints easily. Before you purchase a printer, try to examine prints that it has made on papers that you like: choice of printer can be a matter of personal preference.

Other printers

The smallest, most compact printers – ideal for making cards and small gifts when travelling or at a party – are dye-sublimation (dye-sub) printers. These use a cartridge that contains coloured ribbons and special receiving paper, and are usually powered by battery for maximum portability. They deliver excellent, lively results.

Desk-top colour laser printers are suitable for producing multiple copies of colour images quickly, but image quality lags a long way behind that of ink-jet or dye-sublimation printers. Industrial-scale laser printers are widely used to print photo-books.

▲ All-in-one printer

A combined scanner, copier, and printer is capable of producing excellent prints for day-to-day use. Larger ink-jet machines are best for exhibition-quality prints.

▲ Portable printer

Printers such as this model, hardly any larger than the prints it produces, are ideal for use on location and at social events, but need regular topping up with paper and charge.

HALF-TONE CELLS

Printers can lay more than 2,000 dots of ink per inch (dpi) but since no printer can change the strength of the ink and not all can vary dot size, not all dots are available for defining detail. Thus, printers use groupings of dots – half-tone cells – to simulate a greyscale. At least 200 grey levels are needed to represent continuous tone. Therefore, a printer must control a large number of ink dots just to represent grey levels, reducing the detail that can be printed. In practice, detail resolution above 100 dpi meets most requirements. Now, if a printer can lay 1,400 dpi, it has some 14 dots to use for creating the effect of continuous tone. If you multiply together the four or more inks used, a good range of tones and colours are possible.

▶ Filling in cells

Each cell accepts up to 16 dots - counting a cell with no dot, 17 greyscale levels are thus possible. Cells should be randomly filled. Here, they have a regular pattern, so when cells are combined a larger pattern emerges. The device resolution is used to place more dots in each cell.

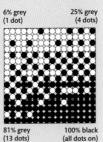

▲ Flat-bed scanner

Modern flat-bed scanners produce excellent results from prints. With a transparency adaptor in place, good-quality scans can be obtained from film.

Scanners

Flat-bed scanners look and work like small photocopiers, but they output image files instead of printed copies. They are useful when you need to turn many drawings, documents, or prints into digital form. The maximum size of the original is usually A4, with well-regarded models made by Epson, Canon, and Hewlett Packard. If you do not need the highest quality or need to make only a few copies, you can photograph the original. Should you wish to turn text on documents into editable text, you can pass the images to optical character recognition (OCR) applications such as Omnipage.

Film scanners are the best way to digitize 35 mm film such as legacy collections, or film from Holga cameras, giving resolutions up to 4,000 lines per inch. If you wish to scan medium-format film (6 x 4.5 cm and larger) a flat-bed scanner may provide acceptable quality. Within fewer than fifteen years after the rise of digital photography, only a handful of film scanners remain in production. Nikon and Imacon models provide the best quality but are very costly. Less costly models and flat-bed scanners can fulfil less demanding standards. Second-hand film scanners from Nikon, Minolta, Canon, Microtek, and Kodak, can offer good buys, but spare parts and servicing are problematic.

▲ Film scanner

A high-quality film scanner is necessary for turning legacy film-based material into digital form. The majority of models accept 35 mm film, but some accept medium-format.

INDEX

abstract images 52-54 animal photography 88 close-up 52 contemporary architecture depth of field 52 focal length 52 shadows 56 animals 88-91 abstract images 88 in black and white 88, 89 cross-processing 88 focal length 90 portraits 89 props 88 subject knowledge 90 telephoto lens 205 viewpoint 89 in zoos 90-91 architectural images 55-57 abstract images 56 colour composition and balance 32, 56 composition 56, 57 contemporary, and abstract images 56 distortion 28, 55-56, 113 focal length 56 foreground reduction 56 image manipulation 56 legal rights 55 lens choice 55, 56, 57 lighting 55-56 panoramas 56, 93 in RAW format 56 security concerns 55 straight and parallel lines 55. 116 tone-mapping 55 ultra-wide-angle lens 56 viewpoint 57 white balance 34-35, 56 see also cityscapes artwork legal restrictions 82

black and white animal photography 88, 89 cityscapes 82 colour to 107, 148-55 duotones 162-63 four-colour blacks 148 landscapes 78, 79 portraits 101, 154-55

Blur filter 125, 130-31 in contrast 22-23 lens movement effect 133 movement 22-23, 113, 131, 132-33, 142 portraits 98, 100 radial 131 reverse tilt effect 133 selective 130, 135 street photography 63 wedding photography 71 zoom 131 brightness colour 30

cameras

high dynamic range 168-69 accessories 206-09 APS (Advanced Photo System) cameras 204 camera bags 209 compact point-and-shoot 196 Four Thirds (4/3) format 198, 199 ILC (interchangeable lens compact) cameras 198, 199 light meters 208 memory cards 210-11 Micro Four Thirds format 198, 199, 204-05 mirrorless compacts 198-11 mobile image storage 211 resolution and quality 197 single-lens reflex 199, 200-01 super-zoom 197 waterproof housing 209 see also lenses camera phone 194-95 photography 102-03 children, photographing 72-75 composition 73, 74-75 fill-in flash 74 focal length 74 lighting 44 patience, need for 72, 73, 74, 75 posing 72 professional cameras 74 travel photography 72 see also portraits cityscapes 82-85 background removal 178 black and white 82 colours of city lights 82 composition 62, 82, 84-85 converging lines 85 depth of field 85 flash 84 focal length 83 framing 84, 85 legal restrictions 82 low-light photography 86-87 cityscapes (continued) RAW files and sharpness and saturation 158 reflections 83 silhouettes 85 skylines 83 street lights and tossing the camera 23 street photography 62-63 telephoto lens 85 traffic 83 viewpoint 85 zoom lens 83 see also architectural images cloning Curves tool 186 distraction removal 134, 142 dust removal 124, 125 noise 186 techniques 186-87 tone 186 close-ups abstract images 52 depth of field 19 flash 42, 213 macro lens 204, 205 perspective 25 portraits 29 against white 31 background, and portraits balance 122, 123 black and white, change to 107. 148-55 brightness 30 of city lights 82 composition 30-31, 32, 33 contrast 30, 31, 32, 33 exposure control 49, 119 flash see flash gamut 139, 183 harmony 136 high dynamic range 168-69 indexed colour file 121 lighting 86 management 114-15 monitor calibration 114-15. monochromatic 32 neutral field 31 originals, tints from 166-67 output profile 114, 115 pastels 32 problems and lighting 119 saturation 140-41, 143 as subject 30 subject colour problems temperature 138, 160 unbalanced 113 vibrance 140, 141 wheel 30-32, 33 see also white balance colour and image manipulation Color Balance control 136-37, 189

(continued) Color blending modes 182, 183 184 Color Range tool 174, 175 Color Saturation tool 166. 167 colour adjustments 109, 119, 138-39 colour enhancement 107 control and Curves tool 145, 146-47 Hue/Saturation control 119, 137, 138, 139, 166, 189 Levels control 79, 120-21 negative film to transparencies effect 164-65 Replace Color tool 138, 139, 166 RGB colour mode 109, 111, Saturation blending mode saturation and vibrance 140-41, 143 subject colour problems 119 tints from colour originals 166-67 composition architectural pictures 56, 57 children, photographing 73, 74-75 cityscapes 62, 82, 84-85 colour 30-31 diagonal lines 13 documentary photography 60-61 framing 16 geometric patterns 16 landscapes 77-78, 80-81 letter-box 14-15 off-centre subjects 21 overlapping subject elements 13 panoramas 92-93 patterns in 17 in portraits 100, 101 puzzles, creating 17 radial 12 Rule of Thirds (golden spiral) 14-15 street photography 62 symmetry 12 tall crop 14 unusual/unlikely subjects computers accessories 216-17 choice of 214-15 graphics tablet 175, 216, 217 printer 218-19 scanners 219 contrast blur in 22-23 colour 30, 31, 32, 33 dealing with low 118

colour and image manipulation

contrast (continued) duotones 163 reduction 122 copyright 56 wedding photography 71 cropping framing 29 scanning 116 Curves tool banding 143 cloning 186 colour adjustment 138 colour to black and white conversions 79, 151 cross-processing 164-65 highlights 145 use of 144-47 vintage effects 156 white balance 136

date and time setting 10 depth of field abstract images 52 autofocus problems 20-21 background removal 178 cityscapes 85 close-ups 19 excessive 113 focusing 18-21 image distractions 134-35 landscapes 77, 78 lens aperture 18-19, 21 off-centre subjects 21 perspective 25 portraits 99, 100 shift and tilt movement lenses 205 travel photography 66 wedding photography 70 distortion architectural images 28, 55-56, 113 facial 29 focal length 29 panoramas 92 shift lens 28 wide-angle lens 28, 29 zoom lens 28. 29 documentary photography 58-61 camera choice 58 caption writing 58 citizen reporting and rights 59 composition 60-61 legal issues and model release forms 61 preparation and background knowledge 58 RAW files and low vibrance reliability and honesty of content 58, 59 safety issues 58-59 ultra-wide-angle lens 59

documentary photography (continued) video images 58 see also street photography; travel photography dust spots 124–25, 126

exposure control blur see blur camera phones 102, 195 colour 49, 119 flash see flash grey cards 208 highlight clipping 112 landscapes 77, 78 Levels control 79, 120-21 low-key images 38, 39 low-light photography 86, 87 measuring systems 36 metering see metering noise see noise optimum exposure 36-37 pastel colours 32 sensitivity patterns 37 shadows 56, 112 tones 36-37 travel photography 66 unsharp subject detail 118

f/number see lens aperture greyscale 162 hard-disk systems 110, 216 RAW see RAW, working with saving and back-up 107, 216-17 tagging, metadata and notes 106-07 file size colour control and Curves tool 147 image manipulation 109 interpolation 130 filters blurring 125, 130-31 choice of 207 flash 41 masking 176-77 noise reducing 87, 124 polarizing 80 sharpening 126-29 vintage effects 156-57 filters and image manipulation Blur filter 130-33 filter effects 176-77 Gaussian Blur filter 125 Sharpness filters 126-29 see also image manipulation fish-eye lens 81 see also ultra-wide-angle

accessories 40-41, 212-13 adjustable angle 212 bounced 43, 47 built-in, limitations of 212 camera phones 102 children, photographing 74 cityscapes 84 close-ups 42, 213 control 40-41 coverage, adjustable diffuser 46, 49 distance 40, 42 effects without 41 electronic 42-43, 44-49, 212-13 exposure process 41, 42 fill-in 45, 49, 74 filters 41 freezing movement 40, 41 Guide Number (GN) 213 halo effect 45 hot shoe design 212 inverse square law 46 LED unit 213 light diffuser 42 light fall-off problem 42, 43 limitations 40 low-light photography 86 meters 208 mixed light sources 49 modelling light 43 overexposure problems 42 portraits 46-47 red-eye 213 reflector, use of 40, 48 shadows 46-48 slave unit 40-41, 212 slow-synch mode 40 soft box 44 studio flash lighting 45, 48-49 synchronization 41 telephoto lens 213 underexposure problems 42 wedding photography 70, 71 wide-angle lens 42 see also lighting focal length abstract images 52-53 animal photography 90 architectural pictures 56 camera phones 195 children, photographing 74 cityscapes 83 colour composition 33 distortion 29 flash coverage 213 image distractions 134-35 landscapes 77 lens aperture 19 lens choice 203, 204, perspective 24-25 portraits 99, 101 travel photography 66, 67

focal length (continued) unsharp subject detail 118 wedding photography 71 see also viewpoint framing cityscapes 84, 85 composition 16 cropping 29

highlights
burning-in and dodging
122, 123
clipping 112
Curves tool 145
duotones 162
high dynamic range 168
RAW format 158
Hipstamatic app 38, 103
horizon tilt, correcting 113,
117

image assessment 10, 108-09 image distractions 134-35, 142 166 image management 110-11 see also record-keeping image manipulation architectural pictures 56 background removal 178-79 banding 143, 159 bit errors 108, 109 Brush tool 166, 186 burning-in process 122-23, capture defects 112, 113 Channel Mixer 137, 152, checklist 109 cloning see cloning Cloud computing 108 colour see colour and image manipulation composite images 188-89 contrast, dealing with low 118 cropping 116-17 cross-processing 88, 164-65 Curves control see Curves tool data loss and back-up 143 defects, avoiding 142-43 Desaturation tool 135, 143, 148-49, 166 dodging process 122-23 dropper tools 136, 138 duotones 162-63 dust removal 124-25, 126, exposure correction 107, 109 feathering 173, 175 file formats 109

image manipulation (continued) grevscale files 162 haloes 142, 143 Healing tool 124, 125, 142 high dynamic range 168-69 image distractions removal of 134-35 image rotation 116 image stitching 190-91 interpolation 130 LAB channel comparison 151 landscapes 78 79 Lasso tool 173-74 178 layer blend modes 169. 180-85 Lavers and Modes control 107 176 Levels control see Levels tool low-key images 38 low-light photography 87 Magic Wand tool 174, 175. 178 management software 111 Marquee tool 173-74, 187 masking 172, 173, 174, 176-77, 179 memory card error and downloads 108 Merge to HDR 169 monitor screen size 215 multiplying filter effects 183 noise reduction 87, 107, 109, 143, 186 panoramas 92, 93, 190-91 pixel selection 172-75 pixellation problems 142 Ouick-mask mode 133, 176 RAW files see RAW, working with Sabattier effect 146, 184 saving copies 117 shadows 122, 123, 143 Shadows/Highlights tool sharpening software 107, 126-29, 142 sharpness, dealing with lack of 118 side effects, unwanted 142-43 sky see sky software packages 106, 111 tagging data and notes 106-07, 110 transparencies to colour negatives effect 165 transparent edges 174 Unsharp Mask (USM) 79. 118-19, 125-27, 142-43 vintage effects 156-57 watery effect and blur 131 white balance 106-07, 109, 136-37, 142 working methods 106-07, 142 see also filters and image

manipulation

landscapes 76-81 background removal 178 in black and white 78, 79 composition 77-78 80-81 depth of field 77, 78 duotone effect 79 essential requirements 77-78 exposure control 77 78 fish-eve lens, use of focal length 77 Golden Section 81 high dynamic range 168 horizons, sloping 113, 117 image manipulation 78, 79 lens aperture 77, 78 lighting 78 motion blur 78 opportunistic shots 80 panoramas see panoramas pastel colours 32 perspective 81 photographer, including in shot 76 polarizing filters 80 RAW files and sharpness and saturation 158, 159 shadows 79 telephoto lens 78 tonal control 77, 78, 79 viewpoint 78, 81 zoom lens 78 legal issues architectural images 55 artwork 82 cityscapes 82 model release form 61, 62 viewpoint 27 see also safety issues lens aperture blur see blur changes, effects of 19 children, photographing 74 colour composition 32 definition 204 depth of field 18-19. focal length 19 focusing 18 landscapes 77, 78 low-light photography 86 portraits 100, 101 wedding photography 70 lenses, choice of 202-05 accessories 204, 205 extenders 205 fixed lens 202-03 focal length 203, 204, macro lens and close-ups 204, 205 shift and tilt movements 205 lenses, choice of (continued) SLRs and interchangeable lenses 204-05 specialist lenses 205 specifications 203-04 see also camera choice: ultrawide-angle lens; wide-angle lens: zoom lens Levels tool banding 143 brightness 145 colour adjustment 109, 119, 140 149 colour to black and white conversions 79, 151 cropping 116 cross-processing 165 exposure control 79, 120-21 use of 120-21 vintage effects 156 white halance 136-37 light polarizing filters 80 lighting architectural interiors 87 architecture 55-56 camera phones 102 children, photographing 44 colour 119 flash see flash high-key, and pastel colours landscapes 78 low-key images 38, 39 metering see metering portraits 39, 98, 100, 101 soft box 44 wedding photography 70, 71 live events 94-97 background knowledge 96. blur and movement 96 environment, recording of opportunities and preparation 96 safety issues 94, 96 shutter lag 96 sports coverage 94, 96-97 two cameras, use of 97 viewpoint and location 94. wide-angle lens 95, 97 zoom lens 96, 97 low-light photography 86-87

metering choice of meters 208 exposure control 37, 208-09 flash 208

metering (continued) grey card as control 136 spot 37 movement autofocus 20–21 blur 22–23, 113, 131–33, 142 tossing the camera 23 unsharp subject detail

nature photography pastel colours 32, 33 see also animals noise causes of 112 cloning 186 control 124, 125 low-light photography 86, 87 reduction, and image manipulation 87, 107, 109, 143, 186 reduction, and RAW files 158 underexposure 38

panoramas 92-93
architectural pictures 56, 93
composition 92-93
distortion 92
image manipulation 92,93, 190-91
landscapes 92-93
pseudo 92
viewpoint 92
wide-angle lens

perspective

close-ups 25 depth of field 25 facial distortion 29 influencing 24-25 landscapes 81 travel photography 66 wide-angle lens 24, 25 portraits 98-101 animals 89 background removal 179 black and white 101, 154-55

blur 98, 100 close-ups 29 colour background 100 composition 100, 101 depth of field 99, 100 environmental surroundings, significance of 100, 101 eyes 66 portraits (continued) facial distortion 29 flash 46-47 focal length 99, 101 group 100 halo effect 45 high dynamic range 168, lens aperture 100, 101 lighting 39, 98, 100, 101 low-key images 38, 39 non-facial 101 profiles 29 RAW files and soft contrast reflections 100 shadows 99 sidelighting 39 travel photography 66, 67, 68, 69 trust 98-100 wide-angle lens 101 see also children, photographing posterized image 109, 120, 147, 152, 163, 165 printers choice of 218-19 half-tone cells 219 with colour management 114-15 colour saturation 138, duotones 162 low-key images 38 sharpening of images 126

RAW, working with 158-61 Adobe Digital Negative (DNG) 158 advantages 158 in architectural images batch conversion 158, 160-61 colour extraction 158 IPEG comparison 158 low vibrance in documentary photography 158 Merge to HDR 169 RAW flow 160-61 RAW styles 158-60 shadows 112, 158, 159, sharpness and saturation in cityscapes 158 white balance 142, 158, 160-61 record-keeping 105 see also image

management

red-eye 213

safety issues documentary photography 58-59 live events 94, 96 street photography 62 viewpoint and trespass 27 see also legal issues shadows abstract images 56 burning-in and dodging techniques 122, 123 clipping 112 in composite images 189 Curves tool 145 duotones 162 exposure control 56, 112 flash 46-48 high dynamic range 168 image manipulation 122, 123, 143 landscapes 79 low-key images 38 portraits 99

RAW format 112, 158, 159,

dealing with lack of 118

skylines and cityscapes 83

160-61

filters 126-29

cityscapes 85

low-key images 39

sports coverage see live

see also cityscapes; documentary photography

street photography 62-63

sharpness

silhouettes

events

sunlight

flare 113 tagging data and notes, and image manipulation 106-07 burning-in and dodging techniques 122, 123 cloning 186 control and Curves tool 144, 145, 146-47 control and mood 38, 39 duotones 79, 162-63 exposure control 36-37 Hue/Saturation control tool image distractions 135 landscapes 77, 78, 79 Levels control 79, 120-21 low-key images 38-39, 86 mapping 55, 168-71 noise see noise

tone (continued) RAW files 159, 160 separation and conversion to black and white 152-53 sharpening software 126-29 white balance see white halance travel photography 64-69 children, photographing cultural considerations 68 depth of field 66 exposure control 66 focal length 66, 67 food and drink 64 opportunities and composition 65, 67, 68-69 perspective 66 photo-sharing 65 portraits 66, 67, 68, 69 recording relationships 66 subject choice 64 viewpoint 66 weather 65 see also documentary photography tripods choice of 206-07

ultra-wide-angle lens architectural pictures 56 choice of 202, 204 documentary photography 59 fish-eye lens 81 underexposure problems 38, 42

see also focal length

vignetting 113 feathering 175 vintage effects 156-57 vintage effects duotone 162-63 vignetting 156-57

effect 131 underwater photography, equipment choice 209 weather see rain; skies; sunlight wedding photography 70-71 white balance 136-37 architectural pictures 32, 34-35, 56 control and image manipulation 136-37, 142 image manipulation 106-07, 109, 136-37, 142 RAW files 142, 158, 160-61 under-exposure 49 see also colour wide-angle lens architectural pictures 55, 56 distortion 28, 29 flash 42 live events 95, 97 misalignment 113 panoramas 92 perspective 24, 25 portraits 101 wildlife photography see animal photography

zoom lens
architectural pictures 56, 57
blur effect 131
camera phones 194, 195
choice of 202, 203, 205
cityscapes 83
colour composition 33
distortion 28, 29
image distractions 134–35
landscapes 78
live events 96, 97
perspective 24–25

ACKNOWLEDGMENTS

From the author

Five editions of this book have run concurrently with almost the whole life of digital photography itself. That the book has grown and developed to keep up with changes in technology and photographic practice is entirely thanks to its readers. My first and biggest thanks are to you: thank you for buying this book (especially to those of you who – I know – purchase new editions to replace their old ones). I am also delighted to record my thanks to readers from around the world who have written to me over the years to encourage me, to suggest changes, to point out errors, and to share ideas. This book, and my other titles, are much improved for your input. Do keep writing – there is plenty of room for improvement!

This book has steadily improved and adapted itself to changing circumstances over its several editions, thanks to the keen attention of my senior editor, Nicky Munro. Sadly for us, Nicky is now happily reading in a greater library in the sky, so this edition is the second not to benefit from her razor-sharp editorial eye for style and detail. But she still hovers at my shoulder, and I'm sure even this edition is all the better for that.

Finally, as the original dedicatee of the first edition, my wife Wendy continues to deserve the dedication and biggest acknowledgment, remaining a steadfast source of inspiration, strength, and good sense.

Tom Ang Auckland, 2018 info@tomang.com

From the publisher

Many thanks also to David Summers and Hugo Wilkinson for editorial assistance, Simon Murrell for design assistance, and Margaret McCormack for compiling the index.

Picture credits

Dorling Kindersley would like to thank the following for their kind permission to reproduce their photographs:

(Key: a-above; b-below/bottom; c-centre; f-far; l-left; r-right; t-top)

70 Corbis: Disc Pictures /
AsiaPix (br). 71 Corbis: (clb, crb).
75 Joe Munro (br). 95 Getty
Images: Naki Kouyioumtzis /
Axiom Photographic Agency (br).
98 Wendy Gray. 99 eva serrabassa (bl); DOF-PHOTO by Fulvio (br).
100 Corbis: Gadd (bl). 101 Corbis:
Ariel Skelley / Blend Images (br).
104 Paul Self. 132 Getty Images:
Heinrich van den Berg (cla).
170-1 Paul Self. 193 Getty Images:
Jessamyn Harris (bc); Photo
Nadieshda (tc); weechia@ms11.
url.com.tw (ca).

All other images @ Tom Ang.